Abstract Painting

Pictures on front cover:

Wassily Kandinsky
Watercolour 9 with black stripes
1912. Watercolour, 37.5 × 27 cm
Munich, Städtische Galerie im
Lenbachhaus

Piet Mondrian
Tableau I, **1921**
Oil on canvas, 96.5 × 60.5 cm
Cologne, Ludwig Museum

Pictures on back cover:

Willi Baumeister
Gouache, 1923
22 × 14 cm
Paris, Private Collection

Jean-Paul Riopelle
Star garment no. 3, **1952**
Oil on canvas, 200 × 150 cm
Cologne, Ludwig Museum

Phaidon 20th-century Art

With 95 colour plates

Afro	Kandinsky	Noland
Albers	Kantor	Pevsner
Appel	Kassák	Poliakoff
Arp	Klein	Pollock
Baumeister	Kline	Popova
Bill	Kooning, de	Reinhardt
Bogaert	Krushenick	Riopelle
Bonfanti	Kupka	Rodschenko
Burri	Larionov	Rothko
Calderara	Lissitzsky	Schumacher
Corneille	Lohse	Sonderborg
Delaunay	Louis	Soulages
de Staël	Magnelli	Taeuber-Arp
Dewasne	Malevich	Tàpies
Fautrier	Manessier	Tobey
Fontana	Mathieu	van Doesburg
Francis	Medek	Vantongerloo
Gorin	Millarès	van Velde
Gorky	Moholy-Nagy	Vasarely
Hartung	Mondrian	Vedova
Herbin	Motherwell	Vieira da Silva
Hoelzel	Nay	Vordemberge-
Itten	Newman	Gildewart
Jorn	Nicholson	Wols

Arsén Pohribny

Abstract Painting

Phaidon — Oxford

The author would like to thank Frau Hildegard Buchmann for her help in revising his manuscript.
The author and publisher would like to thank the museums and galleries for their support in the preparation of this book.

Phaidon Press Limited, Littlegate House, St Ebbe's Street, Oxford
Published in the United States of America by
E. P. Dutton, New York
First published in Great Britain 1979
Originally published as *Abstrakte Malerei*
© 1978 by Smeets Offset BV, Weert, The Netherlands
German text © 1978 by Verlag Herder, Freiburg im Breisgau
English translation © 1979 by Phaidon Press Limited
Illustrations © Beeldrecht, Amsterdam
ISBN 0 7148 1956 5
Library of Congress Catalog Card Number: 79 83786
Printed in The Netherlands by Smeets Offset BV, Weert

Contents

Can one utter the inexpressible, read the incomprehensible?

One day Wassily Kandinsky on entering his studio experienced something magical. In the early dusk he saw a strange 'indescribably beautiful painting infused with an inner glow'. The painting was resonant with a quiet music. Was he dreaming? The tones of the colours and the sounds of their chords could be heard. Through a wonderful delusion Kandinsky did not recognise his own work, but saw an abstract composition long before he had really painted one. He was already occupied then with dimensions of an 'other' non-representational way of painting. He had written an essay on its theoretical possibilities in 1910, the famous *On the spiritual in Art*, published in 1912, the guiding principles of which were followed by the young painters as a revelation and a signpost into fresh areas of art.

There one reads strange things: paintings which do not exist yet but are felt; one has rules in one's mind from a hidden realm as yet unmaterialised. But a 'different' way of thinking was already growing, one which did not arise from objects, but out of spiritual-intellectual sources. And a 'different' way of seeing came into being, which generated and enjoyed the 'inner sounds' of pure forms and the characteristic quality of colours. What appeared at first as a magical coincidence has come to be the symptom of a new way, a way which the Russian Kandinsky had been the first to tread with a passionate artistic temperament and an oriental imagination. His first abstract period has consequently remained as a most characteristic example of the expressive-lyrical or 'hot' trend.

Not long after this, at the opposite 'cool' end, other non-representational compositions arose which competed sometimes with the beauty of a crystal. The Czech Kupka, the Russian Malevich and the Dutchman Mondrian started with the geometrical relationships of a painted rectangle. These relationships were systematically developed with the appropriate contrasts in colour. It is advisable to note the differences between these heterogeneous abstract trends.

Within an area which comprises trends stretching from the lyrical to the geometrical, there are a great number of further movements and personal conceptions which appeared, especially after the Second World War, like mushrooms after the rain. A preview of such shortlived developments can scarcely be sketched within the framework of this book. It is more important to concentrate historically on the focal points and on the permanent problems of abstract painting.

We shall attempt in this book to elucidate the difficulties caused by the renunciation of the representational ways of seeing and look into the concomitant reductive processes and phenomena of intellectualization. We shall be especially concerned with the autonomy of the pictorial – or better visual – elements, with their generative power in terms of content, with the meaning of construction and with the geometrical signs. The anthropological problems posited by the lyrical painting of the post-war period and the existence of the unknown will present us with new and difficult questions.

However, we cannot deal with these problems until we have dealt with particular doubts. For example, is the incomprehensibility of Abstract Art an unusual characteristic? Is it the lack of representational references which prevents its ready interpretation? What other causes might complicate this unfortunate anti-communicative state of affairs yet further? And what chances remain for the unprepared spectator?

Paradoxes

The abstract trends have generated during their existence of some seventy years a profusion of thousands of paintings and related objects. Abstract painting is justly called the typical art form of the 20th century. Yet no one would assert that it belonged to the popular art forms. For the broader public it remains like the Himalayas – too far away, too high, impenetrable and misunderstood.

This state of affairs is not altered by the fact that the biggest and most modern museums of the world allocate important rooms to abstract painting, and it means nothing that the classic abstract works are sold for hundreds of thousands and that even small drawings are rare objects on the art market. In spite of their value abstract paintings have not become integrated into the general culture.

One could rightly object that the whole of modern art is not much better off in this respect. This is the result of a further paradox. Although in the culture of the industrial age optical

systems and the effects of reproductions and illustrations continue to be of an overwhelming importance, the truly visual art survives only as an elitist phenomenon in the background; and in this respect the position of the unrepresentational painting is even more extreme. By the way, its pioneers did not discover and develop it to establish some new kind of folklore. Such ideas emerged much later in the utopias of the constructionists.

At first it looked as though the abstractionists were only willing to show the results of secret laboratory researches. It was only after 1948 that these trends were able – as part of architectural design – to affect the general public on a broad basis. But what preceded was a thorny path of extreme privations made worse by false accusations, deceptions, insanity and later political persecutions.

Now if the abstract painters were willing to make such sacrifices for their muse and its purity, if their belief in a 'pure world of reason and harmony' gave them such strength, then it must be worthwhile to discover its 'liberated elements', its signs and systems and to listen to the 'inner sounds' of its colours. An imaginary journey into this 'other' as yet never perceived world may lead to surprising realisations.

Incomprehensibility

And then it happens: we visit a museum and face an abstract painting with the best of intentions to grasp some of its meaning. One feels a certain alienation, one tries to overcome the distance between oneself and the 'unknown' one faces. Here is one of these very colourful, lyrical compositions full of movements . . . what do we see?

Chaos – that is the first impression – a deliberate chaos, in which none of the dancing specs of colour offers us a clue. The painting appears undecipherable, superfluous, indeed horrible. Other visitors comment that it is a barbaric concoction, an unnatural provocation, something insulting to the natural dignity of man.

On the other wall one of those 'cool' geometrical works appeals to us. Here someone offers the opinion that it may be the design for a pocket diary or the pattern of a house painter, not in any case real art. For 'what does it portray?'

When one asks for pictorial representation, one thinks immediately about a scene with figures, a landscape in the background, about a mass of delightful details to please one's eyes, and to these we like to turn again and again. But before us now we find nothing resembling our preconceptions. We remain disappointed and confused. One step remains to be taken to move from our unfulfilled expectations towards suspicion: perhaps the artist meant to provoke us wickedly, to pull us down into the ugly . . . what are we to do with it? Should we be annoyed or laugh? In any case one could not possibly take this strange fellow seriously.

Yet, despite this dismissal, doubts remain – there has to be something, otherwise these paintings would not be exhibited in a gallery. Perhaps we have missed something important? What did we fail to see?

Sooner or later we realise that our expectations were inappropriate and our standards wrong. An expert would say that our behaviour has been 'unsporting'. How? It would be unfair to accuse a painter of still lifes of deception because he does not paint human figures. And it is precisely this accusation which we have made in the case of the abstract paintings. Can we accuse somebody of incomprehensibility, wickedness, etc, just because he does not depict the generally popular motifs, or at least the well-known symbols of nature? Should we not be interested at least in the motivation of the author? The abstract painters abstained from factual content and the imitation of nature as part of their programme, because they meant to reveal to us completely different non-factual areas of experience – pure feeling or 'musical' colour harmonies for example. And by the way: should one demand that the silent movements of a pantomime be explained by words?

Is it only abstract paintings which are difficult to understand?

Is it not just as difficult to understand the *Mona Lisa* or the *Night Watch*? It is often said that everything is comprehensible which we can recognise and judge within the terms of our own experience, which is what fundamentally decides the way we understand a painting. Let us consider, for instance, our appreciation of such a painting as *The Last Supper* by Tintoretto. We allow our gaze to move slowly over this epic composition, our eyes shifting from one apostle to the next, occasionally resting on a detail, then moving on to the contours of the trees and arcades in the background. At the same time we begin to relate the painting to the real world: the garden, the chalice, which seems drawn correctly, although the hands seem unnaturally long. A psychological mechanism brings order to the actions and gestures of the figures and relates scale and colour to the world outside the limits of the work of art. There is no direct dialogue between us and Tintoretto's

painting; the orderly component of our imagination comes between us and the work of art. This may function as an interpreter, or perhaps a reminder, always guiding our perceptions or judging whether the contents of the painting agree with our rational understanding of the world, whether everything is sufficiently 'comprehensible'. This 'tripartite' perception only occurs in the case of naturalistic figurative art.

Reason and experience can help us to convey the meaning of a work of art by means of verbal description. But in this very process a surprising limitation is revealed. What we achieve with such verbalisation is as far removed from complete understanding as reading a map is from actually travelling through a picturesque countryside. Our words, our sentences and speech formulas crudely divide the beautiful painting into bits and pieces, destroy its unique magic and miss its true, visual grace. The description remains on the surface of both the painting and the aesthetic experience.

The plastic arts as a whole remain beyond the limits of verbal discourse and rational understanding. The beauty of the painting, that which contains its primary magic and subtleties remains unexpressible, unutterable. The secret of Leonardo's *Mona Lisa* or of Rembrandt's *Night Watch*, the truly creative element cannot be encapsulated in a verbal formula. Verbalisation and logical thought can only serve as a means of orientation, we cannot probe into the deeper, irrational areas of a work of art with our rational faculties. These are the province of intuitive reaction and spontaneous perception. According to W. Hoffmann, art expresses that which man cannot see, or cannot any longer see directly. In the demands and execution of his art, the artist identifies that which is almost beyond description.

Can the conclusion that the true substance of works of art is beyond rational comprehension help us in our understanding of more obviously 'incomprehensible' abstract art? It may indeed help us to clear away a number of prejudices which have led us astray, and may also help us in our approach to the more difficult areas of Abstract Art.

Let us now juxtapose a few examples of the two different views and spotlight in the process a few of the fundamental principles of non-representational art. 'Art should truly imitate the beauty of nature', this is the credo of the naturalists, 'it is nature extended'. Opposed to this is the opinion of the 'non-representationalists'-: 'nature is one thing, and art, as a product of man, is another', especially when we are dealing with something of a purely intellectual nature as in abstract painting. Abstract painting is pure form made visible, though it may be subject to the same laws as nature.

'Art is for everyone. Painting has to be generally understandable', assert the naturalists. The non-representationalists on the other hand, claim that Abstract Art is like music, it is for everyone with a sense of rhythm, proportion and harmony and the ability to see and enjoy these.

The latter sentiment on the part of the non-representationalists seems more like a pious hope than anything else, since the general acceptance of unusual phrases or new symbols does not happen overnight. It happens through a slow process of learning proper interpretations, of historic assimilations, influenced by certain social conventions. The naturalistic representational style of painting also once seemed new and incomprehensible. We have only to recall the story of the 17th-century Chinese ruler; while looking at a portrait of Louis XIV, he asked in some puzzlement: 'Is it one of the privileges of the French kings to darken their faces first?' He had misunderstood one of the most important conventions of naturalistic painting, the use of shadows. Do we not tend to react in a similar way when we look at abstract painting?

Some rules and interpretations

The general comprehensibility of abstract painting is dependent on a learning process. Our eyes which are accustomed to naturalistic and illusionist conventions, have to abandon these when we gaze at an abstract work of art. This adjustment is governed by the assimilation of new, non-representational modes and the learning of new visual rules. This process is similar to the learning of a new language with its grammatical rules and its new unusual words and interpretations. Once grasped these together form a new and harmonious world. One of the basic rules of the new language says: 'Abstract art is not out to represent the shape of a thing, it creates its own form'. Here, however, we face a great obstacle. The problem is to learn the rules of the 'new' pictorial language, and as far as possible to forget the 'old' language. But the old rules must of necessity retain their validity within their own domain. According to the rules of the 'materialistic' or representational ways of seeing – with the well-known tripartite mechanism – we shall continue to decipher every dot of colour, every line, as a reference to visible reality. According to the same rules we shall also continue to behave like this while reading newspapers, doing the shopping or watching television. This factually orientated mode of perception, the identification of faces and people, the naming of plants, things and phenomena becomes a bad habit as soon as it is applied to the purely visual. We should be gazing at the stars, not looking

down to earth. If we do not use our fantasy, we shall never be able to overcome the strong pull of the representational way of seeing. Man must continually take one step beyond to cast off the shackles of tradition through this kind of action. Indeed, the discovery of the purely visual, of the nature of space and the principles of universal harmony are the greatest adventures of the 20th century.

The abstract painters are like astronauts who have dared to launch themselves into the darkness of space. Their territory is the dark side of the planets; they chart the existence of invisible stars. There are paintings which exude a strong sense of cosmic experience. Other groups of paintings again resemble microbiological photography which makes small, almost invisible worlds accessible to our eyes; and there are many other technological achievements which have their parallels in non-representational painting. But these are only external resemblances.

The planets, the invisible worlds, which abstract painting discovers for us, are of intellectual origin. Rules of purity and universal contradiction predominate. The forms created by artists do not represent anything but themselves, having no original in the outside world.

By means of this autonomy, this visual independence, abstract painting places itself on the same level as the highest of the creative arts — architecture and music. The musician is an 'abstract artist': he does not imitate the voices of nature, but creates magic with sounds and chords and the motifs of music itself.

Abstract painting is the visualisation of ideas. Already in the works of the ancients ideas were realised first by means of symbolic signs, later by so-called allegories. In this way, the idea of justice, for example, is represented by a solemn figure of a blindfolded woman holding a pair of scales.

Abstract painters construct different kinds of ideas of invisible harmony, of the unending vibrations, the eternal contrasts, out of 'liberated means' or elements. Paints, lines, flat surfaces and colours, liberated from the bondage of imitation, exude a new contrast; each element, or group of elements, generates and multiplies new, exciting energies. Thus Kandinsky wrote in 1910: 'Sharp colours express their natural qualities more vividly in a pointed form (for example yellow in a triangle). Colours which tend towards depth are enhanced in their impact by the use of round forms (blue in a circle).' These ideas on the psychological significance of colour were later developed by him for teaching purposes.

Kandinsky also believed that the pure elements, especially colours, are capable of affecting our inner experiences, even

apart from the traditional tripartite reaction to art; colour is a means of direct impact on the soul. The colour is the key. The eye is the hammer. The artist is the hand which sets the soul in vibration by means of this or that key.

If this comparison always held good and the perception of an abstract painting were thus to become a fluid process, then the following hints and rules would be unnecessary. Unfortunately, there still exists a large number of prejudices which hinder this process. After all it is not as though we made Abstract Art accessible to us, but we ourselves have to make ourselves accessible to it.

How does one look at abstract paintings?

The usefulness of reason when dealing with art has proved itself unsure, as we have seen. What then can we do? We must try to divest ourselves of all 'objective' thinking and start to trust our spontaneous reactions. Painting awakens our feelings, which then rise up in waves, as when we listen to music. It would be advantageous to sense on what particular wavelength the painting is structured; the title may give us a clue to this.

In the most ideal circumstances we should be able to enter into the world of such a painting and submerge ourselves in its harmonies, so that we may not only appreciate the energy given off by its various elements or hear them but also experience them with our whole bodies, enjoy the rhythms, relationships and the feeling of completeness. An abstract painting demands a much more active response from us than a representational one, but the viewer gains the opportunity to participate in the creation, at least for a short time. For this reason, we should, as far as possible, enter and submerge ourselves in the forms and colours, until finally — although this is not possible in every instance — we have the feeling that the colours have come out of the depths of our own being, as though we ourselves had created them.

Our reason will not leave us alone though, and it constantly intellectualises our experiences. Associations begin to emerge, and with them the process of identification.

The attempt at identification can achieve extreme realisation through such a shared experience, especially when it is balanced out by contemplation.

For the onlooker who reaches the state of grace of such an experience of 'awakened seeing', the meaning of abstract painting, the key to the intellectual substance of the universe or the model of basic structure, will no longer be a secret.

The first abstract painting

Who were the first to leave the constraints of representational art behind? Who painted the first abstract picture? These questions cannot be answered with certainty today. A short while ago this was different; the famous watercolour by Kandinsky dated 1910 was held to be the earliest example of modern non-representational painting. Lately a number of contemporary and even earlier paintings have been discovered. Which was the world's first? And how can their simultaneous appearance be explained?

Around the turn of the century a large number of trends in art concerned themselves with these problems.

The Symbolists and late Romantics had visions of a mystical pyramid of super-art with music at its apex. A concern for purity led the artists of the Art Nouveau movement to the creation of many abstract motifs which had nothing to do with the imitation of nature. There was also a deliberate searching for hidden meanings under the surface of invisible reality. Simultaneously there were many attempts to clarify the laws of painting, by which the Post-Impressionists, Cubists, Futurists and others were led to the frontiers of the non-representational. Here something similar emerges to what was discovered by the most ancient of Greek philosophers, the Eleans: the substance of the universe is constituted of several basic elements. Even the most sensitive artists felt a need for a return to an archaic art form, to an original language, to the archetypes, to childhood, to the true nature of the original elements. This return was possible, because then the spirit of art was not yet weighed down with virtuosity and with the ballast of literary content.

This search for origins and the purification of form in art is known as 'abstracting'. It means the extraction of an intellectual and spiritual beauty from reality. In other words 'abstracting' is a movement towards the limits of the world of mental forms. This 'other' world is the realm of the abstract, the non-representational. The concepts 'abstracting' and 'the abstract' denote two qualitatively different things in painting.

Even in the 19th century a number of painters had already broached the realm of the abstract, even if only in a limited way. After Turner and the haunting ink drawings of the poet Victor Hugo, it was the artists of the Art Nouveau movement (in 1893 Henry van der Velde and in 1900 Herman Obrist and his pupil Hans Schmithals) who perhaps came closest to realising an 'abstract' art. During the next few years Adolf Hoelzel (III.2), who exercised considerable influence on the later abstract painters by the ingenuity of his insights, painted 'pure' compositions. Between the years 1908 and 1910 the concern with the problems of non-representational art became even more acute. In 1908 Francis Picabia started a series of 'abstract' drawings and a year later he even painted a series of pictures with circular motifs, but then abandonded these researches. The Lithuanian composer and painter M. K. Čiurlionis also contributed to the 'discovery' of abstract painting in the years 1905–11. Even today his paintings seem to have a strangely unreal quality: the traces of unknown plants and landscapes flow into each other like the motifs of a piano sonata. Kandinsky may have seen these compositions in St. Petersburg and they may even have helped to define his own conception of Abstract Art.

There were other occasional explorers in the area of the non-representational, like the Americans Weber, Walkowitz and Dove, the Belgian Lacasse and others. But it was Kupka and Kandinsky who were the first to be fully conscious of the far reaching importance of their discoveries. Perhaps they did not create the first abstract paintings and are not the first discoverers of Abstract Art, but – and this is important – they built the foundations and developed them.

The Czech Kupka, a friend of the Orphists, had been occupied since 1903 with two basic elements in particular: movement and colour. In doing this he found a factual motif unnecessary and a hindrance. Although he sometimes joined the 'key board motifs' with a water surface or with a female silhouette, nevertheless around 1909–10 he stepped forward into the realms of pure form. Several paintings prove the point. He discovered that the organic whole of each painting is a conglomerate of a number of elements, and its structure determines the morphological, primary images. The opportunity of conducting such experiments first presented itself around 1912, when Kupka's paintings were the sensation of the Paris Salon d'Automne. One painting was called *Amorpha, Fugue in two colours* (III.12) He also worked on a number of musical projects.

At the same time, in Munich, Kandinsky was conducting a number of similar experiments without knowing of Kupka's work. A characteristic watercolour of the 44-year old Kandinsky is generally considered to be the first wholly abstract work of art (III.3). It shows clearly almost all the elements of his later powerful spontaneity, particularly of his *Improvisations*.

Let us take a closer look at this work, however. It reminds us strongly of the daubings of a two-year-old child. These forms,

dismissed as insignificant by some critics, tell us much about the direction of his experiment. The intense patches of colour, which are suspended here as in the whirlpool of creation, are the psychological zero point of painting. Kandinsky deliberately attempts to return to the level of the child and to reconstruct its first reactions to its surroundings. The child already perceives things and faces, but it cannot know their place and meaning nor can it give them a name. It spontaneously rejects them or accepts them. This is the first animal reaction to the world, the aesthetic, pre-rational reaction.

If this behaviour is expressed by means of pen and brush, it produces characteristic daubs and traces on the paper. Kandinsky's abstract watercolour is therefore a sort of psychological archaeology. His probing is aimed at the deep layers of our psyche where the aesthetic reactions or primary origins of art are repressed and covered up by later rationalisation. With this watercolour Kandinsky had entered for the first time the magical realm of the non-figurative. In all probability he had made two decisions; never again to return to the manners of representational illusion and for the time being to explore the outer reaches of art. This explains why he continued to work in two modes between 1910 and 1913.

In the *Impressions* one still finds silhouettes of mounted men, pilgrims and landscapes infused with almost fairy tale colour. The *Improvisations*, almost musical in manner, and the rarer *Compositions*, are revelations of pure lyrical, primeval states of being. Here the liberated colour forms join together in a turbulent hymnic fusion of chords. It was these paintings in particular which established Kandinsky's fame as an artistic revolutionary and as the father of Abstract Art. This fame cannot be diminished by the fact that (if only for a short while) other painters had painted in an abstract mode. They were the Vikings, he was Columbus. Kandinsky and Kupka, and later Malevich and Mondrian developed abstraction by hard but successful experiments which were eventually strengthened by theory. These are the four great founders and real instigators of abstract painting.

Abstract, non-representational, absolute, concrete, informal painting

Up to this point we have talked about some of the main ideas, preconditions and concepts which give rise to the abstract, non-representational way of creating works of art. But we now come to a question of terminology. We need clear concepts which will help us to find a structure in the chaos of our perceptions and to distinguish the most important features in the new terrain of Abstract Art.

Concepts such as 'abstract, absolute, pure, non-representational' and later 'non-depicting, non-figurative, concrete, etc.': these are the so called major terms which are concerned with the whole concept of Abstract Art. Less important concepts are grouped under the names of trends such as Rayonnism, Unism, Structuralism, Tachism, etc. These trends distinguish themselves by their stress on various elements and functions. The main termini mentioned here mirror the great, indeed antagonistic, contradictions of two worlds: the representational and the abstract. They symbolize a protracted activity or its end result of sounding out (abstracting) factual, literary and mimetic characteristics. This activity was undertaken to reveal the unchanging, lawful and essential elements of the reality of life as well as art.

These two contrary worlds are not entirely apart. Between them stretches a zone of half real, half abstract forms of art as the result of processes of abstractions (for example stylisation, reductionism etc).

To be *still abstracting* and *already abstract* are two very different conditions which are nevertheless characterised by similar sounding concepts and may possibly lead to misconceptions. That is why the classic forms of non-representational art should not be labelled 'abstract'. It was valid in the initial period of the movement, but was substituted by the term 'concrete'.

Why is this overall symbolic term still used? 'Abstract' painting is a label, like 'romantic' painting is for works of different origins and importance. For our purposes 'abstract' is a term more generally used than any other. Here is how the classic practitioners have defined this art. According to the writer Michel Seuphor, a friend of Mondrian, Abstract Art is 'every kind of art which does not relate to visible reality; that is, it does not contain any abstract reality whether it provides the initial

impetus for the artist or not.' Similar definitions could be used for 'art without objects' or 'non-representational art', that is art separated from all concrete objects. Neither term is entirely appropriate: 'art without objects' cannot exist without an object – i.e. the painting itself. Further concepts concerning the 'non-objective' can be found in the writings of the Suprematist Malevich.

The term 'absolute art' also needs defining. Adolf Hoelzel, the teacher of many abstractionists, wrote: 'absolute art happens when the energy inherent in the artistic means is deployed without any outside interference'. By 'interference' he means the imitation of objects. Mondrian understood absolute art, that is to say the totally free expression of art. He saw it not only liberated from imitation but free of all individual means of expression, feeling and form. The aim is a concept of supra-individuality, 'objective art'.

The concept 'pure art' (*peinture pure*) was coined by the poet Apollinaire around 1913. He demanded paintings without literary or practical content, integrated and pure 'like plants'.

Related to this group of major terms are the non-representational attempts of the following trends: partly those of the Orphists, Cubists, and Futurists and wholly the Rayonnists, Suprematists, Constructivists and the beginnings of the Dutch Neo-Plasticism. The latter group broke away and forced the others into a new reappraisal and a more appropriate conceptional apparatus. They wanted to substitute the terms 'abstract' which had taken on a multitude of meanings, for the term 'concrete'.

The compositions which had sprung from the intellect and concepts of pure form had nothing to do with ideas culled from the natural world. The concrete exposition, precise, impersonal and immaterial, is mostly based on geometrical forms which have a tangible concrete existence: 'for nothing is more concrete, more real than a line, a colour, a surface' (van Doesburg).

Under the aegis of concrete art the elemental geometricism of the '30s, Structuralism and, after 1950, Ars Accurata, systematic and new concrete art forms, developed. Concrete art formed the basis for Kinetism, Minimal Art and other trends, and gave rise to new concepts in music and the plastic arts.

The post war years saw the development of the enormous, richly structured, non-figurative movement. It developed not only as a reaction against the figurative movement but also as a rejection of the dogmas of the 'cool', geometrical, concrete way of painting. Several trends of this 'hot' abstractionism (sometimes called informal) are typically represented by lyrical and abstract paintings. This totally new approach to spontaneous liberated painting meant a radical change of values. 'Throughout the creative process of painting man experiences himself as content and gives form to this experience' (Claus). This includes the 'hot' French and such groups as Abstract Expressionism, Action Painting, Colourfield Painting, Tachism and Italian Spatialism, Magical Abstractionism, Cobra and others. These concepts reject the different processes and stages of modern abstract painting which we will examine more fully in the following chapters. One final word on this subject. We have used the term 'modern abstract painting' but perhaps abstract painting existed in previous centuries?

Abstract painting has always existed in some form

We have seen that Kandinsky found a pictorial primary language in children's drawings. We know how much Malevich admired old Byzantine ornaments and symbols. Hans Arp, Theo van Doesburg, Auguste Herbin and others were convinced that abstract art was 'man's own most typical creation'. One could write volumes about such theories.

For our purposes there are two important factors. The first is that the abstract artists, as opposed to Renaissance realism, turned to something different, to the traditions of the primitive; they sought old 'abstract' idols and ornaments which contained great spiritual and magical powers. The second factor may be borne out by a visit to a famous museum like the Louvre in Paris: since the old Mesopotamian cultures, indeed since the stone age, there have not only been traces but indeed whole epochs of abstract creativity. These were followed by periods of more figurative art forms. Abstract, like realistic, concepts of art have existed for thousands of years. They form two opposing but constant tendencies.

This polarity of the abstract and of the imitative, within which the pendulum of art history moves, was ascertained in 1908 by Wilhelm Worringer. His book *Abstraction and Intuition*, in which the psychological motivations of artistic abstractions is movingly explained, left a lasting impression on the first generation of abstract painters. We will take one central theme: why is it that at particular points in time artists express themselves in abstract form?

The 'urge towards abstraction' has several reasons. At first, pre-historic man felt threatened by the mysterious forces of nature. He wanted to divorce himself from the 'natural' confusion by means of the human element, of the abstract, mostly

by means of geometrical expression. Was it the fear of chaos, of the uncanny, which moved him towards the abstract?

Later, probably in the first era of civilisation, man reached the conclusion that his capacity to reason and act made him superior to nature. Therefore he demonstrated his wish for order through abstract geometrical forms. At the same time he had to realise that his striving for order on the one hand, and the signs of 'flexibility' on the other, did not only have the same geometrical forms, but also the identical source which keeps the universe in check: the higher eternal energies, the divine. The presence of abstraction, therefore, also meant *being connected with the higher, divine principle* and sometimes also a guarantee of immortality. Ornamental abstractions and geometry therefore became forms expressive of the divine. We can see how these dominate in Islamic, Byzantine and medieval art, as opposed to the 'lower', sinful and more mundane principle of realistic depictions. This comparison is surely reminiscent of the wholly modern Mondrianistic argument?

There is another important motivation for the movement towards abstraction. This is the creative sovereignty of the modern intellectual. It is reminiscent of the arrogance of the alchemists who believed they could create gold out of base metal. Put more soberly: a high intellectual consciousness and handling of purely visual elements leads to pure, never hitherto realised synthesis. With this in mind we can find some general

hints to use in our search for interpretations.

The epochs of predominantly Abstract Art were superseded by representational ones. After the geometricism and the archaisms of the ancient Greeks came the high praise of the beauty of nature of the Phidian and Hellenistic age; after the geometrical Romanesque and the abstract Gothic came the Florentines and their Renaissance realism. Does this mean that the early geometrical formulas, the ornamental arrangements, were superseded by realistic forms? No, for Botticelli, Leonardo and especially Piero della Francesca built up their whole paintings from abstract basic structures. They constructed a compositional skeleton and 'dressed' this 'architecture' with realistic observations from nature. This became the standard procedure.

Abstraction always had been there, and has remained 'under the skin' of every realistic work of art. By carefully observing a representational, figurative painting we discover not only the abstract structure of composition which gives order to the whole, but also the ornamental arrangements of the figurative silhouettes, the musical rhythm of repeated motifs and the counterpoint of colour surfaces. We can even discover 'a great abstract sign' which is generated by the contrast of darker and lighter shades of colour. Each representational painting is informed by this tension between the realistic imitation of life and abstract visual values.

Without straightforward depiction, there remains scope for the creative

Representational – non-representational

In every creative form, in each painting, indeed in the whole of the history of art, the powers of attraction of the two poles (representational and non-representational, or differently put: of imitation and abstraction) attract and repel each other. When Worringer and soon after him Kandinsky observed this dramatic, polar tension modern art came closer and closer to the pole of abstraction. Kandinsky observed in 1912: 'contemporary art embodies the intellectual – spiritual which has ripened and grown towards revelation. The embodied form may be categorised into two poles, 1. the great abstraction, 2. the great realism. These two elements have always been

present in art, the first expresses itself in the second. It seems that today these two elements mean to continue their existence apart from each other.' This observation can be verified in the way natural motifs, by becoming increasingly loose and simple, change into simple flat symbols; finally – in the crystal-like nets of the Cubists – only a few traces of the natural world remain. The experimenting artists, it seems, were so enchanted by this way of painting, by the colour – chords and by their view of the Universe that they forgot about figures and happenings, landscapes and still-lifes. These experimenting painters have been likened to monks, who, far away from the ado and attacks of life, living a withdrawn existence in their cells, believed that they had found the celestial principles of

eternity in simple configurations. But why did painters leave the real, the concrete? And what did they achieve?

What is the 'objective'?

Each work of art which has an object, a figure or a part of nature (even a phantastic one) as its theme is objective. The degree of likeness is immaterial. What we mean by 'object' is therefore not something drawn from nature; we are dealing, psychologically, with the picture of a real object, an image. With 'representational' we denote a rich spectrum of relationships with reality which are *determined* by the existence of the object and the creation of its image. Here we come to the point in question: it is the image which dictates the imitative application of the means and the factual attributes, and not the artist. The task of the artist seems to be reduced quite simply to the skilful creation of the image of objects. In the end the general feeling of malaise amongst the artists turned to the root of all evil: against the object in the paintings. But this meant a fateful interruption of an old tradition and a revolution in painting.

Mimetic and illusionist suggestions and factual attributes had always ensured that one could decipher a painting, because they pointed back to a visible, generally known reality. Faced with the public demand for the representation of that which is generally verifiable and reluctant to conceive art as the repetition of the familiar and conventional, the modernists increasingly voiced their wish for *invention*.

Arguments against the representational

The resistance which caused the rebellion against the all-pervading power of the representational in art and finally its rejection was not the capricious whim of dreamers. Besides the artistic arguments there were also particular social and moral antipathies. The representational object, 'as a false player', had sometimes only a symbolic note.

Most radicals in the modern movement were not against concrete objects as such, and especially not against the natural world. They just were not satisfied with particular aspects and their consequences. Typical of this was the opinion of George Braque: 'What I seek to achieve is for an object to give up its *usual* function. I only pick it up when it is of no further use, as junk, for example, when its *relative* use has ceased to function.'

Why was it that the practical, useful aspects especially, which are the determining factors in an industrial society, were so repugnant to the artist Braque and those like-minded painters? Their situation explains this in part.

The modern artist had long lost his secure position as a useful contributing member in society. As outsiders they were not content with the values facing them and the egalitarian, instrumental way of thinking. In particular they felt shackled by the general fixation, indeed obsession with usefulness which even permeated the ways of perception. The constant stress on 'usual function' or 'relative usefulness' filled them with unease, and it is not surprising that the 'normal, factual' way of seeing became the scapegoat of their criticisms. The modernists realised at once how this *utilitarian* way of seeing, and the way of acting which corresponds with it, put blinkers on the behaviour of normal people, blinkers which hide the true beauty of reality from them. Because of this unfortunate way of seeing, thus the painters argue, the 'normal and normative' person can only see a shrivelled, one-sided, alienated image of reality. Under these circumstances, 'objects' — i.e. the things industrial society aims for and values — had to be suspect and finally rejected as the main protagonists of the creative process.

Soon after this moral rejection a further artistic reaction followed. The representation of objects was increasingly weakened, and the practice of imitation 'which operates with old conventions of seeing '(Hofmann) was practised less and less. The possibilities of the 'fossilised' ways of representing had ceased to be viable for the modernists. In its place they put new methods, such as stylisation, reduction and others which were to lead them in a more direct fashion to the substance and real core of reality.

The turning away from sham-reality

The artistic realisations and processes were also reflected in contemporary philosophy and physics. It was a trend of the times, which affected all forms of inquiry, including artistic ones, into the nature of reality, to try to penetrate to the basic principles, to the 'basic forms of reality'. The transcendental philosophers had announced: 'One does not need the concrete forms of nature which are but formed by chance in the course of the great development.' Seen in this light, the realm of concrete objects, being the result of chance, seemed nothing but the transient froth of the general confusion in the world; in other words something most insecure and deceptive. The object as the embodiment of sham-reality had to be mistrusted. But one important possibility remained, one could

probe underneath the deceptive surfaces, by means of simplification and abstraction, to get at the hidden true reality and its laws.

When the painter Albert Gleizes wrote 'the absence of the concrete follows from a particular concept of the universe which excludes the solidity of material objects', he was arguing already the conclusions of the latest discoveries in modern physics. F. C. Maxwell, A. Einstein, and Niels Bohr with the model of the atom, had rendered relative the assumptions of 'concrete materialism'. The claim to sovereignty of the materialist world was shaken.

The meaning of artistic imagery, too, was controversial. The modernists asked: 'Why should we represent things in an incomplete manner when nature itself presents them already in a much more complete and perfect manner?' And those who want exact representations may use the precision of photography. The existence of photography in fact fed several arguments of artistic conceptions and reasons for attempts at abstraction.

The reasons for abstraction

Up till now we have been concerned with the negative impulses which led to abstraction. But there were several positive reasons which coincided with this trend around the turn of the century. At that time, while the ties with the old Renaissance tradition were being severed, two motivations in particular came to the forefront: firstly the wish to put some distance between the artists and the threatening world, including the unpleasant reaction of the general public; and secondly the growing consciousness of the autonomy of the creative impulse, which protested against every kind of dependence and limitations and proclaimed its rights to freedom. 'As long as art is in bondage to objects, it condemns itself to slavery', Delaunay called out. Even Paul Gauguin had advised a friend: 'Art is abstraction. Take from nature only what you dream of it.'

Nature, its complex reality, remained for many an unpenetrable mystery, the description of which would be nonsense anyway. So the modernists believed all the more in their own powers of imagination and intuition, in an autonomous art. What was important for these social outsiders was to become self-employers, to set themselves a task for their own work; these were purely painterly problems.

After 1908 these wishful concepts were voiced in a psychosis of image-making. 'The human mind wants to force its order onto life and nature, indeed it wants to put itself above nature. It does this by changing nature, or leaving it out completely or by denying the validity of sensory perception altogether' (Brion). Human order was therefore created in images, and it was believed that it was in correspondence with the universal order of things.

The abandonment of the representational in the pre-abstractionist trends.

We will now follow the steps of this metamorphosis which helped to change the pre-abstractionist trends in art. We should keep in mind two main aspects: the gradual abolition of the representational, and the crystallisation of purely visual elements. We shall also deal in addition with some of the processes of abstraction For the Impressionists — the specialists of the 'pure eye' the search for the transitory effects and beauty of light was more important than the object, which crumbled under their brush strokes and spots of colour. Things remained as a spotty, summary impression in the atmosphere. On the other hand a rhythmic, visual vibration of pure colour resulted, which guaranteed the visual unity.

The Fauvists and Expressionists had no inhibitions to loosen further the image of reality and to falsify it. This roughly reduced, rudimentary formulas, tense with passionate expression, tended towards a tighter design of images. The unmixed colour ruled supreme. 'The impression, however, which results from the simple distribution of colour, light and shadow, is the music of the painting', Gauguin wrote, and he was thinking of the creative energies.

The Symbolists introduced a consequential dematerialisation and anchorage of the symbol to the surface of the painting. The figurative was given up in favour of linear cadences and coloristic effects. In the context of this open manner of painting the positive and negative forms (background) were the same.

The orderly power of visual forms, which was meant to simplify and explain the confusion of sensory perception, can also be seen to move to the foreground with the Pointillists, Seurat and Cézanne. The details of the natural world dissolve and their traces scarcely remain as particles of the uniform structure of the painting. 'The order of things is no longer a distribution of objects according to their meaning ... but a strictly visual speculation about the differences of entirely abstract dimensions ... everything is bathed in an ideal atmosphere of pure crystal' (Lhote).

Braque, rather laconically, formulated the difference between Expressionist and Cubist ways of seeing: 'The senses distort, but the mind forms'. The Cubists started not so much from a study of nature, but from the artificial, geometrical existence of a painted rectangle. The amorphous, broken-up parts of objects are articulated in a crystalline structure. It was out of this structure that the formation of Cubist painting, with its dependence on the environment and its rhythmic surfaces, soon developed.

The painters of the group called *Der Blaue Reiter* (The Blue Rider) contradicted the Cubist rationalism. They wished to transpose the drama of sound composition, which they experienced, into colour forms. Their way of painting carried a metaphysical message. The Futurists, too, were no fans of speculation. The things of any worth to them were not objects but the sensations of feeling, and it was the task of the artist to increase their dynamism. In this process the contours of moving things melt into space.

During this process of specialisation among the various 'isms', the broad spectrum of factual content was lost, but by means of this distillation a different aggregate was reached: *the painting as an expression of the human mind.*

Ways towards the absolute and pure

Now the time has come for us to visit the laboratory where the elements and the substance of eternity are distilled by the different means of abstraction. Where in fact does abstraction begin?

The answer to this cannot fail to mention the profound difference between nature and art as a conscious human activity. Seen against the infinitely manifold forms of nature, every kind of art, drawing more than sculpture, is an abstracting process of translation, a selection. It deducts, selects particular points out of the rich profusion. In this case we are dealing only with the simple process of selection in representational art. Next to this there exist higher degrees of abstraction, which can be increased up to the qualitatively different degree of non-representational, abstract art. There every similarity between a theme from the natural world and the theme of an image has vanished.

It is precisely this qualitatively different grade which reminds us of the results of the alchemist's experiments. Out of the furnace filled with new metal, at the end of the smelting process, the pure metal flows while the dross remains. In art too one obtains, in a similar way, at the end of a series of reac-

tive processes, pure visual elements. From these elements further artificial, molecular, 'configurations' may be put together. The paintings are independent. This smelting process has been called the demolition of reality or its dematerialisation, indeed even de-naturalisation. Mondrian believed that he was acting according to a 'law of de-naturalisation'. This law 'engenders the purest primary colour possible'. The symbols therefore gradually lose their roundness, they lose gravity and matter, they become flat and optical. The optical, as the immaterial, tends towards the intellectual concept of purity. And that is the goal of this visual alchemy.

Disaggregation, stylisation, geometry

A similar reduction and elimination of the 'dross' of the representational was also achieved with the following artistic means. In the first instance comes disaggregation, a loosening up, of the entire complex of facts, and thereafter also of individual objects. For example, next to the Impressionist 'fleeting impressions' and the 'sectionalising' of the Cubists, we find the Futurist simultaneous manipulation and analysis: 'Objects in motion multiply themselves ceaselessly, they deform because they follow each other like vibrations moving forward in space . . . this simultaneousness results in a change, in the decomposition of objects, in a scattering and melting of details.' It was a need for expression or the will to bring an intellectual spiritual pre-occupation into the realm of the visible, which guided these painters. The objects were a medium for them, the material track on which their intellectual interpretations moved, little more.

The disaggregation therefore reveals itself as an indispensable in-between stage in the gradual process of abstraction. At the beginning the joints of a thing are loosened up, then a particular joint is taken apart.

Of these prepared 'molecules' only particular ones are selected, simplified and finally systematically integrated into different contexts.

During this process of simplification and change one can follow a unified (systematic) linear or ornamental key. In this case one talks about stylisation, i.e. about creating ornaments. Related to this is the process of creating geometrical patterns. There are several ways of producing these. Either the groups of disaggregated parts are strictly measured according to the geometric axis and diagonals related to the structure of the canvas, or the single parts are abstracted into summarily geometrical schemata, the famous basic forms. But this is a

method which starts off from the object and underpins a basic formula of geometric origin.

From the history of art (for example in Byzantine wall paintings and mosaics or in Synthetic Cubism) the latter process is also known in reverse. One starts from geometrical or abstract images and creates a 'figure'. The artist in this case respects and reveres the higher, mostly spiritual values of his times. 'The abstract design remains clearly visible as the energy-determining form underneath the representational clothing' (Brion).

The growing spiritual awareness around 1900 has found its sensitive spokesmen in many artists. The search for geometrical and other intellectual basic supports is expressive of this tendency. Cézanne's opinion remained famous: 'Everything in nature models itself like balls, cones and cylinders. One has to learn to paint on the basis of these simple forms . . .' This axiom influenced the style of thousands of paintings. H. Matisse spoke of the 'condensation of feeling' and wanted to achieve 'through simplifications of ideas and structural forms . . . an inner equilibrium' of composition.

Reduction

Amongst the various means of simplification, reduction occupies a central position. By using reduction one can achieve on the one hand a quantitative simplification of scale or individual characteristics, on the other the qualitative change of motif or of some factual context into a sign. In any case there is an unbelievably broad scale of possibilities, all of which are still within the realm of Abstract Art. The 'white square on white' by Malevich or the 'black circles on black' by Rodschenko seemed to have reached the limits of the possibilities of reduction, but since 1966 many minimalists and conceptualists have actually transcended it. What may seem to the viewer to be an 'amputation of reality', can sometimes be a bold incursion from the unique into the typical, from the phenomenal towards the idea, or from the articulate towards the basic form. If this be true, then reduction is a clear way to another, more spiritual, intellectual world.

The so called 'descent into the primitive' which used reductive and stylizing means, is a beautiful example of a simultaneous coarsening and intellectualisation.

At the centre of the reactive system are the basic forms. This is not only the well-known block-like rendering of figures during drawing or painting (which art schools substituted for the traditional methods already after 1900), but also a way of seeing which has come to us from Japan. Hildebrand has spoken of 'the principle of abstract seeing'. According to a psychological theory, the basic forms are not the product of speculation or a mechanical blocking. They arise in our psyche, which strives for simplification, are stored there, and actively influence our further perceptions. Thus this economically typifying key functions as part of our *intellectual* activity.

Does such a de-mystification and simplification of the immensely complex changing patterns of nature also mean an intellectualisation? This question will surely be asked, not only by a sceptic, at this point. If we follow the studies in reduction of Bart van der Leck, or the even more famous ones on a series of apple trees by Piet Mondrian, we have to answer the question in the affirmative.

During the repeated studies of an apple tree which took place over years (Ill. 21), Mondrian tried to reach, through reduction and stylisation, the nature of the unchanging. He 'plucked' away the unnecessary details, eliminated the occasional, to get at the basic shape of an apple tree, a net of basic lines. During the later stages, through constant constructive deforming, even the basic shape of the tree disappears in the abstract structure. Here the limit had been overstepped, the symbols of faded materiality changed without trace into purely intellectual definitive signs. Relationships of scale and rhythm are generally applicable over this field of lines.

The formal appearance and unity of an abstract work are not decisive, 'but the *inner necessity* which somehow forces their choice' said Kandinsky about the genesis of an abstract painting. And this same intellectual coherence is never lost in the finished works. 'The justification of forms results from the fact that their reality is entirely based on relationships, and the painting is the place where these relationships, every one of which is arbitrary, together enact a necessity. . .' (C. H. Maldiney).

The advantages of the process of abstraction

The abstracting, especially the reductive, processes may of course be interpreted in different ways. Unbending realists condemn them as a wilful deformation, its adherents on the contrary associate them with the advance into mysterious spheres.

Thus one may compare the visual reduction with the taoistic regression. The taoists of the Far East advise the purification of the process of thinking, from time to time, of all ballast. Through this our attention is supposed to fall on the great reality of the basic forms of being. In the same way the abstract

artists may reach that which is just beginning, energies as they appear in their pre-objective stage; which is equivalent to moving close to creation itself. Next to such mythologising hypotheses there are a series of very concrete results which have been achieved by giving up the representational. Organic paintings independent of reality have been created with visual elements or other means of expression.

Willi Baumeister put it this way: 'The intrinsic energies of the means of expression are the proper ground for the optical view. It is these which the painter of today values above everything else. They do not only constitute his key-board, but are at the same time independent carriers of function and expression. The forms, the colours, lightness, darkness, the widths of lines, exactness or that which modulates, even the corporeal in contradistinction to the flat become the voices of his composition.'

We feel the most radical change in the use of materials; once liberated from the mimetic subjugation, they show their strength as free elements: the colours exude their musical poetry, the lines their tectonic energy, the surfaces their clean expansion and spaciousness; now they themselves become the sovereign theme. All elements unified by simultaneous contrast observe the rule of the abstractional pole.

The undisputed potency of these new creations lies in the optical — intellectual unity of the visual. Its purity is like a living flame 'The flame possessed the purity which allows nothing foreign, and changes everything it touches into itself' announced the poet Apollinaire. And like fire or air or water, these new abstract compositions are worthy of creative meditation. They may become for us icons of our inner visions, or perhaps small hypothetical models of the universal, suprasensory basic structures.

The abstract painting then is a token of an essential connection between the artistic sensibility and the objective energy of the universe. At the birth of abstract painting Apollinaire believed that particular artists and poets determined the image of 'true reality' and saved it from vanishing into chaos.

A new world, never before realised. The conquest of the purely visual, 1910–16

When we examine the reductive processes and explain the individual rules of Abstract Art we have to keep to the essentials. For this reason it must be stressed that it would be a mistake to consider the abstracting processes of the intellectual as an easy straightforward jaunt.

During the considerable simplification which we have used to illustrate the stormy development of the years 1910–14, the inner battles and disappointments, the years of renunciation of the first abstract painters must never be forgotten. What courage they needed during the periods of public misunderstanding and wicked criticism? But was that very misjudgement by the narrowminded not a confirmation of the truth of their way? 'The free, unfettered and unconditional creative act fed by the conceptions of form in the artist, this was the boldest step: an adventurous deed, a move forward into a new world of art, a revolutionary act of liberation' (Rotzler).

The writer Rohan has compared the painters who discovered the abstract with mine workers. They broke through a last barrier while working the pit, and suddenly before them a wonderful, glowing fairyland opened up, a realm of intellectual beauty. They were enchanted, they enthused about this 'new world which no eyes had ever seen'. These painters believed that they had found a realm of moral redemption, and of a possible regeneration for society. Such beliefs and the knowledge of a prophetic teaching helped Kupka, Delaunay, the Futurists, Larionov, Malevich, Kandinski, Mondrian and others to face their most difficult moments.

Some of the turning points in the researches carried out by the father of Abstract Art are already known to us. Kandinsky who had given up a legal career at home in Russia, came to Munich at the age of thirty to study painting. A quick, strange development soon gave this unusually gifted man a position amongst the avant-garde. He became its thinker and spokesman. The activities of his group, Der Blaue Reiter, which included Marc, Macke, Klee, Jawlensky and others, are one of the turning points in the history of modern art. We know already that he had reflected on the principles of Abstract Art before he created his first watercolours in 1910. He was then already 44 and at the beginning of his first abstract period.

The careful observer will detect some meaningful signs of fermentation already in Kandinsky's expressionistic preamble

(the Murnau years 1908–10). His painting was alredy far removed from the formulas of figuration and landscapes. One feels Kandinsky's longing for the 'simple and elementary', one is surprised by his love for the natural elements like water, air, clouds and light, indeed especially for the shades of colour in light. He did not seek particulars, he allowed himself to be inspired by the might of nature and synthetised his admiration in brief gestures. He collected the splendour of colours with unbounded enthusiasm for the festive rainbows and fireworks of his special art. He longed to express in painting the great synaesthetic emotions of ecstasy and frenzy such as 'frustration, meanness, crazy richness, lavishness, thunderstorms, the humming of mosquitoes'. In the cycles of his landscape-like *Impressions* and particularly in the hymnic *Improvisations* he tops everything that had been painted hitherto. Underneath the joy of the first hallucinatory flash of colour one can hear a great rumbling which heralds an earthquake or a great flood. Then, suddenly, the apocalyptic eruption occurs. An explosive act of painting shatters the usual structure and the raving lyrical elements whirl about without beginning or end. The festive and the demonic fuse in a wild marriage.

This kind of lyrical painting becomes an existential act on the aesthetic as well as on the primary level. Kandinsky was convinced that during the action of painting a fusion between the subject and the universe was taking place. In defence of such romantic ideas he added: 'The new purely visual world is subject to the univorcal laws of the cosmos. The artist functions within this process as an organ for the execution of these laws. A super-human energy steers man, but he can guide it only by acts of artistic decision-making.'

During the heroic years of 'the explosion of genius' (1910–14) Kandinsky refrained from doctrinal statements. He attempted to act as though there were no rules, as though each painting was the first: that is, always shocking, unique, but also mysterious. Only during the second abstract period after 1918, which meant rejecting Expressionism and replacing it with a more rational way of harmonising the separate formal details, did he begin to organise the elements of his visual language into a system. His teaching positions, at first in Moscow, then from 1922 at the Bauhaus in Weimar, led him to do this. In his book *Punkt und Linie zur Fläche* (1926), he changed a few of his early associative theories and looked for formal analogies between the visual elements of the world.

'The paint is a basic element, an impregnation of the empty surface. The horizontal is the cold supporting basis, silent and "black". The vertical is active, warm, white. The free straight lines are agile, "blue" and "yellow". The surface itself is heavy at the bottom, light at the top, on the left like "distance", on the right like "house". Each projection of the colours differentiates itself according to its position on the surface' Since his move to Paris in 1933, Kandinsky's way of painting culminated in abstract, biomorphic visions, which nevertheless sought to retain the sense of wonder of a child's imagination. This genius lived in the artistic metropolis of the world in isolation, and died there in 1944.

The French pioneers of Abstract Art

The French cultural milieu had assessed and calmly rejected the abstract tendencies as 'un-French' for a long time; of the many examples the case of Kupka is particularly lamentable.

Only two decades ago we discovered that since 1910 there was a talent emerging in Paris, comparable to that of Kandinsky and expressed by the efforts of the Czech Kupka. He was not only the founder of 'geometrical' abstraction, but also the most significant as well as the most ingenious abstract painter in France. The critics held his paintings to be an aberration. All one knew was that this famous cartoonist and illustrator renounced a brilliant career to indulge in the unremunerative occupation of 'philosophical' compositions. People shook their heads at this eccentric. No-one realised that here was someone with a truly prophetic gift. Kupka's illustrations of the time around 1900 already show how the symbols of the absolute and the metaphysical were meeting. After 1909 he also found adequately 'pure' forms of the absolute and the musical. One of his first completely abstract paintings, *Nocturno*, is dated 1910. We know that Kupka had been occupied with the problems of the 'abstract' and with the process of realising the visual in motion since 1903. He translated the rhythm of motion 'musically' into vertical stripes, so that the apparent sounds worked like the tones of a keyboard instrument. His first paintings exhibited in 1912 also had musical inspiration: *Amorpha, Fugue in two colours* (Ill. 12).

Before the First World War, next to the musical and the coloured architectural manner, he developed two further techniques: the lyrical technique of the 'created motifs' and the very sober sort of 'triangular motifs'. After the war he drew a great deal of inspiration from the world of science and mechanical engineering and the musical world of Jazz.

While Kupka belonged to the group called Section d'Or, Robert Delaunay's starting point was Cubism. After 1910 he was especially enchanted by the dynamism of city life, in particular by the vibrations of its light. His Parisian paintings

are reminiscent of organ chorals, they might have been the vision of an angel. Delaunay flies through celestial spheres, he changes himself into the sun, he conjures up the elements. For this reason Apollinaire has called his concepts 'orphic'. Young European painters revered him and followed in his footsteps.

In 1912 Delaunay painted a series of window compositions the *Fenêtres simultanées*. He constructed these paintings on the principle of light. He explained it in this way: 'It was a really new way of creating without analogy with the past or the present.' His paintings deal with colour for the sake of colour ('couleur pour la couleur'). This was no longer a representation of nature, nor some kind of supranaturalism, but, if you like, the first abstract paintings developed from and out of the essence of colour. 'These windows' opened wide a purely visual reality. Soon after, the *Formes circulaires* (*Circular forms*, Ill. 8) were formulated and became the trade mark of Delaunay. The spectral fanfares of these circles of colour allow us to participate in a flight into the sun. This was one of the significant French contributions to abstract painting. Delaunay talked about 'peintures inobjectives'; for him the non-representational was merely a method: 'I have dared to create an architecture out of colour....' he said. In 1914 he abandoned these adventurous excursions and returned for a long time to the paintings of Parisian life and sporting scenes. Around 1929 he strengthened the Concretist group by joining it again.

The influence of the Futurists

The strong influence of Delaunay's orphism, particularly in Russia, was only surpassed by the Italian Futurists. These passionate fighters against all conventions – for them all known culture was dead – went far beyond previous limits.

Since 1910, this programmatic avant-garde endeavoured to express movement and line in painting. The subjects, such as horses, dancing girls, cars, were only a means for their dynamic approach and their analysis of the different phases of motion. But during this process new 'abstract' signs were generated, corners, lines of energy, parables, curves, which depicted a striving towards the boundless or the parts of an 'abstract motion'.

Yet the expression of the invisible by the Futurists went further. 'By the way, one may notice in our paintings marks, lines and fields of colour which do not correspond to any kind of reality, but prepare and strengthen the emotions of the viewer in a musical way after our own inner sense of mathematics.

Thus we instinctively see the connection between the external scene, the concrete, and the inner abstract emotion. These seemingly illogical lines, marks and fields of colour are the secret key to our way of painting'. The broadest, purely constructive result was achieved by Giacomo Balla in 1913–14 with rhombus-structures. He called them *Iridising Penetrations*.

The thoughts of the Futurists, their exhortations to progress and their adventures in motion studies fell on a richly prepared terrain in Russia. The pro-west, 'Parisian' orientation and the curiosity which was meant as a protest against the conservative system existed side by side with the primitivism of popular or oriental art. This was the dialectic of the avant-garde leader Michail Larionov and his followers Goncharova, Malevich, Tatlin and others, who gathered in groups such as Karo-Bube or 'The ass's tail' around 1912. The writings of Kandinsky were read. In 1910, M. Larionov, after painting in the primitive manner, changed to the non-representational. Between 1910 and 1912 he created an authentic parallel to Orphism, a particular way of painting light rays (Rayonism). It was only later (1913) that Larionov published a *Rayonistic Manifesto*.

The year 1913 was the turning point for modern Russian painting. Out of the turbulent art scene of the Cubo-Futuristic avant-garde in St. Petersburg and Moscow, two spokesmen for the abstract tendencies emerged: the Suprematist Kasimir Malevich, who designed his *Black Square* in 1913, and the Constructivist Vladimir Tatlin. After 1915 their contradictory concepts attracted a large following and the fight of the Suprematists and the Constructivists continued on a large scale after the October revolution.

At about the same time a group was founded in Holland around the journal *De Stijl* and the artists Mondrian and van Doesburg, whose principles closely followed those of the Constructivists.

The autonomy of the painting

'Nature is a reality and my canvas is also a reality', Picasso said to emphasise the artistic independence of his work.

·The autonomy of the painting, fought for and gained through the process of reduction, is one of the most important principles of Abstract Art. It is this which ensures the freedom and scope for visual experimentation. It is this, too, which has liberated the technical means hitherto bound by imitation and opened up new horizons for the development of its inner energies. Only then do the autonomous visual elements and

the natural ones reach the same level. The surface of the canvas, for example, ceases to be a place for projections; in Abstract Art the surface works along with the other elements as an integral part of the organic whole: its borders, its corners, and the axis actively determine the developing composition.

There is no doubt that the liberation of the visual elements, the unleashing of their wonderful power and 'pure' effects is one of the greatest discoveries of the 20th century. This liberation opens up a seemingly unlimited area of innovation and expansion into 'territories never yet trodden', a realm of great freedom. It is easy to understand the enthusiasm of the first abstract painters for this 'new and wholly other'.

It did not take long for the liberated elements, especially the geometrical ones, to show that they could be guided by several 'new' rules. The new visual language bred a new grammar and idiom, sometimes associated with psychology, less commonly with mathematical (universal) laws.

The 'autonomous nature of art', this 'primitive conglomeration of wild intensity and colourfulness', tried to reach an equilibrium in a hundred different ways: the static or the dynamic moved towards an organic entity of their own accord.

What do the grammatical and poetical rules tell us about the beauty of a poem? Does knowing the construction of a sonata help to appreciate it? Not really. Similarly with abstract painting. The notes have to be played and heard, the painting has to be seen and experienced. The kind of balance or rhythm which the painter has struck in his composition can only be appreciated by the spectators through real participation.

There is little point here in giving a brief survey of the numerous grammatical rules of constructing an abstract painting. Only one comment need be made about the above-mentioned aspect of rhythm. Rhythm, as a property of the development of line, vibration or movement, is really something more appropriate in musical or dramatic works. Is it in fact possible to demonstrate it visually? Ornamentalism and architecture do in fact give us countless positive examples of repetitions, parallelisms and the organic interchange of motifs. The concept of 'abstraction' brings painting close to the 'magnetism' of this dimension. The rhythmic forms with their different types of symmetries and the innumerable interrelationships of the different proportions give painting the key to secret powers of attraction. The result is a mysterious pulse which unifies the different parts of the work in the same way as the atoms of the universe are bound together.

'Rhythm binds the separate elements of space and time together again, it disentangles, liberates and completes them and allows everything to return to its organic unity. He who is able to grasp and master rhythm expresses the divine' (A. Surchamp).

The autonomous energy of colours

The purely visual elements do not only serve to demonstrate their liberated energies in abstract painting. While the properties of the autonomous rectangle, surface, line and paint have already been mentioned, the most suggestive of elements – colour – remains to be dealt with. Like the other elements, colour acts in three different ways. It expresses the purely physical, it acts on the soul, and it carries a number of associations. Every trend of the pre-abstract as well as the non-representational art asserts one of these three aspects. The Neo-Impressionists, Delaunay or the Concretists based their work more on the objectively pure (physical) irradiation of the colours. The Expressionists on the other hand meant to express with the strong use of colours a 'liberation of the emotions'. Van Gogh dreamt about 'being able to use a colour in such a way that it fuses with feeling, as music with excitement'.

Delaunay loved the prismatic colour contrasts of the rainbow; like a physicist he appreciated 'the colours with their inherent laws, their slow, fast or ultra-rapid vibrations in their relationship to each other, the intervals in these relationships. . .' He also knew, like El Lissitzky, that the colours are messengers of light; in other words, as guides to a higher spiritual plane, they are capable of moving the deepest layers of our soul. It is the colours which penetrate through our eyes in waves of pure energy and sound the strings of our soul. This comes close to the thoughts of Kandinsky. Adolf Hoelzel looked at the spiritual process of the perception of colour with different, more scientific eyes: 'The simultaneous contrasts caused by the eye itself play a wonderful part in the process of spiritualising colour, in overcoming the material form. In fact they change the meaning of colours and cause a different kind of stimulation in our psyche'.

These quotes demonstrate the many, meaningful, inherent properties of the basic colours. While the Concretists worked by calculating the stable properties, indeed corporeal qualities of the basic colours, the lyrical painters trusted their magical transparency.

Further complications are caused by the associative effect of colours. The most beautiful example of such an interpretation comes from Kandinsky: 'Yellow is a warm colour, it moves towards the spectator, it radiates outwards in an eccentric way. This increases with its lighter shades; there is no such

thing as a deep, very dark yellow. Yellow has the properties of material energy which pours out unconsciously over an aspect and diffuses aimlessly in all directions. Banded into a geometrical form it becomes unsettling, sharp, exciting. This quality can be increased and eventually the colour begins to sound like a loud trumpet or fanfare. It is related to the emotional condition of blind excess, the manic, the insane. It is the colour of largesse, of the energy of summer.'

The realm of the visual

The pure pictorial elements (or means) – paint, surface, line and colour – form the cornerstones on which the complicated texture of the visual is based. Only the liberation and mastery of visual systems makes the existence of Abstract Art possible.

Only the visual, sometimes also called the 'pictorial' – as the specific property of art – was able to create a workable, equal parallel to the laws of nature and life. 'Autonomy of means was the result of the art of painting concentrating on the purely visual elements of external reality. In this process the colours were analysed down to their most elementary constituents, but this in turn made them available to be integrated into an entirely new synthesis. . .' (W. Hess).

This new synthesis is formed by a rhythmic, proportional or equal distribution of 'magnetism'. Purely visual stimulants result, which beg us in vain to look at them: when we do, our experience of this synthesis generates the emotion and conceptualization of completeness and perfection. In other words, through the harmonising participation of our eyes we experience the perfection and completeness of the painting almost physically. During such moments we realise something which we could never do in any other way: the visual, the essence and soul of art.

There is one point to be borne in mind: we can determine the origin and constituents of the visual, outline its tendencies, but we lack words to define its essential character; perhaps this level of appreciation is still too new, too aesthetic, too difficult to grasp. Thus we behave like astronauts who have witnessed a splendid light-filled spectacle on Venus, but lack the vocabulary to express it. They may say: 'It was splendid, just like. . . ', and they realize that such a description is totally inadequate.

We also experiment, in our treatise on the visual, with an apparatus of concepts drawn from the fields of technology, psychology and sociology. We try to illustrate particular aspects by means of political parables, although these are unfortunately rather subjective and mostly too concrete.

There are two parallels of high, spiritual quality and their categories and concepts are often usefully employed as a kind of sighting device for the description of the visual: the architectural and the musical. It is no accident that both, like Abstract Art, are concerned entirely with non-representational areas of art.

The architectural and the musical

It was during the process of clarifying what the visual elements and their conditions were that the tensions and the tectonics of the pictorial square were recognised as autonomous energies. After Seurat and Cézanne, the Cubist Gris introduced the definition 'the architecture of the colour surface'.

For Kupka the architectural conditions of a painting were the principle according to which the morphological, primary images were organised. 'I have dared an architecture of colours,' wrote Delaunay, 'in the hope of creating a dynamic poetry which remains wholly in the realm of the visual means, without any kind of literary associations and descriptive anecdotes.'

The Constructivists stressed the architectural element even more. Mondrian and Malevich saw themselves as the avant-garde for a new kind of architecture, in fact van Doesburg worked on projects with the architects Rietveld and Van Eesteren. According to the Constructivists, every action and object was to be judged from the angle of space, the architectural. It is no surprise that several of the Constructivists had been students of architecture (Lissitzky and Gabo for example).

Under the influence of the Constructivists many paintings became 'architectural' projects or objects. The drive towards clarity, simplicity and objectivity, united Abstract Art, architecture and design of the '20s and '30s, and determined their common preoccupation with geometrical style. While the relationship of the visual and the architectural rested on the common basis of geometry (in the broadest sense), the relationship with music arose out of the analogies between the qualities of tone and colour.

Gauguin had already predicted the validity of this analogy. It was he who searched for the 'music of a painting'. 'Before one even realises what a painting represents one is immediately enthralled by the magical harmony of its colours' he wrote. To achieve the sovereignty of music, the purest and most complete of the arts, was the dream of the Symbolists and the aim 22

of the abstract painters. Kupka and Kandinsky were to bring to fruition the prophetic words of Gauguin: 'Painting with colours will enter a period of musicality. . . .'

We have pointed out already the close relationship of abstract painting and music. But unfortunately we have to omit one of its interesting developments: the researches into instruments of colour-music (Skrjabin, Schöffer etc) or musical colour projections (Eggeling).

Let us end with the thoughts of the American Synchronist MacDonald-Wright: 'Surely painting does not have to lag behind music . . . it too became abstract and purely aesthetic and works through rhythm and form.'

Constructivist trends and geometrical poetry, 1917–39

Between the two world wars the face of Abstract Art changed considerably. It was not determined so much by single pioneers but by small groups gathered around a particular journal or art school. These groups were working towards a change in their cultural environment with the conscious determination of an avant-garde. Their anti-individualistic thinking finds its stylistic expression – mostly based on a constructivist method – in purely geometrical concepts.

Out of a dozen groups and 'schools' with a constructivist trend, the important ones during the years 1917–39 were the Russian Suprematists and Constructivists; their followers in Poland, Hungary and Bohemia; a Dutch group gathered around the journal *De Stijl*; the teachers and students of the official Bauhaus in Germany, and the trends generated by Le Corbusier's *L'esprit nouveau*. After 1930, the 'surviving' members of these groups came together in Europe in the movement known as 'Abstraction-Création', others emigrated to the USA.

The apocalyptic war years, which had shaken the foundations of whole nations and led to the downfall of many a 'noble ideal', created opposing artistic reactions. Under the slogan 'Back to life, to order and tradition' the realist and neo-classical reaction assumed a more conservative stand point.

The 'negative' avant-garde, the Dadaists and later the Surrealists, took up totally different positions. They were convinced that the war had been the natural consequence of an unspeakable system and a fossilised culture; and they did everything, using provocative nonsense and irrationality, to bring the 'holy' values to a resounding fall.

The Constructivists (we shall use this concept from now on for all related schools), of all the schools mentioned, held a different opinion. For them the war had been a mistake, an insane deviation from the rational progression of history. It was necessary to lead a society in the grip of an irrational nationalism back to the paths of reason. Constructivism meant to play a leading role in this enlightenment. The idea of social responsibility and function became an important aspect of all the further researches and actions of the Constructivist movements. During the '20s they really did achieve the desired social roots and the popularisation of their concepts of form; they achieved this through education in design, and by taking an active part in industrial reconstruction, particularly in the use of design and in the development of architecture. It is to the credit of the Constructivists that the researches into abstract painting during that time of concrete application contained a dimension of style, indeed a beginning of culture.

Geometrical trends in Russia

The initiative, after 1917, was taken by the Dutch Neo-Plasticists and especially by the energetic Russian movements. Already before the outbreak of the war much of the ground had been prepared there. Larionov had founded Rayonism, Malevich discovered the new aesthetics of 'pure emotions', and Tatlin developed the basics for a 'culture of materials'. They soon gathered a large following. The similarity of their 'geometrical' ways of expression must not confuse us here; since the exhibitions *Tramway W* and *O, 10* in 1915 they had been bitter enemies.

Kasimir Malevich became the generally acknowledged leader and theoretist of 'non-representational art' in Europe. His geometrical constructions expressed the movement of emotions; this distinguishes him from the great exponents of geometrical painting, Kupka and Mondrian. His painting *Black*

square on white remains a legend. It was the most simple of forms, one could not reduce it any further; the zero point of painting had been reached. What do we mean by this?

The manifold implications of such a deceptively simple act are explained by Malevich himself: 'The things and objects of the real world have vanished like smoke. I have created nothing, I have simply experienced spirit, and in it I have gleaned the New, which I have called Suprematism. It has expressed itself in me through this black surface, which formed a square, and then a circle. In them I have realised a new world of fresh colours. . . .'

This new colourful world of human 'Supremacy' – the predominance of the emotions (for example the emotion of weightlessness) – was developed by Malevich in cycles of free geometrical compositions. After 1920 Malevich realised that these pictures were the closing chapters of painting, and he turned to utopian projects (so called 'Architecture for Planiten', i.e. plaster models for space cities) and also to theory and education. After 1928 his work was condemned as 'degenerate'. His opponent Vladimir Tatlin, the founder of Constructivism as such, stopped painting as early as 1914. Enchanted by Picasso's plastic paper montages, he constructed non-figurative 'counter-reliefs'. A counter-relief seems to create its own space and divide it; in its structure the environment is 'materialised'. It was a purely artificial concept of design, which was later taken up by Soviet and European experiments in building.

Among the contributions of Russian Constructivism two have retained their validity. Firstly, the interaction of the object with its space, a process in which the object may be reduced to its basic structure; secondly, this wonderful concept of the 'molecular' possibilities of production, whereby every contact between the materials or the elements within the painting generates whole chains of connections. This principle of 'synthesis' became the driving energy of Abstract Art.

The influence of Suprematism and Constructivism (even in its productivistic variants) was almost limitless in the first years after the revolution. The art schools, and the construction of official buildings with their monumental interiors, were in the hands of the followers of Suprematism and Constructivism. The whole of Europe saw in Malevich, Tatlin and Rodschenko the prophets of a new world. The year 1921, the year of 'new, economic politics', first showed a cultural and political return to a conservative realism, later proclaimed to be socialist. The Stalinist party dictates of 1925 and 1932 finally eradicated the progressive tendencies in Russia, but their example continued to work on in other countries.

De Stijl

The Russians, more inclined towards geometry, and their Dutch contemporaries are connected only by external similarities. These Neo-Plasticists – or later Elementalists – gathered around the journal *De Stijl*, were not only the strict grammarians of the geometrical, 'universal' visual language, but also utopian visionaries. The work and thoughts of Piet Mondrian formed the backbone of the movement, although its heart and soul were the work of Theo van Doesburg, the tireless editor of *De Stijl* (1917–30), who organised the activities of the group and wrote its propaganda. The methodical, clear-thinking mind of Piet Mondrian reveals itself in his early landscapes. At forty he found in the reductionism of Cubism a formula which allowed him to look into 'the inner substance of things'.

Mondrian had a mathematical answer to the question of the substance of things. He reduced all physical and mental actions to a basic law of contradiction, that of the vertical and horizontal. This basic contradiction, which he related to the feminine and masculine principles, exists everywhere. In the rectangle, which became the hallmark of his work, this principle shows itself in its most concentrated form. In addition, Mondrian resorted to six further elements, three colours (yellow, blue, red) and three non-colours (grey, black and a lot of white), to express the concept of the Universal at its most simple. He knew that 'the universal aspect behind each individual manifestation of nature rests on the equilibrium of objects. . . .'

Finally, in 1921, after eight years of non-representational experiments Mondrian achieved a very strict formula consisting of eight basic elements. The changes of its 'textural proportions' and the colour-rhythms resulted in further variants of harmony (until 1940).

Having achieved this, he bent his mind to reform and was still unsatisfied. He longed to recreate his image of perfection in reality and in a new life style. The paintings were for him only a provisional stage, perhaps the models: 'Art is a substitute as long as life itself lacks reality; it will disappear as soon as life becomes harmonious'.

The rejection of irrationality and the introduction of a new 'white' style united Mondrian with the painters Theo van Doesburg, B. van der Leck, V. Huszár, G. Vantongerloo and the architects J.J. Oud, G. Rietveld, van Eesteren and others. A geometrical programme of forms which transcended individuality was to support the international unity of mankind, to harmonise their souls and to translate the 'logic of pure 24

beauty'. But just here, at the point where the painted 'models' were to be applied, antagonisms broke out. While Mondrian insisted dogmatically on a pure, narrow and closed visual formula, the younger van Doesburg demanded a dynamic organisation of the 'energies of the continuous construction of space'. His introduction of an agile system of diagonals was seen as treason by Mondrian.

Oblique compositions, van Doesburg's architectural projects and the group exhibition *De Stijl* in Paris in 1924 initiated a further period, that of Elementarism. The Elementarist manifestos and theories (particularly at the Bauhaus since 1921) were the works of its dynamic spokesman, van Doesburg. His last theoretical contribution, the explanation of 'concrete art' rendered artists more conscious of the possibilities of highly artificial and independent visual systems and led to the radical clarification of the historical situation in which the geometrical movement found itself. This was his real contribution to the group Abstraction–Création.

The Bauhaus

The development of Abstract Art in Germany during the post-war years had three important focal points: Hannover (Schwitters and Lissitzky), then Berlin and especially the Bauhaus in Woimar (in Dessau from 1925). The Bauhaus was not an art school in a provincial city but a melting pot for all progressive international efforts. As the Russian Constructivists were fighting their last hopeless battles and the energies of the Neo-Plasticists were beginning to fade, the Bauhaus was still functioning as a glittering basis for a future culture. In the footsteps of the Russian schools WCHUTEMAS and INCHUK, the Bauhaus' courses were held according to the most up-to-date principles of art and its classes were democratically led. This was the result of pedagogic researches specially conducted by Itten, Schlemmer, Kandinsky, Klee and later Moholy-Nagy, who had all been summoned by the architect Gropius.

The Elementarist influence of van Doesburg provided the turning point in the evolution of a philosophy orientated towards civilisation and technology. Moholy-Nagy was particularly active in supporting this trend. A style both constructive and architecturally orientated was the artistic starting point of the work carried out at the Bauhaus.

The 'experimental transformation of constructive forms into the production of consumer goods' was the task the reformed Bauhaus had set itself. The methods and systems of the Bauhaus teachers, plus the work of the leading abstract painters such as Mondrian and Malevich, were collected and published in the 'Bauhaus books'. After fifty years their continued publication is evidence that they are still a living source of information and proof of the exceptional niveau of the abstract work of the time.

The Bauhaus was, to a contemporary observer, a research laboratory which contributed to the neo 'geometrical' style of Functionalism. It educated dozens of students in the Constructivist way of seeing and creating. Amongst them were Albers, Bayer, Breuer, Bill, Graef, Leppien, Winter, Schawinsky, and Wols, all of whom went on to propagate these ideas all over the world.

This happened after 1933, after the National Socialists had closed this progressive institute. Their criticism of Abstract Art took a peculiar form. Abstract artists never had an easy life in any country. Their extraordinary discoveries were seldom understood by the general public; their paintings were mostly dismissed as 'intellectual sophistry'. The abstract painters were criticised for ignoring the human form and the human vision of nature. But how wide was the gap between a criticism of the alienation of non-representational painting and a political denunciation?

While the Nazis branded the abstract Bauhaus artists as a 'Jewish-Bolshevic evil', their paintings as 'degenerate' and therefore prohibited, similar art trends were called 'bourgeois formulations' by the Russians and later 'Western decadent art and an expression of class enmity'. The abstractionists, forbidden to paint in their own country, emigrated to be able to preserve their movement.

Abstraction – Création

Unfortunately, Paris, the city of unlimited artistic freedom, gave a cool reception to these immigrants. The prevailing opinion was that Abstract Art had nothing in common with French tradition. The non-figurative paintings of the immigrants were condemned as 'prudish', unmusical and Germanic'. Artistic taste was nationalistic in character.

In this atmosphere, the international group 'Abstraction-Création' began, in 1931, its counter-offensive aimed as much against the prejudices of the conservatives as against the favoured Surrealists. The avant-garde based its activity mainly on the results of the European Constructivism, and during the '30s was able to attract many leading intellectuals. Several of its participants had already lived in Paris for a long time, but,

with the exception of the circle around Le Corbusier, a few exhibitions and a short-lived pre-amble (group Cercle et Carré, 1930), they lived there in isolation.

In May 1931, the initiative taken by Auguste Herbin, Georges Vantongerloo and Étienne Beóthy led to the formation of 'Abstraction – Création, Art non-figuratif', at first as a group very active in the organisation of exhibitions and issuing annual publications (1932–36). Soon however the group grew into an important international movement without dogmatic aims, which had 209 members in Paris and 207 abroad. Amongst them were all the important artists such as Kupka, Mondrian, Kandinsky, Magnelli, Pevsner, Arp, Le Corbusier, Moholy-Nagy, Sofie Taeuber-Arp and others.

They strongly opposed the artistic irrationalists and the cultural and political reaction especially in Germany, Central Europe and later in Spain. Their activity and the clear, scientific theory of the Concretists produced remarkable results long before the Second World War.

The problems on which Kupka, the Suprematists and Neo-Plasticists had carried out preparatory work were now, around 1930, gathered into a formula by van Doesburg, Mondrian, and Bill. Concretism became a higher form of abstraction. The artist no longer concerned himself with the reduction of objects; he simply structured purely visual elements.

Two main characteristics are important to the different strands of the concrete movement (1930–70). Intellectually it is the appreciation of scientific, often mathematical models of thought. On a practical level, the artist expresses these models as visual, geometrical forms.

The meaning of the geometric

We can identify most of the abstract paintings of the period 1917–39 by the 'trivial' use of construction and by their 'naked' geometrical forms. It could hardly be called a fashion since it lasted for so long. In fact it was a process of stabilisation and a way of seeing. We have followed the process of de-naturalisation from this technical standpoint right to its basic forms. We have also ascertained that it is these very geometrical particles which, in conjunction with other liberated elements, constitute the surprising nature of autonomous painting. There are also two methods of assessing content. The stress on the geometric may illustrate the presence of a mathematical order or a universal law, i.e. it expresses an absolute dimension which transcends the individual personality. On the other hand the use of geometric

patterns expresses very human desires, the wish for sharp and precise intuition and for increased perfection on the practical level. The 'geometrical form of thinking' can be found generally at the intersection of these two.

If we look at one of the geometrical paintings of Kandinsky from his Bauhaus period, or those of Mondrian, we recognise the different levels of the geometric at once. At first we become aware of straightforward corners or points of intersection, then coloured triangles, rectangles and circles, then other formations. These are the syllables out of which one may form verses. These verses or configurations already suggest the 'expanded geometry' of relationships – proportional, symmetrical or rhythmical – which bring the harmony or unity of the painting within reach. One final act of synthesis remains to be carried out, possibly with a higher form of this kind of geometry. Clear, rational analysis, logical execution, tight structuring, exactness of practical appreciation and awareness of the limitations, visual precision of the contrasts, the harmonious unison and analogous relation of the parts to each other, are all a vital prerequisite for the completion of a concrete composition.

It remains to decide which of these activities simply serve the logic of the work and which forms further hint at perhaps a cosmogenic meaning or the eternal basic structures.

Plato, following the Pythagorean teaching, declared: 'geometry is that which always persists'. The 'geometrical' Concretists gave considerable thought to this theory. The simple square of a canvas already reflects this rule of the eternally unchanging and determines the further development of the painting in a fundamental way. Although there is not much scope for personal expression and the communication of feelings, 'the eternal' has many thousands of variants, from the suspended visions of Malevich to the mathematical equations of Vantongerloo and R. P. Lohse. Ozenfant and Le Corbusier wrote in 1920: 'A painting is an equation. The more the individual parts fit together, the more the "coefficient of beauty" may come into existence'.

We should not forget the non-numerical interpretations of geometry. A triangle, circle or square can also be an expressive symbol (Suprematism, Herbin) or a sign of space (Moholy-Nagy). The architect Gerrit Rietveld, a friend of van Doesburg, reflected that a geometrical value such as profile, size, colour, weight can be taken up like a familiar object.

In this human context the straight line and the rectangle, as well as the precision and clarity of geometrical art forms, are an expression of their proper function, symbols of the careful, practical works of the craftsman and worker. According to this

theory, the geometrical pattern becomes the hallmark of a human, indeed intellectual sovereignty.

Abstract painting in the USA after 1935

In the mid-'30s the cultural scene of New York seemed like a ray of hope for the sorely tried abstract artists. A number of them such as Albers, Moholy-Nagy, Bayer, architects like Gropius and Mies van der Rohe, later Mondrian, Léger and the Surrealists, found asylum in the USA. This is what happened: the year 1936 was the turning point of historical recognition for both wings of the avant-garde. At that time the Museum of Modern Art in New York held two fabulous exhibitions which surveyed the current scene: the first one to take place was *Fantastic art, Dada, and Surrealism*; when the second one, *Cubism and Abstract Art*, was staged, a comprehensive book by Alfred H. Barr was concurrently published. This account established the leading role of the abstract artists without question and served as a launching pad for further careful activity on the part of collectors and galleries.

By 1935 Mark Tobey began his *White writings*, and by 1936 the first group of American Abstract Artists was founded. Also at this time Burgoyne Diller composed original concrete paintings, and the future protagonists of Abstract Expressionism worked in the service of the Federal Art Project. In 1938 the initiative of Hilla Rebay, a friend of Kandinsky, led to the establishment of the Museum of Non Objective Art (later the Guggenheim Museum in New York). Abstract Art seriously participated in the cultural awakening and new beginning of the United States after the Second World War. 1942 saw the founding of the gallery *Art of this century* by Peggy Guggenheim which gave magnificent support to Surrealists and Constructivist artists. Mondrian was an adviser there and under its aegis the energetic Jackson Pollock began his enormous symbol- and action-paintings.

Between logical painting and the lyrical explosion, 1944–60

After 1945 Europe and its consciousness were in ruins and short term restorations and solutions were sought. Abstract Art and its contribution was never seen in the context of this crisis.

The years 1945–50, with Picasso as the outstanding artist of the time, saw several attempts at a renewal of the revolutionary artistic climate of the heroic years from 1905 to 1938. In this atmosphere of revival created by Neo-Cubism and Expressionism, many of the young artists applied their skills to abstract painting.

The irrational explosion and the prattle in paint of the Abstract Lyricists increasingly gained the upper hand over the geometrical objective tendency in Paris as well as in New York. Their actions were interpreted in terms of individualistic liberation because it was a time of strict organisation, and militarism was still in the air. One could find in their direct, brisk way of painting the sheer joy of life side by side with the revulsion caused by the monstrosities of reality; these artists believed that oppression must be stamped out by an act of magic. This resulted in a strange aesthetic theory regarding the lyrical tendencies, especially the act of painting, which we will discuss later.

The overture of this turbulent lyrical kind of abstraction, however, began between 1936 and 1944. Its protagonists started very early in France with the non-representational painting: Hartung before 1933, Schneider in 1932, Bryen in 1936, Lanskoy and Poliakoff in 1937, Lapicque before 1943; Manessier, Le Moal, Berthol, Ubac studied with R. Bissiére before 1938. The work of these young 'Painters of the French tradition' was exhibited in one of the halls of the Paris salons in the autumn of 1944. The effect of this exhibition was compared with the historical appearance of the Fauvists in the year 1905.

In America it was the immigrants who helped to ignite the fire of abstraction by their example. The conversations of the emigrant Surrealist Mattà with Motherwell, Still and Baziotes, in which the main figure of American 'hot' abstractionism, Jackson Pollock, also participated, were unforgettable. It was Pollock who started the era of Abstract Expressionism in 1943 with his 'murals' for P. Guggenheim, and discovered the foundations of the so called 'Action Painting' around 1947. The numbers of the American Expressionists such as de Kooning, Gottlieb, Hoffman, grew during the war. Soon the situation became hectic and difficult to follow.

Groupings, controversies, developments

By reading the Paris journals of the years 1947 to 1953 one gains the impression that a third world war was in progress. In hard 'battles' it was the figurative Formulists in particular who were attacked by the followers of socialist Realism on the one side and by the Concretists, who wanted to start a new Bauhaus-programme, on the other. These 'Geometricians' became extremely active before they were in their turn attacked and pushed aside by the increasingly stronger Lyricists. The foundation of the Salon des Réalites Nouvelles in 1946 was an important event also shared by the members of the Abstraction-Création. There and in the Journal *L'art d'aujourdhui* (1949–55), edited by Bloc, the leader of the group L'Espace, all followers of logic-in-art and Concretism had their say. Next to Herbin, it was Alberto Magnelli who became a much appreciated master. In addition to the original principles of Concretism, a new way of looking at spatial relationships was found and the artist himself was accorded stronger consideration. These new concepts were important, but the 'Mechanics of Abstract Art' had a difficult time in a Paris given to lyricism. The art critics accused them of narrow-minded dogmatism which resulted in an academic way of looking at art and the 'icy wastes of the universal'; after 1950 their position appeared lost.

The years of triumph for the lyrical trends followed. Their predominance, which grew increasingly after 1947, remained unshaken throughout the '50s.

The rise of the Lyrical Abstractionists began in America in 1947. Pollock poured and splattered paint over enormous surfaces in a state of creative ecstasy. Newman painted the first pictures consisting of enormous stripes and participated with Motherwell, Rothko, Hare, Baziotes and others in the founding of the Abstract Art school 'Subjects of the artists' in Greenwich Village.

1947 also saw the decisive breakthrough for the Lyricists in Paris. The gallery Drouin, which had already discovered Fautrier, Dubuffet and Wols, exhibited work by the leader of the Parisian abstractionists Roger Bissière. A further Wols exhibition had a shattering effect. Almost simultaneously the gallery Conti exhibited Schneider and Hans Harting (works from 1935). The massive appearance of 'L'imaginaire', the first of a series of exhibitions organised by Georges Mathieu, the leading figure of the lyrical school, gave a comprehensive and pragmatic character to the movement.

The original title of this exhibition, *On Lyrical Abstraction*, pointed to a particular concept of art which originated with van Gogh, Picasso, Brauner and Arp and ended with Bryen, Hartung, Mathieu, Riopelle, Ubac and Wols. Later P. Tàpies and the sculptor Stahly joined. These painters turned against geometrical Concretism and against its cult of the artistic means by stressing the role of the inwardly free individual and his right for strong, expressive emotions which may burst form asunder.

During the next few years the situation became more complicated by further changes in the language of art. The name and style of Wols were taken up by four different movements. While the 'painters of the French tradition' did not lack official recognition, by 1951 the truly creative artists, with M. Tapié as their spokesman, were still finding life difficult, particularly because of their 'interpretations of the informal' or 'un art autre' (different art).

In what way did these lyrical movements differ? The 'painters of the French tradition', who were admirers of Bonnard, had once also been called 'Abstract Impressionists'. Painters such as Bazaine, Manessier, Singier and others started out from nature motifs or expressed their ideas with symbolical 'landscape impressions' of a very graceful colouring. The real Lyricists (or informal painters), like the American action painters, had a strong aversion to the repressive tendencies of proscribed forms and their function. Their work culminated in the spontaneous gesture of the act of painting and its traces and signs.

This was a real revolution. Not the painting itself but the act of painting, in which the pent-up emotions wildly break loose in whirling brush strokes of destructive explosiveness, became the symbol of such art. By destroying the discipline of form the painter thought he was destroying all other tyrannies as well. He felt liberated of fear, of the rational 'shackles of convention' and the symbols of repression. In this sense a lyrical painting was understood to be a political act. The finished painting was merely a relic of the battle.

Paris loses its monopoly of culture

In 1952, under the leadership of the critic C. Estienne, the second wave of Lyricists gathered in the October salon of Paris. They are known in the history of art under the nickname Tachists (*tache* = spot). Was this an answer to the sweeping American influence in Europe after the style of French sensualism?

In 1948 the first Franco-American confrontation took place in Paris. The visitors to the Venice Biennale were shocked

again in 1950 by the 'drippings' of the Pollock compositions. It was only on the occasion of the second Franco–American confrontation ('Vèhemences confrontées') of 1951, that the peculiar American features were awarded the status of a meaningful contribution. The painter Russell wrote of that time: 'The paradox of American painting is embedded in its very existence. The painters who have fought heroically against a brutal and anti-aesthetic civilisation to create a progressive art of the 20th century, saw their actions as a gesture of liberation and defiance, as a confirmation of the dignity of the human mind. It is difficult to describe this art if one does not approach it traditionally, as poetry of the non-poetic, as an uprising against de-personalisation, against the absence of a valid mythology, against every kind of utilitarian consideration. Even the idea of the painting as a lasting and precious work of art meets with refusal from many American painters'. Few were to know that around 1950 the first steps forward towards the hegemony of the American art and the American art dealer had been taken. At the beginning of the '60s, New York took over from Paris as the metropolis of the art world. In addition, a polycentric situation was developing in Western Europe; Milan, the area between Amsterdam, Düsseldorf, Hamburg and other big cities, became the nerve centre for the distribution of Abstract Art.

The original contributions of individual countries can only be mentioned briefly. While Switzerland was known as the preserve of Concretism, in Germany, after Baumeister, Nay and Winter, even younger Lyricists rose to fame (Schulze, Götz, Hoehme, Kalinowsky, Dahmen). Particularly interesting was the surge of activity generated by the Italian groups such as 'Forma uno' (Dorazio, Perilli, Turcato), the Concretists of Milan, MAC (Soldati, Munari) and especially the 'Specialists'. These painters, such as Capogrossi, Crippa, De Luigi, and others, gathered around the prophetic figure of Lucio Fontana and his manifestos. They burst open the square confines of the painting in order to realise in a dynamic way the concept of space. The younger informalists constituted the 'Nuclear movement' (1951–58) and later sought to join the Expressionist group of the north called Cobra. The Cobra members, such as Jorn, Appel, Corneille, Jacobsen, Alechinsky and others, expressed with their volcanic impetuosity the cruel elements but also the naïve. Next to their great model Jean Dubuffet they are the representatives of the so-called 'generative figuration'.

When some centres of Lyrical Abstraction stagnated, new ones were formed and found their very active focal point in countries with authoritarian systems. In Spain it was the group El Paso (Tápies, Millarés, Cuixart, Feito); after 1956 the move-

ment appears in Poland, Yugoslavia, Czechoslovakia (both the Kotiks, Medek and the group 'D'), later also in Moscow (Bieljutin and his school, Vasiljev, Nemuchin). This way of painting which resists regimentation by the state dared, in spite of the danger of persecution and chicanery, to express a symbol of liberation by means of the unfettered act of painting.

The lyrical process of painting and the changing of values

The American Abstract Expressionists and the European lyrical painters also introduced far reaching aesthetic and semiotic changes in the art of painting. A philosophy evolved which had as its focal point the physical act of painting in the dialectical interaction with its pre-conditions (irritation, archetypes, matter) or with its results (traces, signs, calligraphy, magical messages).

The initial reaction of most lyrical painters to their environment was one of negation. They were convinced of the falsity of the visible forms of sham-reality. All 'solid forms' in culture and art, as also in organisational systems and the habits of society, filled them with horror. These 'solid forms' put the energetic structure of true reality and vitality in fetters, and would, according to the Lyricists, lead to the alienation and degradation of life. It was in the name of life that they sought to burst upon the fossilised forms with their wild emotions, to tear apart the appearance of things and to set in motion the original energies. Therefore the Lyricists' influence was of an emotionally vital, and therefore expressive, kind; there followed a spontaneous chain reaction of eruptions from a condition of trance-like irascibility. Everything which might steer or dampen this chain reaction from the outside – all concepts, plans and rational interference – had to be eliminated. The meaning of the act of painting was not predictable in beautiful plans and rational theories. Most of all they did not regard a finished painting as a harmonious object of timeless value. Indeed, the idea of timelessness became more and more questionable. Lyrical painting was not meant to produce lasting works of art, but a sort of ritual, a pantomime full of magic.

Faced with the empty canvas the Lyricist felt threatened. His inner self told him to act, to defend himself, to undertake anything in order to maintain self respect. The painter behaved as if he were persecuted. He had to create, he had to react immediately without any help, without any model to guide him. The canvas was his friend. The quick creative reaction and the singularity, the authenticity of the act of painting, decide the result of the battle.

Action painting becomes a battle and an act of realisation

With his naked soul irritated and tense the painter climbs into the painting as if this were a ring. He has forgotten all rules and 'abstract' dogmas, he does not know what he will encounter.

This artistic fight starts like an eruption with an unarticulated primeval scream. The surface is cut to bits. Here the painter fights with everything at his disposal, his brush is sometimes a whip, sometimes a sword. He hits, he avenges himself, he liberates himself, he feels cruel and touched. He finds self-expression and redemption.

'When I am in my painting' Pollock has said 'I am not conscious of what I am doing. Only after a period of familiarisation can I see what I have done. . . .' His critic Harold Rosenberg has seen the new problematic position in this light: 'The painting as action cannot be separated from the biography of the artist. The action painting has the same metaphysical substance as the existence of the painter. The new way of painting has made any distinction between art and life superfluous.'

The artist experiences his own hidden energies and preferences, he feels volcanic impulses of a murderous and a magical kind. He senses the powers of nature straining through his body, and feels a common bond with his materials, with the surface and colours. The act of painting as the orgiastic apotheosis of life, of self-realisation: this is the true meaning of this kind of lyrical painting. Once finished, the content of the painting is therefore seen as an organic constituent of the stream of life. 'By means of colour one has to create a space which constitutes its own reality, so that others may see in it a living continuation and growth of life as a real thing' (Claus).

Action as destruction and construction

The process of lyrical or 'active' painting consists of acts which happen in varying depths of intensity. It seems that this particular way of painting searches for the shortest, most striking path from a state of 'irritation' to an 'answer', to a 'trace', to a 'cipher' or a sign as the basic element of Lyricism. On the way, it tears apart the remains of the figurative (Wols), or it cancels out appearances (Hartung), or it wants to dissolve the limiting sense of form (Rothko). Action painting, which started off from a position of negation, can, however, change its course and lead away from deformation towards constructiveness. The actions appear, when all is said and done, as expressions of a positive activity, as a way of communicating and giving.

Action painting leaves traces of very differing quality.

Between the states of destruction and reconstruction there are many forms of 'not being quite there'. Probably they are signs of an embryonic condition. This applies particularly to the 'material way of creating' of the Informalists (Dubuffet, Tàpies, Medek) which displays an unbelievable arsenal of pre-morphic, open half-signs. Even the 'open' chance techniques, such as the brush-writing and the American technique of 'dripping', are part of this formative stage.

This dialectic change of direction does not always happen in a positive way. The closing phase can clearly culminate in an increased sense of negation (Soulages, Vedova, Millarés). Dramatic traces accumulate in layers and form signs; in some cases further growth may result in 'supersigns'.

The traces and signs of these actions are never simple to read. They present a considerable difficulty, but surely also a practical challenge: the deciphering of a complex, many layered text. The viewer is in a difficult position, like being confronted by the pythian oracle: several interpretations may be considered. Many painters have made creative use of this particular ambivalence (i.e. the different constituent elements of a painting and the changing position of the painter), which has been seen in different ways by the lyrical movements. We close this chapter with an enumeration of the most important lyrical movements and trends which display dissimilar accentuations and historical connections.

The trends of lyrical abstraction

The painters of **Abstract Impressionism** (Bazaine, some pupils of R. Bissière) are also known as the painters of 'the French tradition'. Their paintings were popular because of the French fusion of reason and emotion. They translated the experience of nature into particular ornamental symbols.

The term **Abstract Expressionists** applies to hundreds of painters, especially Americans, such as de Kooning and Hofman, and Europeans such as Nay, Saura, Vedova and others. The pictorial quality of broken colours and lack of contrast are their main characteristics.

Abstract Expressionism was developed by Jackson Pollock into **Action painting**, one of the typical American concepts. This is a very dramatic way of painting full of bold, careless and monumental gestures. Huge canvases on which the paint was spurted, dripped and poured were called 'Overall compositions'.

Lyrical Abstraction (since 1947), in the narrow sense of the word, found its main protagonists in Wols, Mathieu,

Riopelle, Serpan and others. They paint 'with the control of consciousness switched off, in a trance. This becomes an automatic gesture known as a lyrical explosion' (Hoffmann). The act of painting in which man becomes aware of himself is quick and leaves the incarnated impulses of cosmic energies behind. 'Lyrical' here also means to recreate the poetic relationships between man and nature.

After 1951 most lyrical painters came together under the new label of **Informal art**. The main stress was on the 'non-means of matter' and the 'not-yet-forms', for example in the 'openness' of the canvas. (Fautrier, Dubuffet, Michaux, Tàpies).

A peculiar aspect of Lyrical Abstraction appeared in the sign-paintings of Hartung, Tobey, Lapicque, Kline and Morita who wanted to communicate visionary meditations.

The paintings of **Magical Abstraction** showed different aspects. The signs and 'hieroglyphics' were to make possible a connection with a hidden world of 'energies'.

The term 'magical' was used – apart from the informalists – for very different painters: on the one hand Burri, Baumeister, Bissière and some Spaniards who liked to work with rough materials, on the other also for 'unmaterial' painters such as Miró, Capogrossi, Musić, Medek and some Japanese and Chinese. There are three more movements which are part of the historical conclusion of the lyrical tendency. There is first of all the American **Colour-field painting** (Newman, Rothko), which has fascinated us with enormous chromatic surfaces suggestive of the American sense of space. These painters had a strong influence on the later 'post-painterly abstraction' and the so called 'hard-edge painting'. A further phenomenon which arose out of the non-dogmatic, humanist concept of content within the lyrical tradition is called **Genetic Figuration**. The figurative which appears in the paintings of this movement in broken parts and signs (de Kooning), but also as a whole structure (de Stael), did not hinder the lyrical urge to make the nature of things apparent; on the contrary. At times, this style tended also to the imaginative post-Surrealist conceptions.

During the years when total abstraction was at its height, the half-figurative excursions of de Stael, Bissiére. Pollock, were branded as treason by the critics. This heresy, this return to the figurative symbol was a reaction to the tiredness caused by the lyrical inflation; for this reason some third-rate painters attained eminence and were termed pejoratively **Tachists** or spot painters. Guerin, who used this term for the first time, said later: 'From a dot to a daubing it is but a step, a bad step, which avoids talent, for with these dots we enter directly into the dark ways of matter. . .'

Around 1960, as the decline of the manifold movements of Lyrical Abstraction began to be felt, the trend still acted as a powerful starting point for the counter movements: Pop-art, New Figuration, systematic painting and Kinetism, New Realism and Minimal Art.

Visual researches and systems, 1960–73

The years 1947–58 witnessed the triumph of the Lyrical Abstractionists. The protagonists of this movement did not hesitate to criticise and mock the beliefs of their vanquished rivals, the 'geometricians'. Mark Rothko repeatedly said that a good painter has to forget 'memory, history and geometry'. For Wilhelm de Kooning geometry was aimed against art and an expression of insecurity. A relatively friendly criticism condemned geometric abstraction as a 'formation which is alien to reality'; it may, at the most, be part of the logical fictions of reason. Such works might be appropriate for the academics, but surely not for the researchers with a really creative mind. What did their beliefs look like?

The 'geometricians' used the dark days spent in the shadow of the prospering Lyricists to create authoritative and dynamic changes. Already shortly after 1955 and especially at the beginning of the '60s it became apparent that they had transcended the mere propagation of a geometrical sense of order and proportion. At first one gets the impression that these new paintings and objects in space are created, indeed fabricated, in a still more exact yet more rational manner, but soon one realises how different this geometry is. For geometry and rational methodology too are now only used as a means.

The works of the so called 'geometricians' appear, after 1960, increasingly geometrical, because, to achieve their ends, they expanded the vocabulary of conventional, strict geometry beyond all recognition.

Some local schools, the South Americans, and in particular the Italians dislocated the poetical span of the paintings with their sensualism and subjectivity. One of the leading geometricians in Paris, Jean Dewasne, said in 1948 (*Options Nouvelles*) that a 'quasi-biological structure' would determine the course of art to come, and its naturalism will be formulated in relation to man.

The principles of a natural approach were decisive for several groups during the 'renaissance of the geometrical' after 1955. The kinetists of all kinds, the op-artists and systematisers, visual researchers and Minimalists, the new Concretists, as also the groups Zero, Hard-edge and the conceptionalists, in other words an enormous amount of artists who influenced the artistic scene between 1960 and 1973, were at bottom concerned with human values, with organisation and life. They all longed to end the isolation of modern art.

Kinetism and trends of visual research

In Europe it was the museums in Holland, Germany, Sweden and Switzerland which set the points for this phase of the development, and in particular the Parisian gallery Denise René. In 1955 the first kinetic exhibition called *Le mouvement* took place there. The art historian Pontus Hultén (who later organised much larger exhibitions in Stockholm and Amsterdam) had ascertained, in conjunction with V. Vasarely, in his famous *Yellow manifesto*, the possibilities of a new kind of art, a rediscovered kinetism. The contribution of this kinetism were the paintings of Vasarely, Agam and Soto with their dancing and jumping structures, the light-machines of Schöffer, and the moving objects of Calder, Bury, Tinguely which really turned and changed like living beings. The use of pulsing light made this 'art of motion' one of the most wonderful artistic innovations of the 20th century.

'Motion is a spark of life which makes art truly human and realistic' (Vasarely).

At that time the star of Victor Vasarely, which illuminates the sky of recent art, had just started its steep rise. After a period of emblematic composition he tried again to use 'chequered contrasts', the contrast of negative and positive forms. These creations open and close, so that the whole surface seems be breathing: we gain the illusion of ceaseless motion. Vasarely built these pictorial organisms, which come to life under our eyes, like cells from 'plastic units': always a circle in a square, with colour contrasts. He always kept in mind his audience who thus becomes an active participant; he counted

on his systems being put to social use, perhaps in industrial production which opened up possibilities of mass-produced 'multiples' (cheap originals for everybody). Vasarely really became a designer and it was in this spirit that he worked on the main contents of Systematic Art.

Systematic Art may be grouped together with serial, optical, kinetic and other related trends in art and seen as an aspect of the interdisciplinary sphere of visual research. What are its problems? It is on the one side determined by visual colour — forms, on the other by the perceiving audience. This throws up the question of what connections are possible between the two. But is the person who asks this question still a painter, an artist? The creative artist of late becomes now a research technician. Hoelzel, Itten and of course Kandinsky had already been occupied with this problem in an unsystematic manner. The first systematic contributions were those of the Bauhaus masters Albers (*Interaction of colours*, 1963) and Moholy-Nagy (*Vision in motion*, 1947). Moholy-Nagy introduced the dimensions of time and light as far as they related to perception into visual research. According to this conception the painting is no longer the end result but a richly structured subject of research. While the main factor is regarded as 'light', the analysis of the painting becomes the analysis of light and motion, and it is the rhythm of light in space which lends aesthetic coherence to the whole. The problem is looked at in a similar way by Max Bill, who thinks that one ought to study the object of the painting as an instrument for demonstration and dialectical purposes. The painting is therefore a model for the technology of perception.

An artist who regards himself as a technician of painting and perception must be occupied with the optical and psychological side of the processes of perception. His question is: how can these be brought together with a feeling of liberation and the wider-ranging activities of the mind (such as self-realisation, imagination etc).

These researches and attempts brought the 'aesthetic operators' back to the production of individual paintings and kinetic apparatuses. One remark illuminates the wider context.

The pictures of Op Art (optical art, around 1963), whose rhythm and clever contrasts bombarded the eye like a machine-gun, were out to make capital of the realisation that 'our perceptive faculty tires quickly and the span of concentration is too short' (L. Lippard). Serial pictures and objects as an aberration of systematic art are based on the principle of addition of similar elements. Here too Max Bill prepared the ground. Later he was superseded by the complicated solutions of his compatriot R. P. Lohse.

The most successful groups in this area were the young 'research collectives' such as Groupe des Recherches Visuelles (which included Le Parc, Morellet, Sobrino and others), the group Enne in Padua, Gruppo T (which included Colombo, Boriani, Varisco and others) in Milan, Gruppo Uno (Carrino, Uncini, Frascà) in Rome, the Club of the Concretists and the Kreuzung in Prague, the group Dvigenje in Moscow, and others.

The origin of this very methodical way of working is to be found in the Bauhaus of the '20s, the time of the apotheosis of the machine. Serial art preserves the molecular character of the de-personalised mass product. The Bauhaus people regarded the ability to repeat without any variation and the high precision factor as an aesthetic contribution: 'for the machine is finally a human invention'.

What is the theme of serial or systematic art? What is the aim of the so called 'ars accurata' and the kinetic apparatuses? It is the mere fact that a work of art is perceived which becomes the real theme here. The goal was to be the lessening of the distance between the audience and the 'operator' by means of an increased consciousness of the entire process of perception.

In addition a further interesting problem appeared: consequential, technical thinking with rational elements can lead to a surprising contradiction. Rational visual systems and kinetic instruments provoke perceptions which lie beyond the laws of explanation and control. The rational here serves the irrational, the shocking. Does this not reflect the historical situation of our civilisation?

Hard-edge and Minimal Art

The situation in the United States, which had put itself at the head of artistic developments, showed, towards the end of the '50s, the same symptoms which had appeared in Europe. Since 1958 a change of taste became apparent, even with the Abstract Expressionists, which expressed itself in a desire for simplified and clear forms.

A handful of 'geometricians' who had survived the heroic years of unfettered Abstract Subjectivism now moved to the fore. Their influence, particularly that of Ad Reinhardt, Barnett Newman, Josef Albers, but also Mark Rothko, will spread as it allows new trends and visions to open up. At the same moment as Neo-Dadaists and the propagators of figurative art cried: Abstract Art is dead', this group of painters, together with Pop-artists, began to forge the destiny of American art.

Ad Reinhardt, a symmetrical painter of condensed colder spaces and black paintings, created a prototype of the new form and a new theory of extraordinary intensity. The over-stretched canvases of Barnett Newman have the depth of the Atlantic and the unending expansiveness of a Mexican night. They embody the transcendental longing to outdo the greatness of nature.

Hard-edge was again an authentic movement of America; as a contrast to the softness of some abstract work 'hardness' became necessary. 'It consists usually of an emblematic sign, which is larger than earlier idiom. Most of all it is not geometrical in general, but a sharply constructed free form which only appears geometrical by virtue of its decisive precision' (L. Lippard). The best known exponents of Hard-edge were Leon Polk Smith (already since 1950), Elsworth Kelly, who saw the surfaces of paintings as containers for vibrating colours, and then two painters from Washington, Morris Louis and Kenneth Noland.

Their intensively suggestive colours recreated spaces beyond the confines of the canvas. The 'deductive art' of Frank Stella, the 'repulsive art' of primary structures and the 'non-relational concept' resulted after 1964 in Minimal Art: it seems to be the art of giants who throw about their strength and who demonstrate simple experience of wholeness as a summation. Within the framework of the primary structures these pictorial fields have expanded into bodies of colour and these in turn into an ambience of form which could restructure the urban landscape. Objects, which sometimes look like the remains of a temple, prevail and have influenced even great architects such as Louis Kahn. Structuralists and Minimalists such as Judd, Morris, Sol le Witt, André, Jo Baer and others based themselves on a wider system of ideas which stretched from Surrealistic biomorphism to Bauhaus designs and crystallography. In this way they are able not only to avoid academic stagnation – the fate of older 'geometricians' – but also to take further steps in the direction of the conceptual and of the art of ideas.

What does Abstract Art give us?

More than anything else, non-representational paintings and objects mean an expansion of our experience into several new dimensions, and journeys into the regions of 'other' symbols. These abstract paintings can either remain a matter of like and dislike or become a means to a new and concrete way of interpreting the world, an aesthetic certainty which is only

possible in this way and no other. Abstract paintings discover the nature of true reality under the surface of things; they are the result of individual ways of seeing the world; they may also be considered ways of creating a world. Abstract paintings, regardless of the school they belong to, are autonomous and on the same level as the many other attempts of man to find meaning in a chaotic world, to perceive this world truly and to give it a sense of order.

Short biographies of the painters

Afro (Afro Basaldella)
Born in 1912, he died in 1976 in Rome. Started as a neo-Cubist, representative of Italian Lyrical Abstractionism; first single exhibition in 1932 in the gallery 'Il Milione' in Milan, visited the USA in 1951; lived in Rome.

Albers, Josef
Born in 1888, he died in 1976 in New Haven, Connecticut. Studied at the Academy of Art in Berlin, Essen and at the Bauhaus in Weimar; 1923–33: taught at the Bauhaus; emigrated to America in 1933; several visiting professorships at Black Mountain College, N. Carolina, Harvard University, Pratt Institute, New York and other American High Schools. Published *Poems and Drawings* (1961), *Interaction of Colour* (1963); his series of paintings *Homage to the Square* (since 1950) influenced Op Art, Kinetic Art, and the new Abstractionism.

Appel, Karel
Born in 1921, he founded the Experimental Group with Corneille and Constant which joined Cobra in 1948. Appel represents an Abstract Expressionism which does not exclude representational elements; he lives in Paris and Amsterdam.

Arp, Hans
Born in 1887, he died in 1966 in Basel. Studied in Strasbourg and Weimar, participated in the exhibition of Der Blaue Reiter in 1912; 1915: first abstract compositions; 1916: joint founder of the Dada group in Zurich; 1917: met Sofie Taeuber, later his wife; friendship with Theo van Doesburg and co-work on the Cafè L'Aubette in Strasbourg (1926–28); 1925: went to live in Paris; friendly with the Surrealists; member of Abstraction–Création and the Swiss group Allianz. During the war in the south of France; 1946: returned to Paris where he also worked as a sculptor, his work earned him the first prize at the Biennale in Venice.

Baumeister, Willy
Born in 1889 in Stuttgart, he died there in 1955. After an apprenticeship as a house painter he became a pupil of Hoelzel at the Stuttgart Academy; participated in the autumn exhibition of 1913 at the Der Sturm gallery. Visited Paris often. 1928: teacher at the municipal art school in Frankfurt, asked to leave in 1933; member of Abstraction–Création; his paintings were called decadent. 1939–44: went into hiding; after the war professor at the Academy in Stuttgart; 1947 published *The Unknown in Art*.

Bill, Max
Born in 1908 in Winterthur. Art school in Zurich and at the Bauhaus 1927–29; since 1929 architect in Zurich, also worked as painter and designer; member of Abstraction–Création. 1937: joined Allianz; 1944 founded the journal *Abstract/Concret*; organised Swiss exhibitions of Concrete Art; 1951–56: dean of art school in Ulm, author of numerous publications.

Bissière, Roger
Born in 1888, he died in 1964 in Boiserette. Came to Paris in 1910, after 1917 friendship with A. Lhote and G. Braque. 1925–38: taught at the Academie Ranson, influenced Manessier, Ubac and many others of his pupils; lived in Lot since 1939; 1936: exhibition at gallery Drouin, later at the Bucher Galerie in Paris.

Bogart, Bram
Born in 1921 in Delft; self taught. 1943: first exhibition in The Hague. 1951: went to live in Paris, informal period; since 1961 has lived in Brussels and Ohain, Brabant; beginnings of monochrome massed colour fields; 1963/64: received the prize of the Belgian art critics and in 1969 the European prize for painting.

Bonfanti, Arturo
Born in 1905 in Bergamo 1924–26: went to local art college; 1926: went to live in Milan; designed many posters and animation features; first Concretist paintings. Since 1946 many journeys to Paris where he stayed for long periods; lives in Milan and Bergamo.

Burri, Alberto
Born in 1915 in Città di Castello. Studied medicine in Perugia; as a prisoner of war in 1944 he began to paint; lived in Rome since 1945; participated in many of the Biennali in Venice; 1955: exhibitions at Museum of Modern Art in New York.

Calderara, Antonio
Born in 1903 near Milan. 1924: quit studies to become an engineer and started painting; self-taught. First exhibition in 1923. 1961: first exhibition of abstract paintings; many exhibitions abroad; influenced by Mondrian and Josef Albers.

Corneille (Cornelis Guillaume van Beverloo)
Born in 1922 in Lüttich. 1940–43: academy in Amsterdam; founder member of Cobra group in 1948; exhibitions 1951 and 1954 in Amsterdam; 1953 and 1954 in Paris; lives in Paris.

Delaunay, Robert Victor Felix
Born in 1885 in Paris, he died in 1941 in Montpellier. 1903–08: critical appraisal of the works of Cézanne and the Cubists, follower of the Fauvists. 1911: member of Section d'Or; 1912: participated in exhibition of Der Blaue Reiter; cycle *Simultaneous Windows*; 1932: founder member of Abstraction-Création. 1937 decorated the pavilion for the railways and air-traffic of Paris World Fair.

de Stael, Nicolas
Born in St. Petersburg in 1914, he died in Antibes in 1955. Studied at art school in Brussels; 1932: went to live in Paris where he worked as a decorative painter; travelled to Spain (1935) and North Africa; 1940: returned to Paris; 1945: exhibition at Bucher Gallery; several exhibitions in New York; returned to figurative work in 1953.

Dewasne, Jean
Born in 1921 in Lille. Self taught; first abstract paintings in 1943; 1945–56—: member of the group around Denise René Gallery in Paris; 1950–52: taught at the Academy for Abstract Art; many theoretical papers, created the monumental painting for the Winter Olympics in Grenoble (1968); lives in Rome.

Fautrier, Jean
Born in Paris in 1898, he died in 1964 in Châtena – Malabry. Trained in London; wounded during First World War; 1921: first exhibition in a Paris garage; 1928–33: abstract illustrations; exhibited at the Drouin gallery in 1945; 1951: participated in 'Signifiants d'Informel'; 1955 and 1956: exhibitions of the Rive Droite gallery; first prize at Biennale in Venice (1964).

Fontana, Lucio
Born in 1899 in Argentina, he died in 1968 near Varese. Since 1905 lived in Milan, after 1918 again in Argentina where he worked as a sculptor with his father. 1928: studied at the Accademia di Brera in Milan; 1931 the first, 1932 the second exhibition at a gallery in Milan with abstract experiments; published *Manifesto Bianco* in 1946, which was published as the first manifesto of Specialism in Milan (1947).

Francis, Sam
Born in 1923 in San Mateo, California. Studied medicine and psychology at first; painted abstractly since 1947; has lived in Paris since 1950; works with Léger and Riopelle; stimulated by Japanese calligraphy.

Gorin, Jean Albert
Born in 1899 at Saint-Emilion-de-Bain. 1921–22: art school in Nantes; turned to pure abstraction in 1926, influenced by Ozenfant and Le Corbusier; friend of Mondrian; member of Abstraction-Création in 1932; first neo-plastic reliefs 1946: founder member and secretary of the Salon des Réalités Nouvelles. 1960: retrospective in Luttich. Lives in Paris.

Gorky, Arshile (Vosdanig Manoog Adoian)
Born in 1904 in Armenia, he died 1948 in Connecticut. Studied in Tiflis. Came to USA in 1920, artistic studies since 1925; after 1930 developed his 'organic' style of abstraction; after 1934 meetings with the Surrealists; 1950 retrospective at Whitney Museum in New York.

Hartung, Hans
Born in 1904 in Leipzig. Studied the old masters in Dresden in 1914; 1922: painted first abstract water colours; 1931: first exhibition in Dresden; 1935: emigrated to Paris; 1939: in the Foreign Legion and 1943 in De Gaulle's army; 1944: wounded seriously near Belfort. Important representative of informal non-representational painting.

Herbin, Auguste
Born in 1882 near Cambrai, he died in 1960 in Paris. 1898: studied in Lille; 1901: went to live in Paris; 1909: worked in the Bateau–Lavoir with Picasso, Braque and Gris; 1917: first abstract work; 1931: founder member of the group Abstraction-Création; 1949 published the book *L'Art non-figuratif non-objectif*.

Hoelzel, Adolf
Born in 1853 Olmütz/Mähren, he died in 1934 in Stuttgart. After an apprenticeship as a printer, he studied at the Academy in Vienna in 1874–76, from 1876 on in Munich; in 1882 saw Impressionist paintings in Paris; from 1888 on in Dachau. In 1891 he founded a private school, researched into a theory of colour; 1905: created the *Komposition in Rot*; called to the Academy in Stuttgart where he taught until 1919; 1918: exhibition in Hanover; important contribution towards paving the way for Abstract Art in Germany.

Itten, Johannes
Born in 1888 in Südern–Linden, he died in 1967 in Zurich. Studied at the University of Bern and the Academy in Geneva; 1913–16: pupil of Hoelzel in Stuttgart, first abstract compositions, 1919–23: developed new theory of design at the Bauhaus in the *Vorkurs*. 1926–34: had his own school in Berlin; since 1932 also dean of the art school in Krefeld; since 1938 director of art school and museum in Zurich, reconstructed the Rietberg Museum in Zurich; after 1960 published books on his theory of colours and work at the Bauhaus.

Jorn Asger (Asger Oluf Jorgensen)
Born in 1914 in Vejrun, Jutland, he died in 1973 at Århus. Representative of Abstract Expressionism and leading Danish member of the group Cobra; created together with Léger the decorations for the Palais des Temps Modernes at the Paris World Fair; after 1948 continued his work in conscious opposition to the informal painters Hartung and Wols. 1951–52: published a theoretical book.

Kandinsky, Wassily
Born in 1866 in Moscow, he died in 1944 in Paris. 1886: studied law and economics in Moscow; 1897–1900: studied at the Ažbè school in Munich and at the Academy with F. von Stuck; founder member of Neue Kuenstlervereinigung, Munich, in 1909; 1911: founded the Blaue Reiter; 1914: returned to Moscow. 1922–23: taught at the Bauhaus in Vienna, Dessau and Berlin; 1933: emigrated to Paris; started the movement of abstract painting and was one of the most important artists of the 20th century; his book *On the Spiritual in Art* (1912) influenced a whole generation of artists.

Kantor, Tadeusz
Born in 1915 near Cracow. Until 1939 studied at the Academy in Cracow, influenced by Surrealism; 1954: he discovered informal painting in Paris which stimulated him to paint abstractly. Kantor is one of the most prominent of modern Polish artists.

Kassák, Lajos
Born in 1887 in Hungary, he died in 1967 in Budapest. Emigrated to Paris in 1909; met the avant-garde, started to paint and write; published the journal *MA* in Budapest until 1926. 1931: first exhibition of his Constructivist paintings in Vienna; 1932 in the Berlin Der Sturm Gallery. 1960 first exhibition in Paris.

Klein, Yves
Born in 1928 in Nice, he died in 1962 in Paris. 1946: first paintings in monochrome and theoretical work; 1957: blue period and simultaneously the first 'Immateriellen' of fire and air which lead him to Action Art.

Kline, Franz
Born in 1910 in Pennsylvania, he died in 1962 in New York. Studied at Boston University and London: several exhibitions since 1950 at the Egan Gallery in New York. Taught at Black Mountain College and Pratt Institute; important representative of Abstract Expressionism of the New York school.

Kooning, William de
Born in 1964 in Rotterdam. Studied at the Academy there; influenced by the Flemish Expressionists; went to USA in 1926 and worked as a house painter. 1934: first abstract paintings; 1948 first exhibitions at Egan Gallery in New York; leading representative of American Abstract Expressionism; lives in New York.

Krushenick, Nicholas
Born in 1929 in New York. 1948–50: studied at the Art Students League, in New York; afterwards with Hans Hofmann, developed into an Abstract Expressionist; since 1962 has been moving towards the ornamental Hard-edge art.

Kupka, František
Born in 1871 in East Bohemia, he died in 1957 in Paris. 1889: studied at the Prague Academy; 1892: at the Vienna Academy; 1896: went to Paris; 1899: illustrations and caricatures; participated in the Salon d'Automne since 1900; 1910: first abstract paintings; 1911 participation to the Section d'Or. 1932: honorary president of Abstraction-Création; 1946: retrospective exhibitions in Prague and Paris. Next to Kandinsky the most important initiator of Abstract Art.

Larionov, Michail
Born in 1881 at Tyraspol near Odessa, he died in 1964 in Paris. 1898–1902 studied in Moscow; 1908: participation in the exhibition 'The Golden Vlies', 1911 'Karo Bube', 1912 'The Ass's Tail' where he exhibited rayonistic paintings; 1913 manifesto of Rayonism. 1914 emigrated to Paris with N. Goncharova, worked with Diaghilev's Russian Ballet; 1948 retrospective exhibition of Rayonism in Paris.

Lissitzky, El (Elieser Markovitch Lissitzky)
Born in 1890 in Potschinok near Smolensk, he died in 1941 in Moscow. 1909–14: studied at the Polytechnic of Darmstadt; since 1917 participation in group exhibitions in Russia; 1919: professor of the Academy of Witebsk, first 'Proun' paintings; 1920–21: worked with the Constructivists especially INCHUK in Moscow; 1922: 36

participation in the first Russian exhibition in Berlin; 1923: 'Proun-Raum'; co-editor of the journal *Object*. 1926: abstract designs for State Museum of Hanover; 1928: design of Soviet Pavilion at the Cologne Fair and return to Moscow. Lissitzky was one of the most important representatives of Russian Constructivism.

Lohse, Richard Paul
Born 1902 in Zurich. Studied in Zurich, exhibits his strictly constructivist paintings since 1936; member of the group Allianz, first serial paintings started during the Second World War; retrospective exhibitions 1970–71.

Louis, Morris (Morris Louis Bernstein)
Born in 1912 in Baltimore, he died in 1962 in Washington. Studied at the Maryland Institute of Art. Later worked for the Federal Art Project in New York. Taught in the Workshop Centre in Washington D.C. since 1947 where he met K. Noland. Discovered in 1954 by the art critic Clement Greenberg; many exhibitions followed. Louis was a representative of Colour-field painting.

Magnelli, Alberto
Born in 1888 in Florence, he died in 1971 in Paris. Self taught; painted his first work in 1907; 1914: went to Paris where he met the Cubists and painted his first non-representational works; permanently resident in Paris since 1933; member of Abstraction-Création, worked with Arp and Delaunay; 1954: retrospective exhibition

Malevich, Kasimir Severinovich
Born in 1878 in Kiev, he died in 1935 in Leningrad. Studied art in Kiev from 1885; 1910–14 influenced by Cubists and Furists. 1912: participation in the 'Ass's Tail' exhibition. 1913: first Suprematist designs; 1915: exhibitions 'Tram W' and '0, 10'. 1919–22: worked for UNOWIS in Witebsk, 1923–27 worked for INCHUK in Moscow; 1926: travelled to Poland and Germany; the Bauhaus published his book *World Without Objects*.

Manessier, Alfred
Born in 1911 in Saint Ouen, Somme. Studied in Amiens; in Paris from 1931; studied architecture and fine art; met R. Bissière in 1935; several exhibitions since 1937. Since 1945 in collective exhibitions representing France abroad; many windows and abstract paintings with religious themes.

Mathieu, Georges
Born in 1921 in Boulogne-sur-Mer. Studied law and philosophy as well as English Literature; painter since 1942. Went to Paris in 1947 and organised the exhibitions of Lyrical Abstraction. Wrote the manifestos which influenced the American Abstract Expressionists. Edited the journal *United States Lines Paris Review*; exhibitions at

the Drouin Gallery since 1950; in 1956 on the stage of the Sarah Bernhardt Theatre he painted a canvas of 12 × 4 m in a few minutes; influenced by Japanese calligraphy and one of the founders of Tachism.

Medek, Mikuláš
Born in 1926 in Prague, he died there in 1974. 1942–9: studied art in Prague; since 1951: participation in an active, illegal group of Surrealists; first international contacts since 1958. 1963 and 1965 exhibitions, in 1964 in conjunction with the 'D' group in Prague; participation in representative exhibitions since 1964. 1969: awarded the State prize.

Millarés, Manolo (Manuel Millarés Sall)
Born in 1926 in Las Palmas. Self-taught, represents a type of informal art with strangely threatening configurations; founder member of the group 'El Paso'; lives in Madrid.

Moholy-Nagy, Laszlo
Born in 1895 in Hungary, he died in 1947 in Chicago. Studied law, first paintings in 1917. Worked with Kassak on the journal *MA*; suprematistic influences in 1919; went to live in Berlin; exhibited experimental collages and photogrammes in 1922 in the gallery Sturm. 1923–8 teacher of metal work at the Bauhaus, occupied with architecture, typography, photography, the stage, experiments with light and colour, 1928–33 in Berlin; in USA since 1937, director of New Bauhaus and the School of Design in Chicago.

Mondrian, Piet
Born in 1872 in Amersfoort, Holland, he died in 1944 in New York. 1892–4: studied at the Academy in Amsterdam; 1908–10: Symbolist period (Domburg); 1911–14: Cubist period in Paris; 1914–17: first abstract compositions, 1917 founder member of De Stijl together with van Doesburg, van der Leck, Oud and others. 1919: returned to Paris, where he published in 1920 his book *Neo-Plasticism*; 1922 retrospective exhibition at the City Museum in Amsterdam; 1925 left De Stijl; 1931: participation in Abstraction-Création; 1940–44 in New York.

Motherwell, Robert
Born in 1915 in Aberdeen, Washington. 1937–8 in Paris; 1937–41: studied at Harvard and Columbia University; 1941: in Mexico with Mattà, cycle of collages; 1944: exhibition at the Guggenheim; 1947–51: several exhibitions at the Kootz Gallery in New York, founder member of the School 'Subjects of the Artists'; editor of a voluminous Dada anthology.

Nay, Ernst Wilhelm
Born in 1902 in Berlin, he died in 1968 in Cologne. 1925–28: studied art in Berlin; 1931–32 in Rome; 1937–38 in Norway. After the war influenced by Abstract Expressionism; 1950: first retrospec-

tive exhibition at the Kestner Society in Hanover; 1956: at the Biennale in Venice; 1962: at the Folkwang Museum in Essen; many publications.

Newman, Barnett
Born in 1905 in New York. Studied at the New Yorker Art Students League; taught at many American schools; 1950 and 1951 exhibitions at Parsons Gallery; 1959 'documenta' in Kassel; founder member of Colour-field painting.

Nicholson, Ben
Born in 1894 in Denham, England. His parents were painters; studied at Slade School, London; stayed in Paris, Cubist paintings. 1934 first abstract compositions; member of Abstraction-Création and the English group Axis; friendship with Mondrian. After 1945 lived in St. Ives, Cornwall, with a group of young painters. 1955: retrospective exhibition in Paris, then in Amsterdam; main representative of Concrete Art in England.

Noland, Kenneth
Born in 1924 in Ashville, N. Carolina. 1946–48: studied at Black Mountain College with J. Albers. 1948–9 with O. Zadkine in Paris. Taught at the Institute of Contemporary Art in Washington and the Catholic University there. 1958 and 1960 exhibitions at the Jefferson Place Gallery in Washington; 1964 at the Biennale in Venice; lives in Vermont.

Pevsner, Antoine
Born in 1884 at Ord, Russia, he died in 1962 in Paris. 1902–11 studied art in Kiev, then at the Academy in St. Petersburg; 1912 and 1913–14 in Paris, 1914–16 with his brother Naum Gabo in Oslo; 1917 in Moscow, professor at the Academy; 1920 the brothers wrote the *Manifesto of Realism*; 1922 emigrated to Paris; founder member of the group Abstraction-Création; constructivist sculpture was his main preoccupation.

Poliakoff, Serge
Born in 1906 in Moscow. 1924: studied in Paris at several academies; 1935–37 at the Slade School in London; met Kandinsky, Delaunay and Freundlich; since 1946 participated in the Salon des Réalites Nouvelles; 1947 and 1949 exhibitions at Denis Renè Gallery and in 1956 at the Bing Gallery in Paris; lives in Paris.

Pollock, Jackson
Born in 1912 in Cody, Wyoming, he died in 1956 in Southampton near New York. Studied art in Los Angeles from 1925; from 1929 studied in New York at the Arts Students League; first abstract work around 1940; 1944 first exhibition in Art of this Century, New York; 1948 and 1951 exhibitions at Parsons Gallery, New York; 1950 and 1952 at the Biennale in Venice.

Popova, Ljubov
Born in 1889 in Moscow, he died there in 1924. 1910–14 studied art in Moscow and Paris; 1914 participation in the Karo Bube exhibition; 1915 participation in the Karo Bube exhibition; 1915 in Tram W' and '0, 10' in St. Petersburg; developed from Suprematism towards Constructivist productions; teacher at WCHUTEMAS in Moscow; 1922–23: designed stage sets.

Reinhardt, Ad
Born in 1913 in Buffalo, he died in 1966 in New York. Studied art history at Columbia University 1931–36; 1937–47: member of the association American Abstract Art and taught in Many schools and universities; 1946: exhibition at Parsons Gallery.

Riopelle, Jean-Paul
Born in 1924 in Montreal. Since 1947 in Paris where he became known through exhibitions; 1949: Gallery Creuze; 1952: Studio Facchetti; 1954: Rive-Droite Gallery; 1956: Gallery Dubourg.

Rodchenko, Alexander
Born in 1891 in St. Petersburg, he died in 1956 in Moscow. 1907: studied art in Kazan; 1914–15: non-representational compositions; 1916: exhibition 'Magasin'; 1918: cycle *Black on White*; secretary of the Federation of Artists and teacher at WCHUTEMAS in 1920–30; communication studies.

Rothko, Mark
Born in 1903 in Devinsk, he died in 1975 in New York. In the USA from 1913; studied at the Art Students League in New York; 1933: exhibition at Parsons Gallery; after an Expressionist period began to paint abstract works in 1945; found his own style in 1947; taught at the California School of Fine Arts; 1951–4 at the Brooklyn College.

Santomaso, Giuseppe
Born in 1907 in Venice where he studied art at the Academy. 1928 first exhibitions; travelled to Holland and Paris; since 1940 many exhibitions; since 1952 an Abstract Impressionism has become apparent in his work.

Schumacher, Emil
Born in 1912 in Hagen, Westfalia. Representative of Abstract Expressionism, after education at Art School in Dortmund, 1934–45 worked as a technical draughtsman; began to paint artistic landscapes only after the war; moved towards informal art after 1951; made 'touch objects' since 1957, which resulted after 1958 in colourful surfaces with simple lines.

Sonderborg, K.R.H. (Kurt Rudolf Hoffmann)
Born in 1923 in Sonderborg, Denmark. Studied 1947–49 at Art School in Hamburg; 1953: member of the group Zen 49; his infor-

mal work began with the use of automatic techniques, later often monochrome paintings.

Soulages, Pierre
Born in 1919 in Rodez, France. Self-taught; since 1946 in Paris; participation in the Salon des Surindépendentes and other collective exhibitions; mono-exhibitions in 1954 and 1955 at the Kootz Gallery in New York. Stage designs.

Taeuber-Arp, Sofie
Born in 1889 in Davos, she died in 1943 in Zurich. Studied art; 1916–29: taught at the Art School in Zurich; member of the Dada movement with H. Arp whom she married in 1931; 1926–28: together with Arp and van Doesburg decorated the Cafè L'Aubrette in Strasbourg; 1927–40 in Meudon near Paris; member of Abstraction-Création and Allianz; 1937–40: edited the journal *Plastique*.

Tàpies, Antonio
Born in 1923 in Barcelona. Studied law; in 1946 turned to painting; 1948–51: founder member of the group and journal *Dau al Set*; 1950–51: in Paris, later in Holland; 1953: exhibition at the Jackson Gallery in New York and many other exhibitions; in 1952, 1954, 1956, 1958, 1976 at the Biennale in Venice.

Tobey, Mark
Born in 1890 in Centreville, Wisconsin, he died in 1976 in Basel. Self-taught; from 1911 in New York and Chicago; 1923: teacher in Seattle; after travels in the Middle East, back in Seattle; 1931–38 in England; 1933–35: first *Calligraphies*, travelled to Mexico and China; 1939: return to Seattle; from 1944 exhibitions at the Willard Gallery in New York.

van Doesburg (C.E.M. Küpper)
Born in 1883 in Utrecht, he died in 1931 in Davos. Self-taught; painted from 1899; 1908: first exhibition in The Hague; from 1912 poems and articles in several journals; 1917: founder member of the journal *De Stijl*; 1917–26: architectural projects with Oud, Van Eesteren; 1922: at the Bauhaus; introduced Dada to Holland; journal *Mècano;* 1924: worked for the Leonce Rosenberg Gallery, Paris; 1926: manifesto of Elementarism; 1926–28: designs and decorations for the Cafè L'Aubette; 1929–30: in Paris co-editor of *L'Art Concret*; 1930: lectures in Spain, arithmetical compositions.

Vantongerloo, George
Born in 1886 in Antwerp, he died in 1965 in Paris. Studied art in Antwerp and Brussels; 1917–22: member of De Stijl group; 1919–27: in Mentone; from 1927 in Paris; 1931: founder member of Abstraction-Création; from 1937 curved line compositions; 1949: exhibition with M. Bill and A. Pevsner in Zurich; 1960: participation in the exhibition Art Concret, Zurich.

van Velde, Bram
Born in 1895 in Zonderwonde, Holland. Difficult childhood in Leyden and The Hague; house painter and decorator; 1924 and again in 1936 in Paris; participation in the Salon des Surindépendentes; first single exhibition 1946 at the Mai Gallery, 1952 at the Maeght Gallery.

Vasarely, Victor
Born in 1908 in Pécs, Hungary. 1925–29: studied art at the Bauhaus *Mühely* in Budapest; emigrated to Paris in 1930; worked as commercial artist; 1944: founder member of the Denise Renè Gallery; 1955: yellow manifesto of Kinetic Art, many exhibitions.

Vedova, Emilio
Born in 1919 in Venice. Self-taught; participated in exhibitions since 1936; development from Expressionism and Cubism towards Abstract Art; 1943–44: fought in the resistance; concept of committed art; from 1949 many exhibitions.

Vieira da Silva, Maria Elena
Born in 1908 in Lisbon. 1977: studied art in Paris; married A. Szenès in 1930; exhibitions from 1933 at the Bucher Gallery, and from 1949 at the Pierre Gallery; 1939–46 in South America.

Vordemberge Gildewart, Friedrich
Born in 1899 in Osnabrück, he died in 1962 in Ulm. 1919: studied at the Academy in Hanover (architecture); from 1919 Constructivist paintings; 1924: founder of the 'Group K'; member of De Stijl; 1925–26 in Paris: 1929: exhibition at the gallery Povolotsky, Paris; 1932: with Abstraction-Création, 1936: in Berlin, then in Switzerland; 1938–54: in Amsterdam; 1953: first prize of the Biennale in Saõ Paulo; since 1955 professor at the Academy for Design in Ulm.

Wols (Alfred Otto Wolfgang Schulze)
Born in 1913 in Berlin, he died in 1951 in Paris. Studied photography, then at Africa Institute Frobenius in Frankfurt and at the Bauhaus in Berlin; emigrated to Paris in 1932 where he worked as a photographer: interned in 1939, when he made hundreds of drawings; 1941–44 in Paris; 1942: exhibitions of his gouache pieces at the Parsons Gallery, New York; 1945 and 1947 at the Drouin Gallery in Paris. 1978: retrospective exhibition at the Biennale in Venice.

Bibliography

G. C. Argan, *L'Arte moderna 1770–1970*, Florence 1971

C. Blok, *Geschichte der Abstrakten Kunst 1900–1960*, Cologne 1975

M. Brion, *Geschichte der abstrakten Kunst*, Cologne 1960

J. Claus, *Theorien zeitgenössischer Malerei*, Reinbek 1963

J. Claus, *Kunst heute*, Reinbek 1965

František Kupka 1871–1957, Exhibition Catalogue, Prague 1968

M. and D. Gerhardus, *Cubism and Futurism*, Oxford 1979

C. Gray, *Das grosse Experiment: die russische Kunst 1863–1922*, Cologne 1974

W. Hess, *Dokumente zum Verständnis der modernen Malerei*, Hamburg 1956

Hommage à Wassily Kandinsky, Luxembourg 1976

W. Hofmann, *Grundlagen der modernen Kunst*, Stuttgart 1966

H. L. C. Jaffé, *Mondrian und De Stijl*, Cologne 1967

W. Kandinsky, *Uber das Geistige in der Kunst*, Munich 1912

W. Kandinsky, *Punkt und Linie zur Fläche*, Berne 1964

F. Kovárna, *Mířství ornamentálni a obrazové*, Prague 1934

Lexikon der modernen Kunst, Munich, Zurich 1963

'Malewitsch-Mondrian und ihre Kreise. Sammlung Hack', Cologne, Ludwigshafen. 1976

C. L. Ragghianti, *Mondrian e l'Arte del XX secolo*, Milan 1963

G. Rickey, *Constructivism*, London 1968

W. Rotzler, *Konstruktive Konzepte*, Zurich 1977

M. Schreiber, *Kunst zwischen Askese und Exhibitionismus*, Cologne 1974

Seit 45. Die Kunst unserer Zeit, Bd. I., Brussels 1970

K. Thomas, *Bis heute*, Cologne 1971

I. Tomassoni, *Lo spontaneo e il programmato*, Milan 1970

'Was die Schonheit sei, das weiss ich nicht'. Künstler, Theorie, Werk., Nuremberg, Cologne 1971

W. Worringer, *Abstraktion und Einfühlung*, Munich 1976

'Every work of art starts technically in the same way as the cosmos – through catastrophies which finally, out of the thundering noise of instruments, create a symphony which is called the music of the spheres; to create a work of art is to create a world', declared Wassily **Kandinsky**. Behind this confession hides the meaning of his 'pictorial theme', the many variants of which he composed in the years 1912–14.

The *Painting with a red spot* belongs to the most expressive works of this epoch. Its

1 Wassily Kandinsky
Painting with a red spot, **1914**
Oil on canvas, 130 × 130 cm
Paris, National Museum of Modern Art

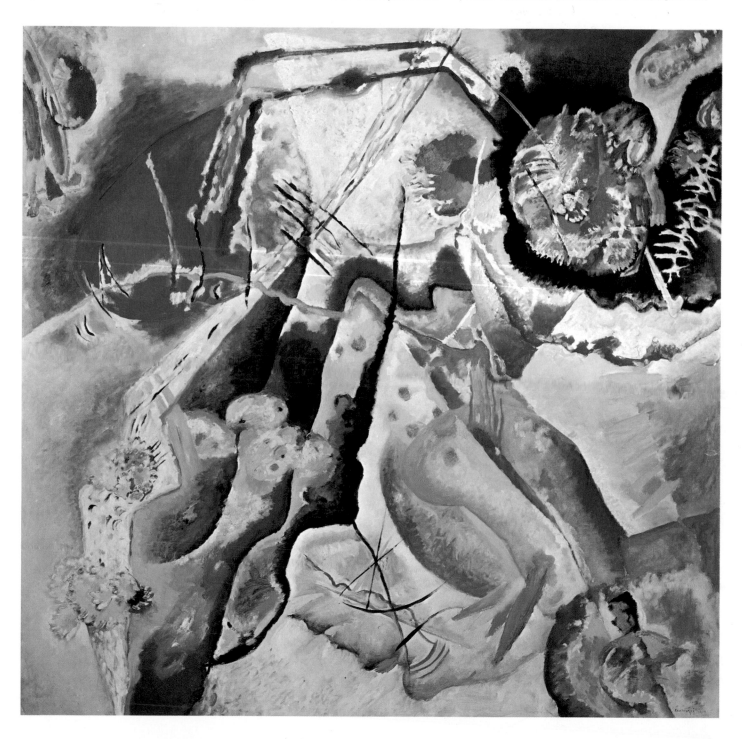

41

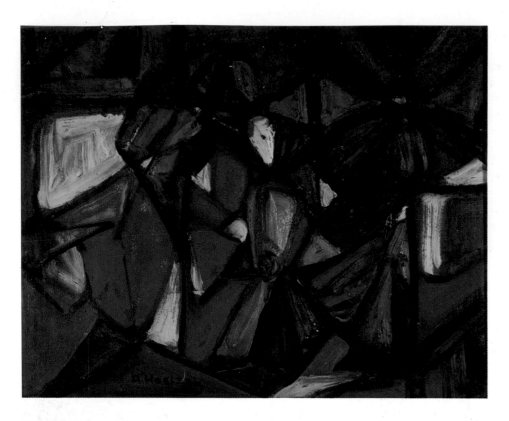

2 Adolf Hoelzel
Abstraction 2, c. **1913–14**
Oil on canvas, 150 × 191 cm
Stuttgart, National Gallery

new suspended signs, unheard-of colour harmonies and emotional feelings are easier to understand if we look first at the *Composition 4* and the *First Abstract Watercolour* (Ill. 3 and 4): both pictures represent a former stage of his development. *Composition 4* still retains some landscape references from Kandinsky's Expressionist Murnau period. The mountains, valleys and trees appear here only in the form of short ciphers and one can imagine the shadows of two pilgrims who wander through this mystical landscape. This motif, as well as a mirage which appears in the structure as on a screen, reminds one, as far as contrast is concerned, of Kandinsky's illustrations for Russian fairy tales (1903–05). This fairy-tale-like imagination also inspires a series of *Improvisations* in which the romantic idiom (horsemen, castles, cliffs) appears in a strongly denaturalised form. Kandinsky, as a

follower of theosophy, visualises the 'resounding spiritual world'. His *Composition 4* is the equivalent of a lecture on the theme 'how to compose dynamically'. The strong black lines dominate and give rhythm to the colourful light and dark contrasts. The diagonals of motion dominate. They cut the 'blind' angles off, lead to the heart of the painting and steer the movements and tensions of the passionately razzled colour forms, which, however, obey certain rules.

How far are these rules related to the rules of musical concepts? We already have to ask this question about the predecessors of Kandinsky; it applies to the Lithuanian composer M. J. Čiurlionis and further to Adolf **Hoelzel**. This painter, who belongs to the generation of van Gogh, Gauguin and the Symbolists, had his own school in Dachau. He worked out important theories

for pedagogical purposes, in particular colour composition theories. His results were not unknown and were the reason for his being called to the Academy in Stuttgart (1905). On the other hand the consequence of his own theories led him to non-representational compositions and painting on glass. A stained glass structure can be detected in his *Abstraction 2* (Ill. 2), which was created seven years later.

The original flower and butterfly motif was stylistically unified by several layers of paint; now the composition revolves around the contrast of blue and red which is the strongest of all contrasts and offers us Hoelzel's colour range. He himself said: 'The world of artworks is contained in the idiosyncratic use of the artistic means. This opens up the possibilities of physical and metaphysical content. . .' Hoelzel's opinions were taken up at the Bauhaus, where his theories influenced J. Itten, O. Schlemmer, W. Baumeister, I. Kerkovius, and others who studied with him. How far was Kandinsky familiar with Hoelzel?

The *First Abstract Watercolour* by Kandinsky has been mentioned above. It can be interpreted as a plunge into the deep naïve layers of the soul, an attempt to reconstruct primary aesthetic responses to reality. Are these sounds and syllables which cannot yet form words and sentences? According to another opinion we are faced with a dissected message, with 'bits of words without syntax' (Hoffman). At any rate this watercolour was not the product of chance but a protest against the prevailing fashion of Art Nouveau, the crammed surfaces of the Cubists and the deformed figures of the Expressionists; it was a step away from fossilised form into a realm of open relationships, into a world of unfettered elements.

Kandinsky was able to realise the technical side of their visual properties all the better by using this liberating probe. A sheet of paper, for example, is nothing in itself but may become everything. When the sharp lines of a pen or the soft strokes of a brush interrupt its surface the sheet itself becomes a symbol of many meanings. Even

the dots of colour are uneven. The longer transparent strokes of the brush are suspended at a certain depth and seem to form the base of a fluid space. Smaller and more intensive colour dots, some of the red-blue contrast, move to the fore-ground and can almost be physically grasped; haptic linear signs and long brush strokes set this drawing into motion – they are more energy than form. The sheet of paper becomes a field of energies, a real fragment of the sur-rounding space. Thus come into being the new words, the increasingly new interpreta-tions which can then be seen in masterpieces, like *Painting with a red spot*, where they form a winged dramatic poly-phony. It is a feast, a homage to Romanticism which culminates in a display of colours like a firework. All Kandinsky's compositions show a similar 'ceaseless flood of primary phenomena'; a colourful echo resounds in a chromatic continuum which is often interrupted by cloudlike pre-morphic zones.

The strong rhythm of these pictures is caused by the different ways of painting: here full of temperament, there carefully thought out, quite often also the result of a quick decisive act. It is these spontaneous, impulsive reactions which bring out the inner voices and which lead to the discovery of new metaphors. These extremely fast acts of painting do not lack inner coherence: they are stimulated first of all by a sudden intui-tive realization of the wholeness of nature and by a spontaneous emotion. The next moment ignites in the painter a strong sense of longing which liberates itself by an

3 Wassily Kandinsky
The first abstract watercolour, **1910**
Paper, 50 × 65 cm
Paris, Nina Kandinsky Collection

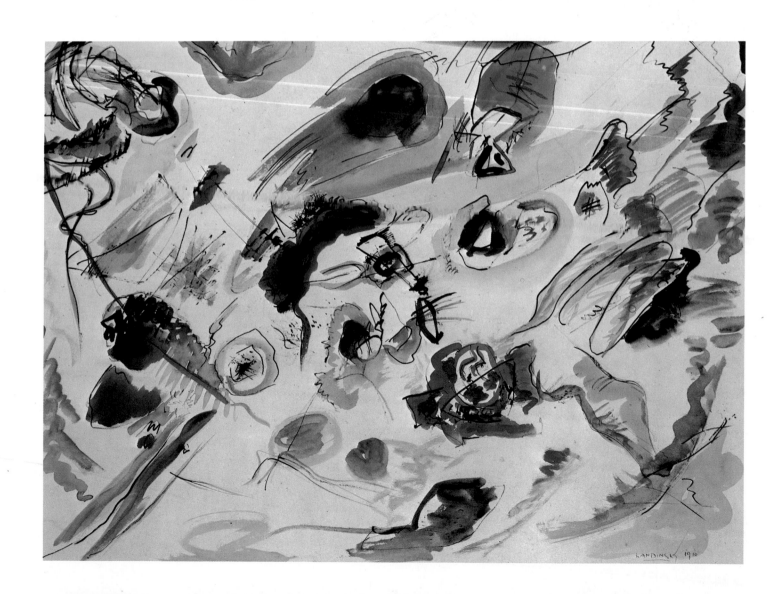

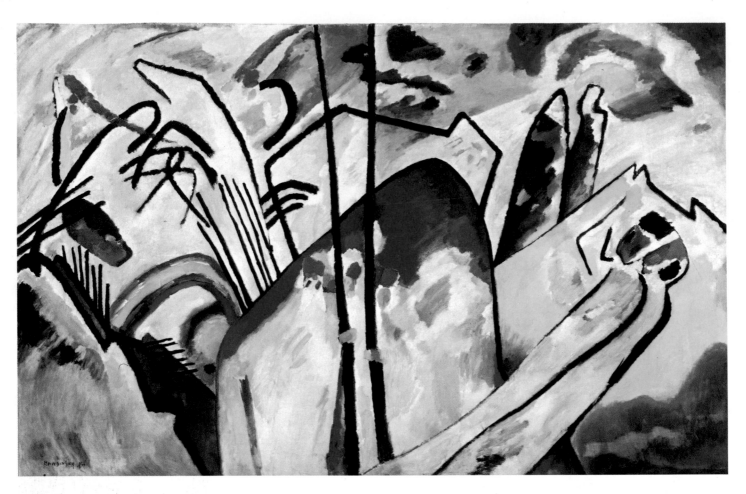

4 Wassily Kandinsky
Composition 4, **1911**
Oil on canvas, 159·9 × 205·5 cm
Düsseldorf, Art Collection of
Nordrhein-Westfalen

immediate act of painting. This phenomenal immediacy – from the emotion to the visible trace – without thinking, without the detour of natural figuration, this was a further historical discovery of Kandinsky's. Such painting becomes an existential event.

The beginning of the war ended Kandinsky's great stormy period. In 1914 he went back to Moscow. *Red spot* (1921) and *In Blue* (1925) introduce us to a different Kandinsky. The orphic poet and avant-garde leader now becomes a scientist of artistic language and endeavour. At 52 he was appointed by the revolutionary government to a professorship and made a commissioner responsible for the enlightenment of the people. In 1919 he founded the Museum for Artistic Culture, and by 1921 he had started twenty-two provincial museums. In 1921 he founded the Art Academy in Moscow, but difficulties of many kinds were proving too

much for him. At the end of the year he left Russia for ever with his wife Nina, he stopped in Berlin and then went to Weimar where he was appointed a professor at the Bauhaus.

The large painting *Red spot* came into being during the difficult months before his emigration. He painted it at a time when the slogan 'easel painting is dead' had paralysed the entire Russian avant-garde. This composition reminds one of the view a trapeze artist has looking down to the ground: there, a splendid parade of forms is in circulation. They have simple cut-out silhouettes and they contrast clearly against the tender, light background. How far are we removed now from the stormy primeval chaos and the force of cloud formations!

It has been mentioned often that this different Kandinsky let himself be influenced by the Suprematism of Moscow. But next to 44

geometrical patterns on the surface and the 'eternal' space in the background, here too he is the magnificent Kandinsky of simultaneous tensions, of diagonals and charming accentuations; it is he, the exotic narrator of events, and they bear the stamp of his idiom. It was these signs in particular which he developed during his time in Paris (Ill. 7).

Now the quickened colour forms are able to express finer shades of emotion, but according to the laws of contrast it is a loud red which enables us to 'hear' the stillness of the surrounding space. A red spot, a half-ellipse or a disc became motifs as near to Kandinsky's heart as had been the horsemen in 1912. 'Red contains effervescence and flow, it moves much more inwards than outwards, it is male energy'. Kandinsky wrote, 'Light, warm red appears decisive, loudly triumphant like fanfares! Vermilion is like a slowly burning passion, tubas and strong drumbeats. . . . Strong red can be deepened, which increases its intensive fire, it cowers ready for a wild jump, it sounds like passionate deep cello tones. Brightened up it appears youthful, full of joy like the clear singing sounds of a violin or small bells'.

Different grades of red which are further influenced by the surrounding surfaces can be seen in the Bauhaus painting *In Blue* (1925). Many of the geometrical motifs of

5 Wassily Kandinsky
In Blue, **1925**
Oil on carton paper, 80 × 110 cm
Düsseldorf, Art Collection of
Nordrhein-Westfalen

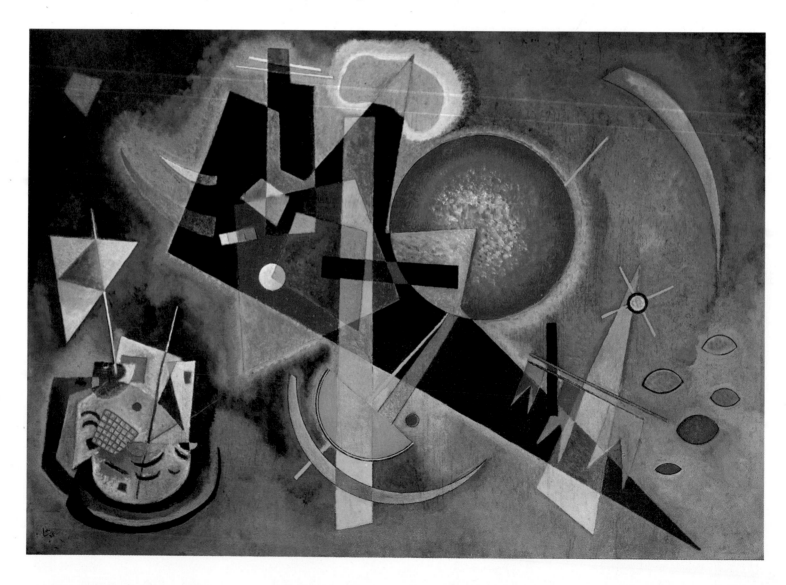

45

the Suprematists are given a different value here and set into a tighter, organic and dramatic way. One could look up the individual interpretation of these signs in his pedagogical book *Paint and line in relation to surface* (conceived in 1914, published in 1926). In this painting a particular contrast appears, namely that of triangle and red disc; let Kandinsky himself explain: 'A vertical line which joins a horizontal one brings about an almost dramatic sound. The touching between a triangle and a circle has a similar effect to that caused by the finger of Adam touching that of God in the fresco by Michelangelo. And if the fingers are not so much anatomy and physiology but some-thing more, namely artistic means, then circle and triangle are more than geo-metry, they are the artistic elements. . . Mathematical mathematics and artistic mathematics are totally different areas.'

The joyful composition *Blue sky* was painted by Kandinsky in 1940 in Paris, where he had been living since 1933 in rela-tive isolation. His primary signs became complicated amoeba-like configurations. Are these signs of things remembered from his earliest childhood? It has been said that the paintings of his last period present our eyes with unreachable seascapes. If this is true then we are probably faced with the 'aquaria of his childhood'.

6 Wassily Kandinsky
Red spot 2, **1921**
Oil on canvas, 138 × 181·6 cm
Paris, Nina Kandinsky Collection

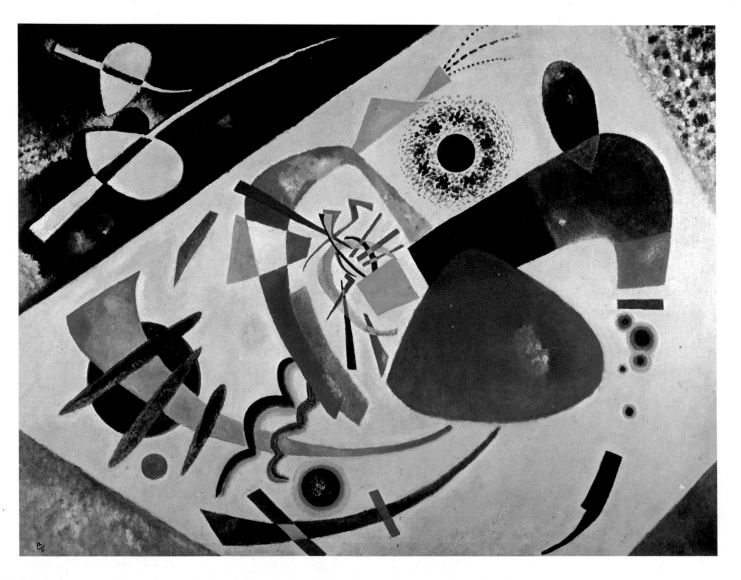

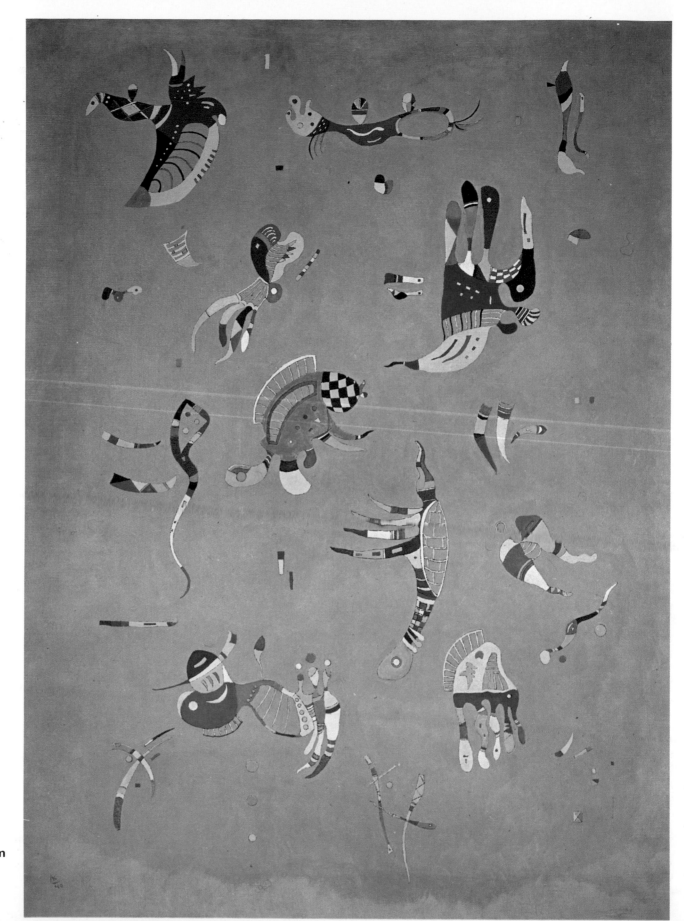

7 Wassily Kandinsky
Blue sky, **1940**
Oil on canvas,
100 × 73 cm
Paris, National Museum
47 **of Modern Art**

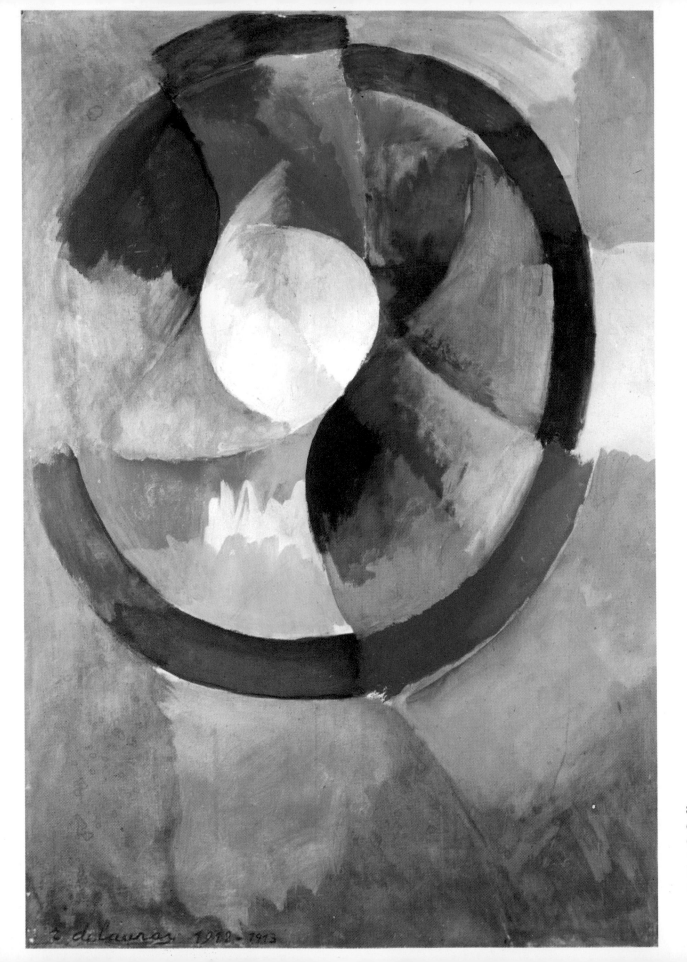

8 Robert Delaunay
Circular forms, **1912–13**
Oil on canvas
100 × **68·5 cm**
Paris, Sonia Delaunay
Collection 48

The two paintings by Larionov and Delaunay attempt to interpret the vast theme of light. Both painters felt the decisive super element of light to be a cosmic energy, which ceaselessly stimulates life with its dynamism and rhythmic change. How differently the two painters look at this! Larionov, who had been occupied with rough, popular primitivism, here took a full jump into the non-representational; this included Futurist elements.

Robert **Delaunay**, a poet of pure colours, had experienced the Neo-Impressionist way of seeing; he had also come back from a jaunt into Cubism armed with the concepts of geometrical structure and simultaneousness. But while the Cubists sectioned off their models through layers of space and painted in grey-brown tones, the Orphic Delaunay ignited his *Eiffel towers* and *Simultaneous Windows* like rainbows. This was a lyrical revelation. Amongst the numerous admirers of Delaunay were Marc, Macke and Klee. By means of the non-figurative *Circular forms* (Ill. 8) Delaunay interpreted a cosmic metaphor, which comes close to the Chinese Yung-Yan, the symbol of universal contradiction. While Delaunay saw the universal contrast as a whirling propellor, Larionov conceived a cosmic rain of light and shadow. In Delaunay's work centrifugal curves arise from a burning sun-like centre, set themselves in contrast to circles and originate the vibrations of the prismatic colours. In Larionov's painting diagonal light rays cut across each other. On the left the blue rays of night predominate; on the right is a stream of daylight; the in-between area is indicated by the rhombic forms of reality. Small 'notes' fly through this world of rays like meteorites and make it sing.

Delaunay's paintings — even those executed during his second abstract period after 1930 — can be recognised by a trademark, a painted circle, which he reduced from an original whirl.

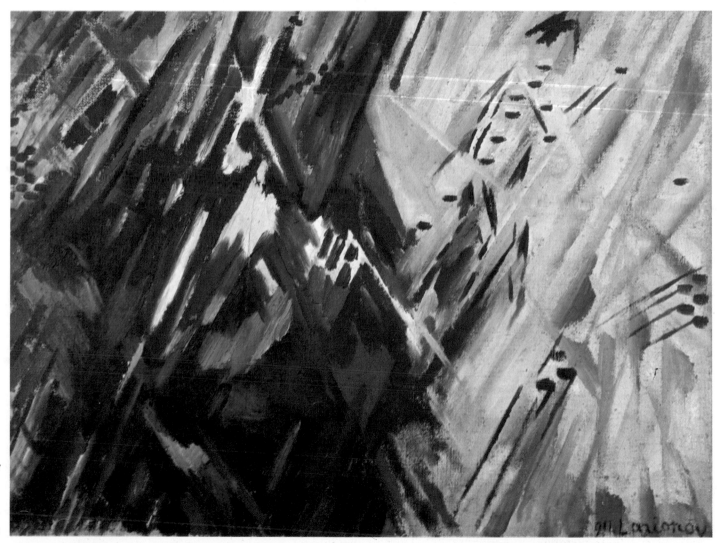

9
Michail Larionov
Rayonism, **1911**
Oil on canvas,
54 × 70 cm
Artist Collection

10 František Kupka
Compliment, **1912**
Oil on canvas, 111 × 108 cm
Paris, National Museum of Modern Art

Michail **Larionov** and his friend Natalia **Goncharova** painted the first Rayonist works in 1910–12. In 1912 they exhibited for the first time and published the manifesto of Rayonism in 1913. There one reads, among other things, 'For simplicity's sake we express the ray on a surface with a few lines of colour. The objects which we see in everyday life do not matter in Rayonism ... The painting has in a certain sense something fluid, it gives us the sensation to be outside time and space, the feeling of what one terms "the fourth dimension"...'

By strengthening the impulse of motion, Delaunay and Larionov have reaffirmed and developed the Futurist contribution from a different angle. This was an important preamble to the later Kinetic experiments. In 1914 Larionov and Goncharova went to Paris where they were welcomed by the poet and spokesman of the Parisian avant-garde, Apollinaire, and were regarded as important discoverers. During the long-lasting co-operation with S. Diaghilev's 'Society of the Russian Ballet', Larionov was influenced by folklore in his costume designs and used Rayonist concepts to create innovative theatre designs.

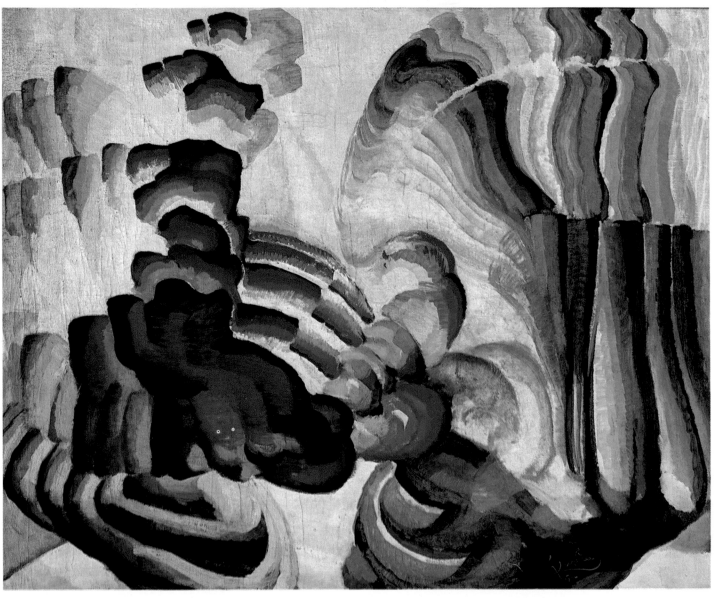

František **Kupka**, who had painted *Nocturno* and other non-representational pictures already by 1910, had been occupied for some time with thoughts about the absolute eternal and metaphysical. We find these spiritual preoccupations already in his Symbolist illustrations. Since 1903 he had tirelessly tried to represent the elements of time and motion, as well as those of musical movement. He wrote in 1905: 'I don't think it is necessary to paint trees, as people can see better ones in the original on their way to the exhibition. I do paint, but only ideas, the synthesis; if you want, the chords.' His musical interests and his philosophical thoughts were for him, as for Kandinsky, a bridge to the 'absolute'; Kupka had taken both a theoretical and a painterly path to the absolute. *Vertical surfaces 1* (1912, Ill. 11) continued the problems of his earlier *Keyboards*. Although they may express a softening of tone, nevertheless a vertical pillar creates an imaginary architecture. Kupka was the first abstract painter who only used geometrical elements.

In the 1912 Salon d'Automne in Paris two related paintings by him caused a sensation. The public was faced with abstract painting for the first time. Now began the days of mockery and destructive criticism, which Kupka lived through with his strong faith unshaken. But there was also half-official recognition for his daring, innovative art. One of the two paintings *Amorpha, Fugue in two colours* (Ill. 12) may remind us — with its three great contrasts — of Delaunay's *Circular forms*. Only here the emotive, spontaneous, Orphic elements are largely subordinated to speculative construction. The circles and curves of this configuration, which, like those by Rodschenko, is drawn mechanically with a pair of compasses, determine the tragic contrast between the spheres of light and deep night, between blue and red streams whose interaction symbolises a fugue.

A further Orphic path led Kupka to the painting *Compliment* (Ill. 10). This extremely dynamic vision belongs to the series of so called 'created motifs'. The large, cloud-like cascades attain through their wide, gleam-ing range of colours an unbelievably lyrical effect. Only the masterpieces of Kandinsky, or those of the 'inobjective' Delaunay, stand up to this competition. Here the

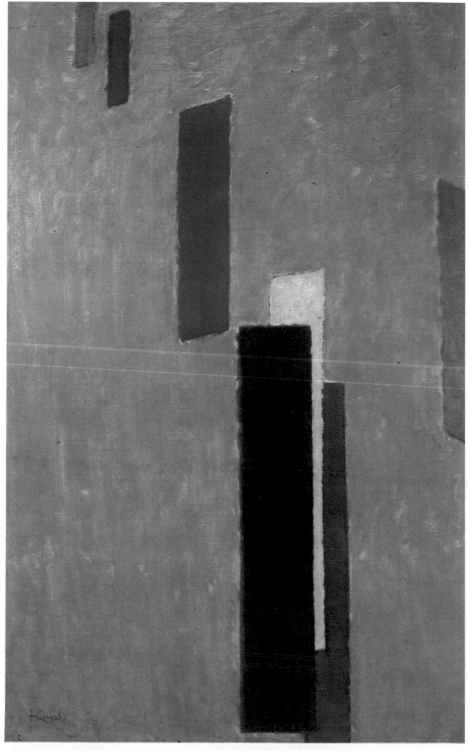

11 František Kupka
Vertical surfaces I, **1912**
Oil on canvas, 150 × 94 cm
Paris, National Museum of Modern Art

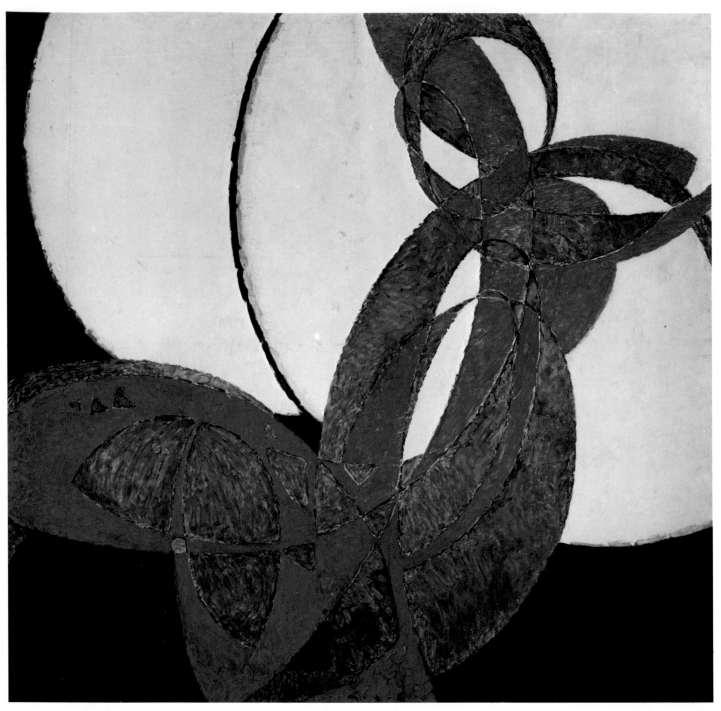

12 František Kupka
Amorpha, Fugue in two colours, **1912**
Oil on canvas, 211 × 220 cm
Prague, Národni Gallery

morphological, indeed vegetative, primary images determine the composition, not the architectural elements, which occupy the foreground in other paintings.

Compliment was probably based on a 'cosmic experience' which was not founded on scientific observations and methods but rose in a grandiose way out of his feelings and intuition.

Kupka, who never betrayed his visions in spite of unbelievable difficulties, was to receive real recognition only as an old man. The paintings he left us are the richest from a thematical point of view.

The small painting of Edward **Wadsworth** (Ill. 13) stands here as symbol of the great multitude of abstract attempts which were carried out between 1912 and 1918 in Europe and America. For many Americans such as Max Weber, Dove, Walkowitz, especially for the bold Hartley, and furthermore for the Synchronists MacDonald Wright and Russel, it was an adventurous excursion. The scene in Paris around 1910–12 and the unforgettable Armory Show of 1913 in New York provided the first points of reference.

England saw the foundation of an avant-garde inspired by the Futurists and called Vorticism. An anti-cubist, dynamic balance informs the Wadsworth composition. The jagged rhythm and the growing and sinking away into a whirl, an epicentre, shows the architecture of Vorticist ideas. The artist wrote: 'A painting is first of all the animation of a dead surface through the rhythm of colours and forms in space.'

13 Edward Wadsworth
Abstract composition, **1915**
Gouache, 42 × 34 cm
London, Tate Gallery

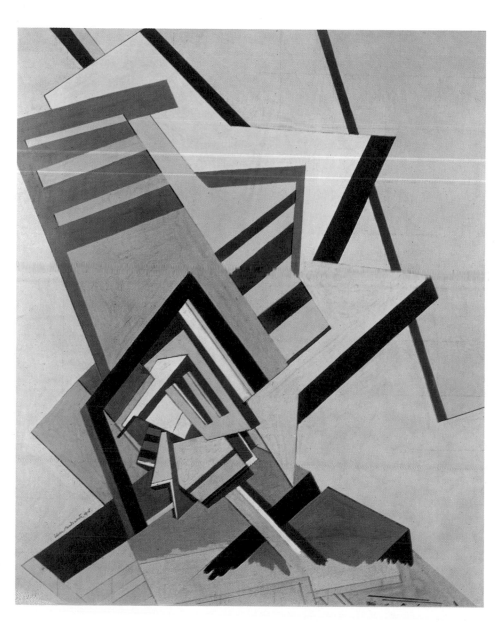

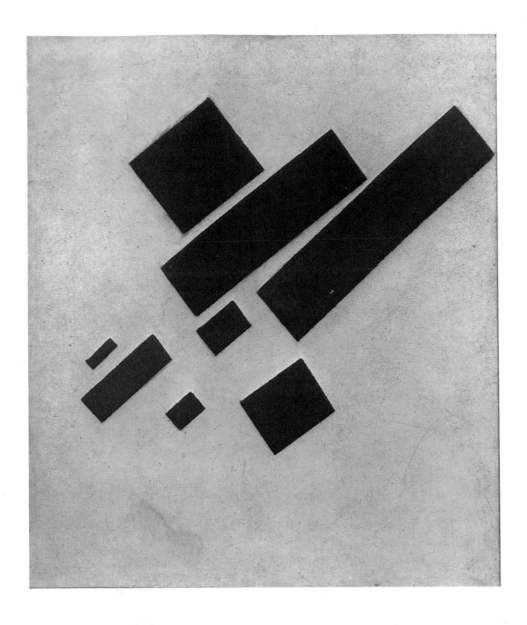

Thus equipped Kasimir Malevich started on the path towards his prophetic vision. During the decisive period of 1912—15 this friend of Larionov created his own version of Cubism and discovered at the same time the horizons of the non-representational. This was the result of several factors: a further Cubist geometrical reduction as well as the inclusion of the dynamic feelings of the Futurists and other neo-platonic and theosophical attitudes. Most important, however, was his particular disposition: he had the mighty intuition of a genius, he longed for pure emotions, for a totally liberated world. 'It is only the timidness of consciousness and the artist's own mediocrity which led him to be deceived and create an art from the forms of nature, from the fear to lose the fundamentals on which man and the Academy originally based their art. . . . I have broken the charmed circle and have escaped the tyranny of objects; the charmed circle which encloses the artist and the forms of nature' Malevich wrote.

Already in 1913 Malevich — partly through a study of stage design — had arrived at the three basic forms: cross, circle and square. The square was to him a 'zero form', 'the majestic, newly-born' of the liberated world, for 'behind zero lies the way to new methods of creating', the way towards Suprematism, the beginning of a 'new culture'.

By 1915 Malevich was already exhibiting some twelve Suprematist compositions, among which *Eight red rectangles* (Ill. 14).

Here the whole magic of a feeling for life which had shed the fetters of utilitarianism was already displayed. It was not so much the geometric form, which expresses only objectivity, but an emotion he called 'a feeling of pure non-being' expressed in the movement of colour-forms which was the most important thing. A Suprematist construction is based first of all 'on the weight, speed and direction of motion'. So it is the diagonals, i.e. the curves of motion, which we are meant to participate in through the flying groups of rectangles. It is enough to make one giddy. Who would not imagine

14 Kasimir Malevich
Eight red rectangles, **before 1915**
Oil on canvas, 57·8 × 48·5 cm
Amsterdam, Stedelijk Museum

There are several cases in the history of art where the fact of someone not quite grasping an idea did in fact lead to a step forward in the development of art itself. The 'case of Malevich' is one of the most interesting. Standing at the crossroads of contemporary philosophic and religious thought in Russia, and influenced by Expressionism, Cubism and Futurism, **Malevich** produced a few undogmatic but very personal and strange 'shortened versions' of these currents, which have brought the professors to the brink of despair.

orbiting satellites which are being built into a space station. *Supremus no. 50* (Ill. 15) again points to this solution, by which Malevich was troubled as by a utopian vision. Apart from several sketches in pencil there is also a description of these 'new machines', so called *Planiten* – an interplanetary architecture. This new architecture of space cities was supposed to influence architecture on earth – a futuristic thought very much in line with the great revolutionary changes of the time. These visions of Malevich, who considered himself a citizen of the planets, were not meant in an anthropological sense but more in a cosmic and absolute way. In this same way he was also to deal with the art of painting. In his 'white on white' compositions of 1914, he not only reached the extreme point of re-action, but also touched upon the ideal of light characteristic of oriental wisdom. Here, six years after the black square, Malevich reached the final step in painting. The rough brush has replaced the pointed pen of the theoretician and utopian thinker. Malevich's feeling for form and his thought survived his bold but nihilistic decision in the works of his followers (such as Popova, Lissitzky, Moholy-Nagy, Ad Reinhardt). How far was such a decision influenced by the mere pragmatism of the hungry years of the revolution? What merit did the contrary 'materialism' of the Constructivists, with its one-sided cult of architecture, production and work, achieve here? As against the Suprematist idealism and the pure expression of feeling, there was always the increasingly sharp opposition of Tatlin's 'fetishism of the material' which wanted to negate the social values of production in the manner of an industrial designer.

The obvious contradictions between Suprematism and Constructivism were not so sharp in the work of the students of WCHUTEMAS and INCHUK. El **Lissitzky** is an example of this kind of work (Ill. 20). While he was already propagating Constructivist ideas in the west with the journal *Wjetch – object* , as an artist he was still thinking in the Suprematist way.

55

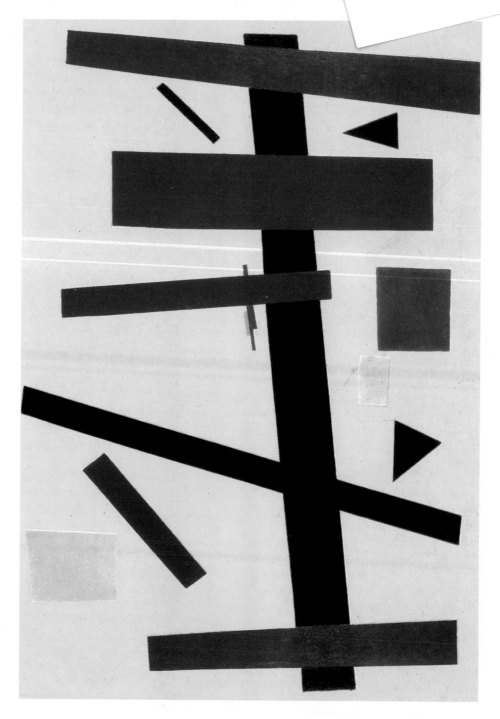

15 Kasimir Ma
Supremus no. 50,
Oil on canvas, 97
Amsterdam, Stedel

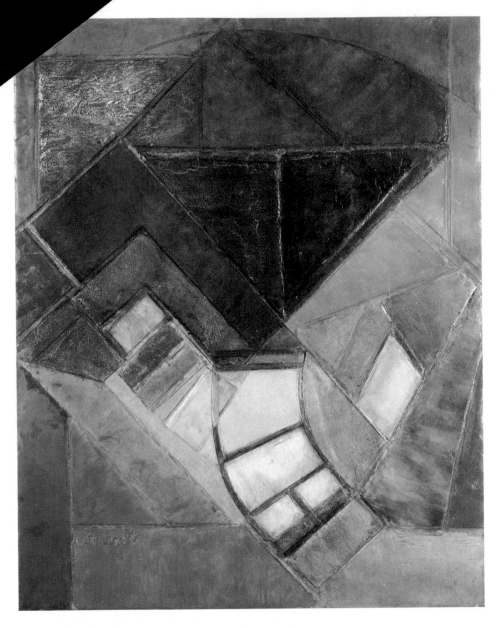

16 Antoine Pevsner
Grey scales, **1920**
Oil on canvas, 62 × 48 cm
Private Collection

Ljubov **Popova** (Ill. 18), the most gifted of Malevich's followers, tried to vary the Cubo-Futuristic formulas and to paraphrase Tatlin's contra-relief in painting. The example of Tatlin is clearer yet in the watercolour of **Rodschenko** (Ill. 17); but this configuration, which looks as though it had been created by an engineer, has much more of the spirit of Suprematism than of the products of 'the culture of Malevich'.

As a contrast, the *Grey scales* (1920, Ill. 16) of Antoine **Pevsner** is a pure crystal of Constructivist materialism — although in the same year the painter clearly turned to Realism in the famous manifesto.

Antoine Pevsner and Naum Gabo, after lengthy studies abroad during which they looked at examples of Cubism and Tatlinism, clearly expressed their opposition to the political opportunism of the Social Constructivists. They found the short-sighted dilettantism in the ante-chamber of industrial production particularly disgusting. They were looking for a general approach; they did not want to design individual objects (such as chairs, tables, lamps or a house) but reach the great laws and energies of reality through repeated 'constructive' renunciations. Therefore they put together the following basic principles: '1. We reject colour as an artistic means. Colour is the idealised, optical face of objects, it gives an external and superficial expression. Colour is accidental, it has nothing to do with the inner essence of things . . . 2. We renounce the expressive quality of a line . . . we assert that a line only indicates the general direction of static energies and their rhythm in objects. 3. We reject volume as an artistic and plastic spatial form . . . we assert that depth is the only artistic and plastic spatial form. 4. We reject mass as a plastic element. . . . We take four surfaces and from them build the same volume as from four tons of mass. Therefore we give back to sculpture the line as an indication of direction and therewith declare depth to be the only form of space. . . .'

While we can demonstrate these demands with our illustration, it is the fifth

point which broke new ground, the rejection of up-to-now static art: 'We see in sculpture a new element, the kinetic rhythms, we take them to be the basic form of our perception of real time'. This meant the birth of Kinetism which became an independent art form after 1955.

The sculptor N. Gabo, and A. Pevsner, who also soon became, in Paris, a constructive sculptor, followed their ideas up with further innovations, for example Topology (the creation of space). They also modified the position of the Constructivists. The artist is an intellectual who conducts scientific researches in the aesthetic field. The objects constructed by him have no value as such but are only valid as instruments to demonstrate the results of research. From this it followed that 'the technological civilisation is not aesthetically sterile, and the beginning of science does not mean a suppression of art' (C. Argan).

It was to take almost 40 years for these theories to be creatively realised by 'visual research'. Art was not destroyed by the steamrollers of technology, something many of the Russian Productivists, including Rodschenko — a brilliant photographer — seemed to wish for.

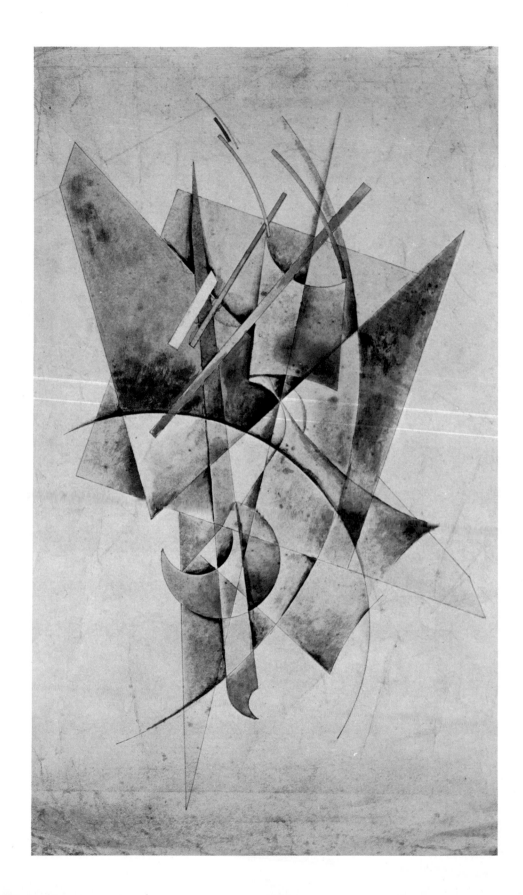

17 Alexander Rodschenko
Without title, **1917**
Watercolour, 60·5 × 34·5 cm
57 Cologne, Gmurzynska Gallery

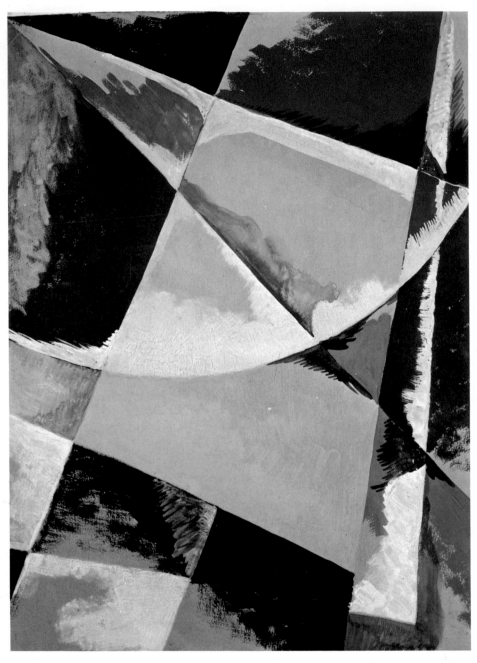

18 Ljubov Popova
Gouache, **1914–16**
46 × 34 cm
Private Collection

El **Lissitzky**, after studying architecture since 1914 devoted all his energies to the avant-garde; he worked on illustrations for children's books and was enthusiastic about Malevich's thoughts and paintings. These two were fused in the design for the book *Of two squares* (1920; published in 1922 in Berlin). Ill. 20 shows us the third page of the tale *For all the little children*. The text reads: 'Dont read, take paper, sticks and squares of wood; fold it, paint them, build. Here are two squares – they fly from far away towards the earth, and fearfully – they see black. A bang – everything falls about and on the black surface red appears, clearly. Here is the end.' This was more than a children's book; it was, with a subtle political purpose, a dialectic instruction for young Constructivists, a new kind of publication which also brought about a typographical revolution. El Lissitzky, who worked with western Constructivists as an ambassador of Soviet avant-garde culture, introduced a series of innovations (for example in the design of exhibitions) which were appreciated in central Europe and imitated.

Next to Poland, where the followers of Malevich created authentic movements (Unism, Strzeminskis and others), Hungary developed a Constructivist centre, especially around the unique personality of Lajos **Kassak**. This self-made man, writer and editor of the legendary journal *MA* (*Today*, 1916–25) worked with Moholy-Nagy, Bortnyk, Béothy, and L. Péri. In his collages and graphic work the influences of Synthetic Cubism, Constructivism, and Dada come together. Single words, and the fragments of words, had the effect of magical incantations. When he abandoned experiments in art for literature in 1928, many non-figurative Hungarian artists were already playing an important role abroad, in Paris and at the Bauhaus in particular.

19 Lajos Kassak
Collage no. 22, **1922**
39 × 31 cm
Paris, Denise René Gallery

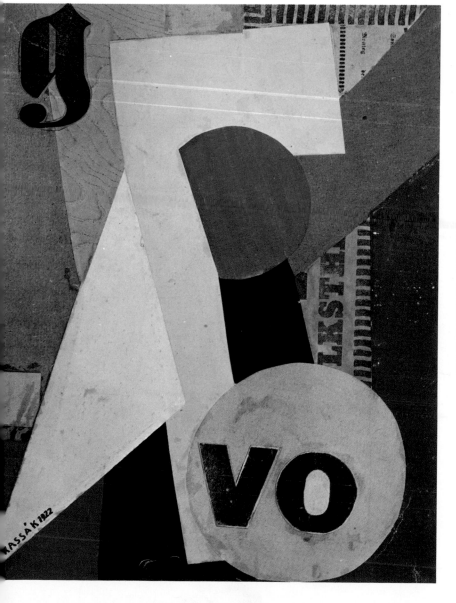

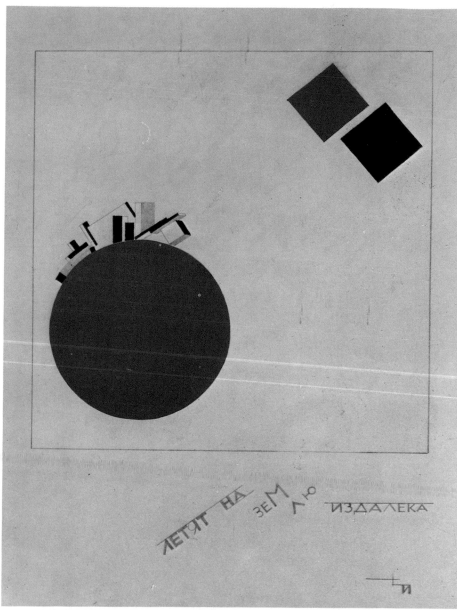

20 El Lissitzky
Study for the page of the book
'A suprematist history of two squares in six constructions', **1920**
Watercolours and pen on carton paper, 17 × 17 cm
New York, Museum of Modern Art, Sidney and Harriet Janis Collection

21 Piet Mondrian
The grey tree, **1911**
Oil on canvas, 78 × 106 cm
The Hague, Municipal Museum

Piet **Mondrian** drew his inspiration from similar sources as the Russian Malevich. But how different were the results of this Dutchman who thought in the spirit of Jansenism and Spinoza. Already a mature man and recognised painter of landscapes and flowers, he left this successful career and went to Paris in 1911. The Cubist desire to conform to natural laws had captured him. But the acute critic Apollinaire soon perceived that this stubborn Dutchman had designed his own Cubism. In fact Mondrian was simply more consequential. At a time when even the Cubists were slowly returning to the figurative representation — particularly through the montage of reproductions and letters — he concentrated all his energies on the uniform non-representational structure of the painting. He said later: 'The Cubists retained the

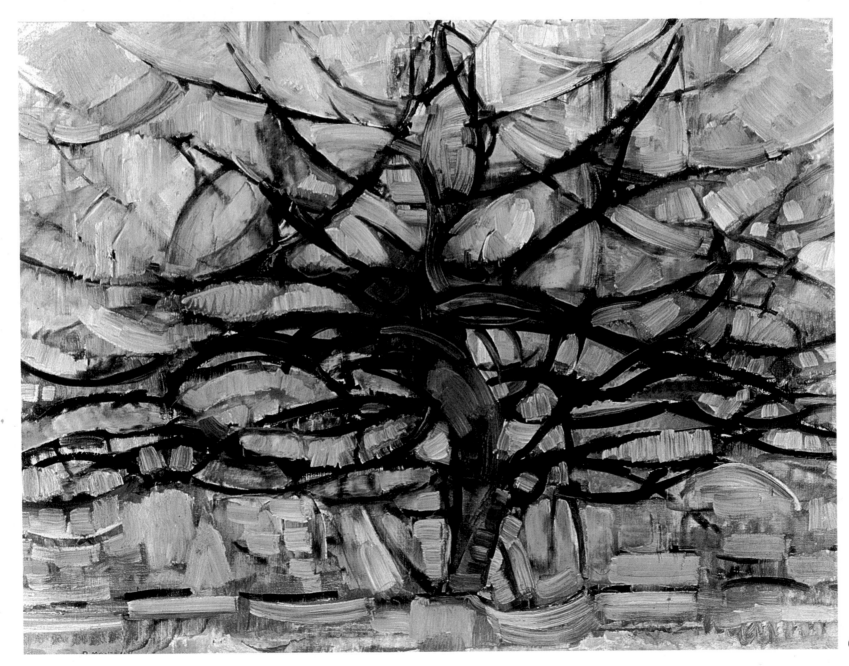

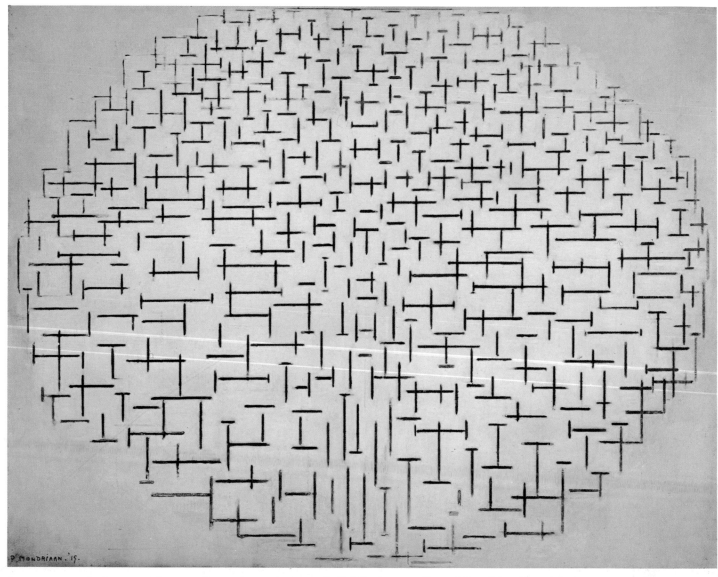

three-dimensional space ... their way of seeing remains deeply materialistic; my thinking on abstraction, on the other hand, rests on the belief that such a space must be destroyed; to achieve the destruction of the object I have reached the point of using surfaces'. *The grey tree* (III. 21) betrays his starting point: it represents a renunciation of beautiful colourfulness and the introduction of what is unique. Mondrian, who was thinking anthropologically, was looking for the essence, the unchanging aspects. He 'distilled' the same motif methodically – first the apple tree, then the church, the harbour – in several paintings until he arrived at a

configuration, a 'magnetic field' of generally applicable relationships of the natural order which were contained in the motif. His solutions came close to the realisation that the logic of a painting and the structure of an act in the natural world are governed by the same constant law. His friend, the philosopher Jan Schonemaeker, supported Mondrian's search. According to him all structures are based on a mathematical principle. This thesis informed Mondrian's main aim too: to give shape to the underlying laws.

The years between 1914 and 1921 are those of his first non-representational

22 Piet Mondrian
Pier and ocean, composition no. 10, **1915**
Oil on canvas, 85 × 105 cm
Otterlo, Rijksmuseum Kröller – Müller

61

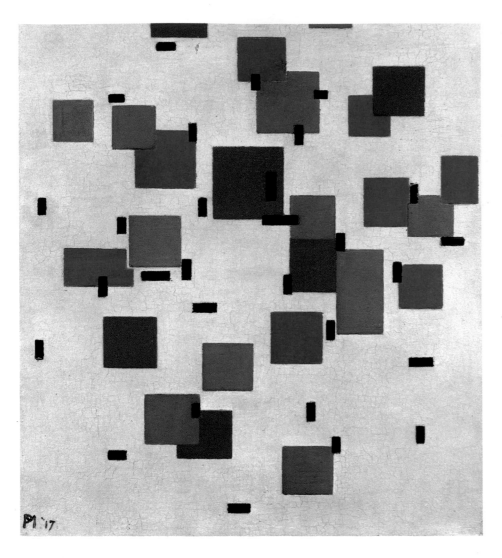

23 Piet Mondrian
Composition in blue 3, **1917**
Oil on canvas, 50 × 44 cm
Otterlo, Rijksmuseum Kröller – Müller

period; it was a time of many different experiments and much thinking. During the war he stayed in the neutral Netherlands by chance. There he made friends with kindred spirits, such as Bart van der Leck, the agile Theo van Doesburg, the poet Kok, the architect Oud and others with whom he founded the journal *De Stijl* to voice the common theoretical thoughts. This circle also founded one of the most important western Constructivist movements, Neoplasticism. Mondrian's theoretical work, published in 1920, was the result of this first period of abstract research.

Pier and ocean, composition no. 10 of 1915 is one of a series of paintings which have been termed 'plus-minus' (Ill. 22).

From single but still figurative drawings, which he sketched under the open sky, Mondrian derived a unison of the natural laws of the world. Thus the 'plus-minus' signs are the result of a reduction of nature, already symbols of the primal contradiction, the horizontal and the vertical principle. Mondrian was a follower of the neo-Platonists who believed that the outside is indicative of the inside. The inside, the inner, underlying principle is the true reality. How can one get to it? Mondrian answered: 'I feel that it can only be reached by means of an increasingly pure act of creation, but it must not be influenced by subjective emotion and ideas. I have tried for a long time to discover those particular aspects of form and natural colour which cause, subjective feelings and states of mind and impair the vision of pure reality.

Behind the changing natural forms lies unchanging pure reality. Therefore one has to reduce natural forms to their pure and unchanging condition.'

One of the possible motivations of the last sentences can be found in the composition *Composition in blue B* of 1917 (Ill. 23), which may perhaps remind one of an architectural design, but was created without any model. A certain similarity with the paintings of Malevich cannot hide the differences. While Malevich expressed a dynamic feeling through diagonals and dissimilarities, Mondrian aims at constancy. It was his dream to achieve the unchanging principle of harmony, to reach the ideal of perfection and put it 'above all mundane misery' and tragedy. In a certain sense he was a classicist, a successor of architects like Palladio; this was why everything emotive or even dramatic, which was the strength of someone like Kandinsky, filled him with horror. Mondrian's dogmatic insistence on this ideal of beauty led to the break up of his friendship with van Doesburg. When he was back in Paris in 1921 Mondrian found his definitive universal formula: it was a kind of lattice which consisted of eight elements (Ill. 24). 'In my early paintings', Mondrian wrote, 'space still provided the background. When I

felt a lack of unity I brought the right angles together and the space became white, black or grey, the colour red, blue or yellow. The rectangles were negated as forms and neutralised. . . .'

Mondrian's visual language was not rich, but it allowed countless variants which were probably meant to express one thing only: the unchanging structure of consciousness. He varied the distances of co-ordinates in the 'lattice' which resulted in different relationships of the squares. In fact different points of perception were given, which always produced harmony. It is the kind of harmony which immediately assures us: the vertical lines correspond to the uprightness of our bodies, the horizontal ones to the ground; we gain the secure position of someone who is in a safe internal room. This assurance stays constant even when the square of the painting is turned on its corner (Ill. 26).

What more does Mondrian show us through his variants (1921–1940)? Firstly: the effect of the primary colour changes with expansion and form. Secondly: two zones of different size can express the same value by having a different depth of tone. Thirdly: harmony is achieved by means of squares of different size, that is to say by dynamic contrast.

The idea of a natural order which had been intellectually deduced from nature was made concrete again by Mondrian. This corresponded to his strict ethic: our actions must have the same clarity, absoluteness and inner truth as our thoughts. Thus we may understand why he believed that the Neoplastic works of art were feeding back what they had received from nature.

Like Malevich in 1919, Mondrian often reached a point when he thought he had come to his 'last painting'. In 1931 it was the *Composition with two lines*, in 1939–40 a series of severe paintings without colour (Ill. 25). He was already on the move by then; from 1938 on he lived in London, and in 1940 went to New York, after his house had been bombed. There he wrote his last essay in 1942: 'In order to prevent the surfaces of paintings from presenting themselves as rectangles, I have reduced the colours, and strengthened the lines of motion by putting one across the other. The surfaces were cut and made to disappear'. But at that point he achieved a strange rhythmical effect, caused probably by the pulsating metropolis of New York, which led him to new and unexpected solutions. In *Broadway Boogie-Woogie* (Ill. 27) he changed his light lattices into fluorescent, running stripes and further

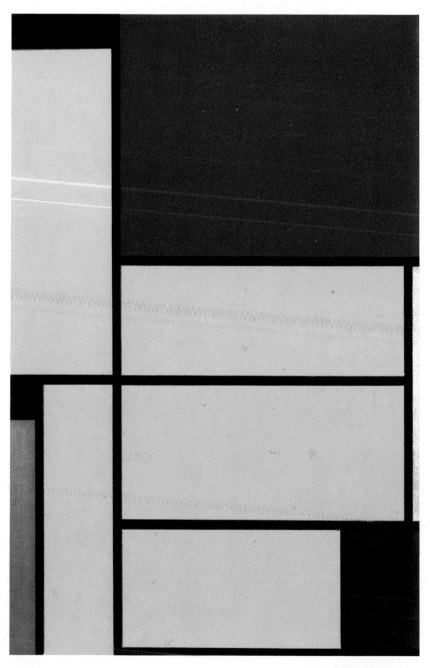

24 Piet Mondrian
Composition I, **1921**
Oil on canvas, 96·5 × 60·5 cm
Cologne, Ludwig Museum

25 **Piet Mondrian** *Composition with red, yellow and blue*, **1939–42**
Oil on canvas, 72·5 × 69 cm
London, Tate Gallery

partitioned his small zones. The rhythmical pulse of these small squares within the same painting were a first sign of Kinetism and of hard-edge painting. The remote high priest of Neoplasticism told the outsider Bart van der Leck and the dynamic van Doesburg one year before his death that they had been right. As an example we have *Rhythm of a*

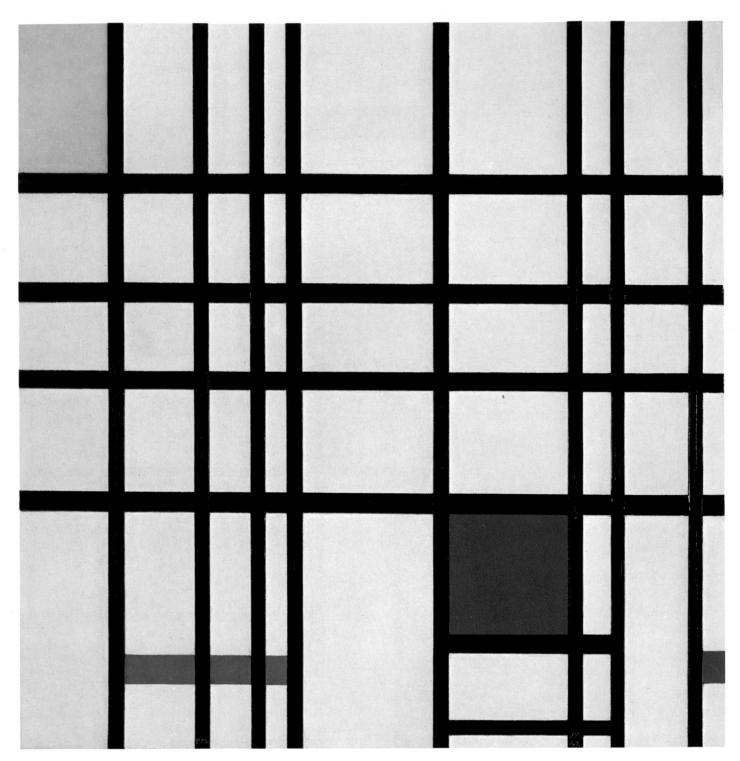

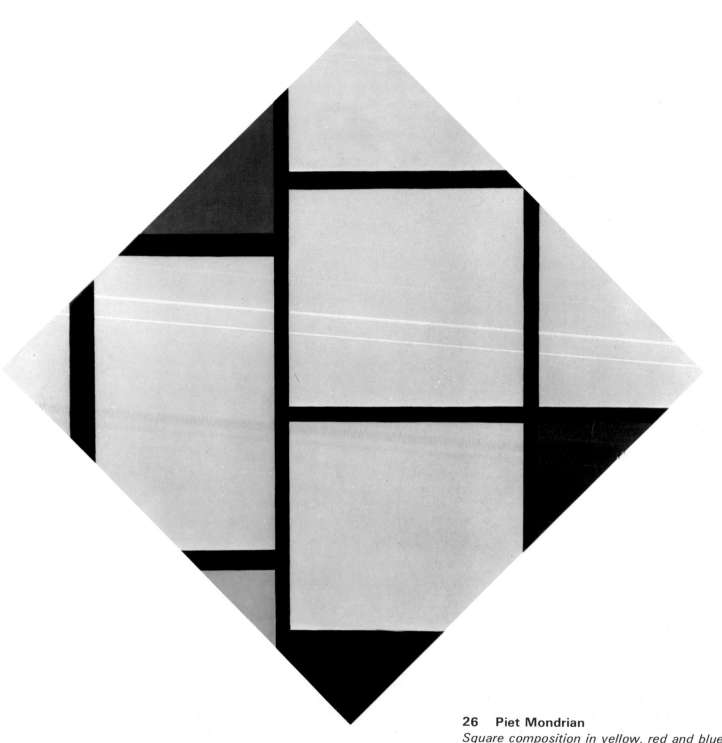

26 Piet Mondrian
Square composition in yellow, red and blue, c. **1925**
Oil on canvas, 124·8 × 124·8 cm
Washington, National Gallery of Art,
Herbert and Nannette Rothschild Foundation

Russian dance (Ill. 29) by van Doesburg. On this long shape a rhythmic course of basic contrasts 'gesticulates', silently. It is one of the paintings which were created directly under the influence of the reductions by van der Leck. Even Mondrian did not escape this influence between 1916 and 1918.

27 Piet Mondrian
Broadway Boogie-Woogie, **1942–43**
Oil on canvas, 127 × 127 cm
New York, Museum of Modern Art

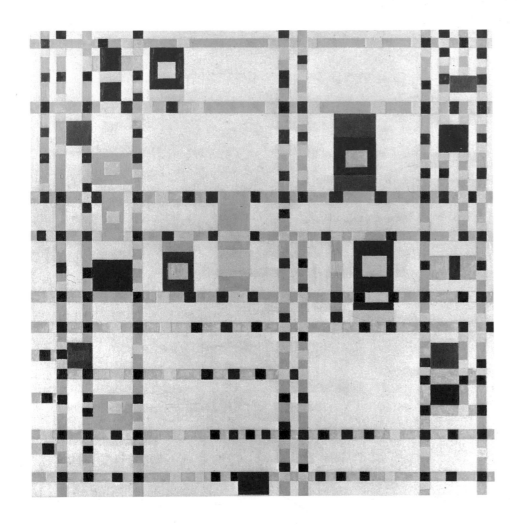

Van Doesburg's *Contra-composition 5* of 1924 (Ill. 28) was, as the title indicates, aimed against the Mondrian dogma of the vertical-horizontal harmony. It is a model of Elementarism, an example of how a symmetrical conception can suggest a strong passionate message and a burning dynamism. Similar structures can be seen in his wall paintings in the Café L'Aubette in Strasburg (1926–28).

Van Doesburg's work is the expression of one of the most active and versatile minds of the Constructivist avant-garde. It was he who edited the journal *De Stijl* for thirteen years (1917–30), who organised the group

66

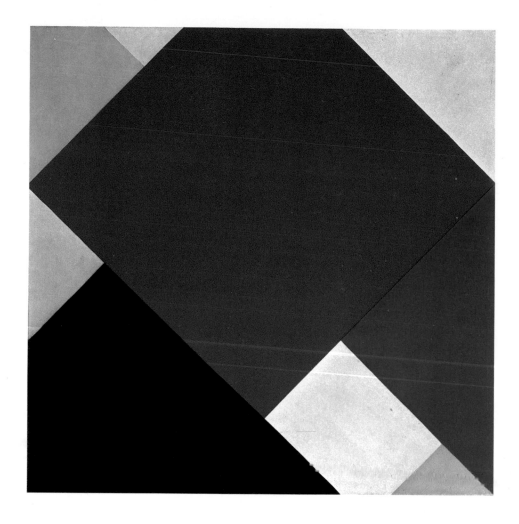

28 Theo van Doesburg
Contra-composition 5, **1924**
Oil on canvas, 100 × 100 cm
Amsterdam, Stedelijk Museum

29 Theo van Doesburg
Rhythm of a Russian dance, **1918**
Oil on canvas, 136 × 62·5 cm
New York, Museum of Modern Art,
Donation of Lillie P. Bliss

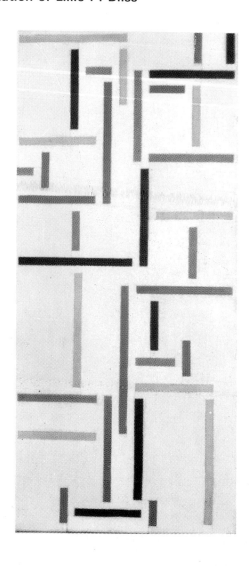

around it and publicised its aims throughout Europe. It was he who put his revolutionary ideas into practice, actively co-operated with architectural projects, and contributed the elementary principles behind the spatial conception of colour. He organised international congresses (especially between 1921 and 1923), pedagogical discussions and theoretical papers.

He became a dynamic institution who exerted many influences.

One of his last contributions in 1930 was the formulation of the basic principles of concrete art: 'We look ahead to a time of pure painting and the time when we shall construct the intellectual form, the concrete realisation of the creative mind. We want concrete not abstract painting, for nothing is more concrete, more real than a line, a colour, a surface. Once they are liberated as means of expression they are on their way towards the real goal of art: to create a universal language.'

Comparing two reproductions, one of a painting by Johannes **Itten** (Ill. 30), the other by Laszlo **Moholy-Nagy**, may remind us of the strange story which the meeting of these two great teachers with such different minds produced. The place was the Bauhaus

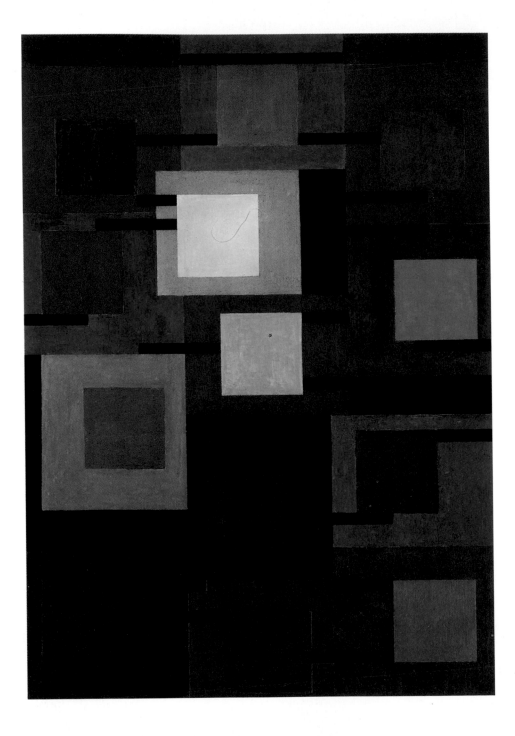

30 Johannes Itten
Variation 3, **1957**
Oil paste on carton paper, 90 × 64 cm
Stuttgart, National Gallery

in Weimar in 1923. At that time Moholy-Nagy, an enthusiast of the machine culture and of rationalism, succeeded the Expressionist researcher Itten who was not afraid to stimulate his creative mind with oriental ritual. In spite of this, these two antipodes found in abstract painting and in constructive montages an ideal terrain for visual and material researches which show their different ways of thinking.

'I became aware that the scientific civilisation was reaching a critical stage,' Itten said and turned to eastern philosophy for an answer: 'so I came to the conclusion that our outward way of scientific research has to be supplemented by a universal way to achieve the harmony of the soul'. 'Looking at the indescribable world which is man', this pupil of Hoelzel started, in 1916 in Vienna, to practise his unique didactic method.

His fame as a very sensitive teacher reached the ears of Gropius, who called the young Itten to the Bauhaus. It was Itten who started the 'initial course', a revolutionary institution (release of the creative energies, experiencing materials and constructions, the laws of painting). Something of his teaching, which had a flexible regard for subjective characteristics, can be recognised in the expressive *Variation 3* of 1957 (Ill. 30). 'Geometrical and rhythmical forms, the problems of proportion and composition were worked through. . . . Next to the teaching of polar contrasts, the exercises aimed at relaxation and concentration were very successful. Creative automation was recognised as one of the most important factors of creative work. I myself worked on geometric-abstract paintings which were based on careful construction.'

Soon after the arrival of the 28-year-old Moholy-Nagy, the Bauhaus saw the beginning of a new movement set out to achieve an aesthetics of the economic-technological forms and their industrial use. Moholy-Nagy, who had developed as a painter under the influence of Russian and Hungarian Constructivism, had the mind of a physicist and the methodical will of an engineer. As a painter he was an explorer of spaces who applied the principles of Lissitzky and Rodschenko with imagination.

In the painting *Coloured lattice no. 1* (Ill. 32), which was probably done in Berlin, he defined the mathematical co-ordination of the Suprematist emotive dynamism more

68

precisely and also applied the results of Constructivist researches into materials. He painted the basic surface with a deep blue, evenly, with skilful intelligence, somewhat like an examination paper. He created the different positions in space by means of an evident grading of his mathematics, through colour values and through measurable distances. His aim was to achieve an identity of physical and geometrical space, not only in depth or width but also through light. Our perception achieves immediate contact with this intellectual process. Moholy-Nagy's painting looks like a model or sketch from which one could proceed into detailed projections of design.

Composition A XX (III. 31) plays with the following polyvalence: the contradiction of flatness and depth, of the unbending and the flexible, of the transparent and the solid; the spatial element promotes a highly conscious participation and develops in the spectator a conceptual realisation.

The *Composition No 169* (III. 33) by Friedrich **Vordemberge-Gildewart**, deals with a similar problem. It is only possible to follow all the spatial connections via the main motif and by paying proper attention. In conjunction with the group around *De Stijl*, to which Vordemberge-Gildewart belonged after an interesting avant-garde activity in Hanover (1919–26), he participated in the crystallisation of a new type of concrete painting which developed into a 'learning apparatus', an 'instrument for the development of consciousness.' The sharp increase in the consciousness of our possibilities of perception, the registration of the growth of perception, becomes clearer after a period of contact with the work of art.

These 'learning-system' paintings were produced with the artistic application of scientific thought. 'Art can mediate thought in such a way that an idea is directly perceived as information' Max **Bill**, a friend of Vordemberge-Gildewart, wrote. 'The more exactly a thought hits the target, the more unified the basic idea is, the closer the thought finds itself to mathematical think-

ing; and the closer we come to a proper structure and the universality of art. . . . Such new art arises out of a vision which moves in a realm close to thought, a realm which gives a certain measure of security, as well as a measure of uncertainty and indetermination; in other words it moves in a borderland where it is possible to open new areas of perception and to make them accessible to the senses.' Such paintings as Max Bill writes about here demand that we cultivate and think about the opposite of that which is 'known' in art, i.e. the 'unknown', and that we consciously reflect on it as a

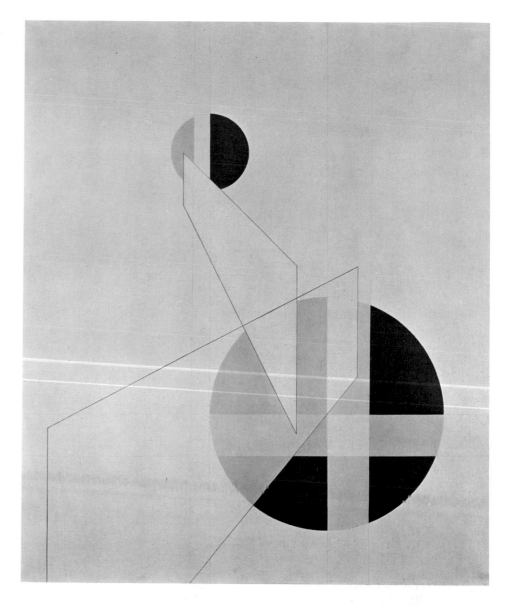

31 Laszlo Moholy-Nagy
Composition A XX, **1924**
Oil on canvas, 135·5 × 115 cm
Paris, National Museum of Modern Art

32 Laszlo Moholy-Nagy
Coloured lattice no. 1, **1922**
Oil on canvas, 75 × 58·5 cm
Meriden (Connecticut),
Mr and Mrs Burton Tremaine Collection

source of inspiration. Emotive reactions and the unconscious are somehow present in the composition of an exactly 'geometrical' painting.

Max Bill's *Four closed colour groups* (Ill. 34) presents us with this great didactic problem. The painting has an added kinetic element. The 'diagonals' and 'points', although crammed into a frame, are powerful enough to make our gaze unsure and to create an impression of nausea, of the indeterminate, the unknown. Is this only an optical illusion? If we reflect here on what is happening, where the uncontrollable comes from, we may be led a little closer to self-realisation.

The compositions of Vordemberge-Gildewart and Gorin on the one hand and the paintings of S. Taeuber-Arp and A. Magnelli on the other show us not only the wide range of abstract painting during the '30s but also the undogmatic orientation of the group Abstraction-Création. It was, with its 416 members, a large, impressive and world-wide movement.

33 Friederich Vordemberge-Gildewart
Composition no. 169, **1934–48**
Oil on canvas, 80 × 160 cm
Philadelphia, Museum of Art

34 Max Bill
Four closed colour groups, **1971**
Oil on canvas, 47·5 × 47·5 cm
Private Collection

The Florentine Alberto **Magnelli**, who acquired French naturalisation, retained a few poetical symbols of the atmosphere of a night in a harbour in his *Ronde océanique* (Ill. 35).

This self-taught man began to paint within the circle of Cubists and Futurists, but by 1915 he was already working on abstract painting which consisted of simple but energetic elements. Magnelli rehabilitated the basic forms of the early Renaissance which had been covered by a mass of observations from the natural world. From such basic forms rise constant visionary palaces, machine-like fauna, and the utilitarian objects of the atomic age. Even a monument may be the result, as in the painting shown here, with its dramatic silhouette rising against a green background. The time of Magnelli's great fame, however, came only after 1946.

We have seen, by contrasting the work of Itten and Moholy-Nagy, how different temperaments may express themselves through 'geometrical' colour forms and have realised how indescribably comprehensive this form of expression is. This is also confirmed, from a different angle, by contrasting the two painters mentioned above with Arp, Herbin and Gorin. This comparison makes it clear that the geometrical way of painting is the outer cloak of 'something', of a substance to which we should apply all our energies in order to understand it.

35 Alberto Magnelli
Ronde océanique, **1937**
Oil on canvas, 114 × 146 cm
71 **Paris, National Museum of Modern Art**

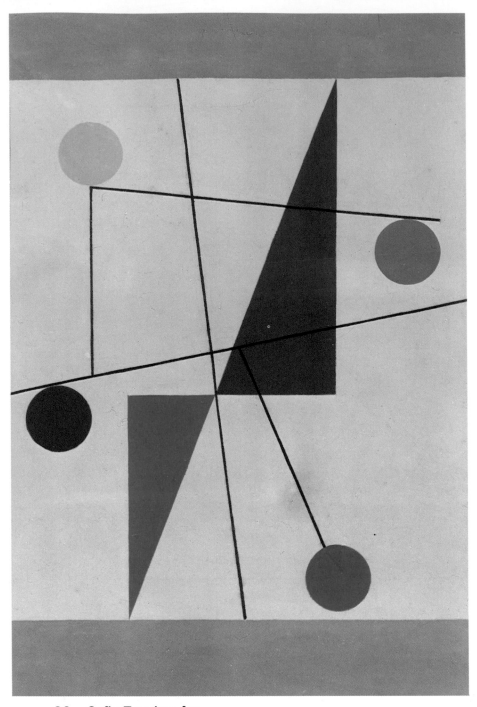

36 Sofie Taeuber-Arp
Gouache, **1932**
42 × 28·5 cm
Paris, Private Collection

Next to the ethereal but musical *Composition no 9* by Jean **Gorin** (Ill. 40), which has the construction and transparency of a Gregorian choral, the *Relief painting* by Hans **Arp** seems to express the spirit of carnival; with a little imagination one can sense a harlequin in this work. The painting was completed in 1915 and is constructed from elements similar to Mondrian's *Composition in blue B* (Ill. 23) but without its regularity. The joyful mood of Arp's collage-like improvisation arises precisely from its irregularity. It too obeys a law of chance.

This 'adventurous irregularity' softens the geometrical corners and points to Arp's fairy-tale-like conception of the organic and cloudlike. At the sametime one can see here one of the Dada scherzos which still came out of historical foundation in 1916: somebody is making fun here of the severity of lofty mathematical relationships. Hans Arp, the founder member of the Dada movement, found his own ground after 1922 in the construction of reliefs and in sculpture.

The paintings of his wife Sofie **Taeuber-Arp** emanate a joyful, lively sound. Her *Gouache* and *Watercolour* retain the decorative flavour of her textile designs; the truth as expressed in materials was something close to her work. The 'decorative' character does

37 Sofie Taeuber-Arp
Watercolour, **1927**
39 × 28 cm
Paris, Private Collection

38 Hans Arp
Relief painting,
1915
Collage,
88 × 75 cm
Paris,
Francois Arp
73 Collection

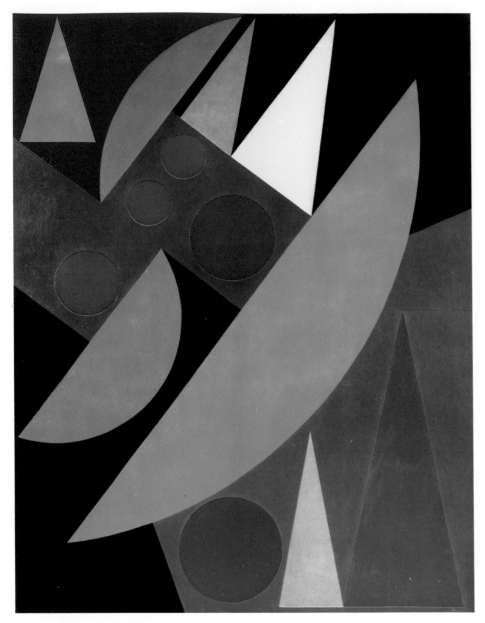

39 Auguste Herbin
Rain, **1956**
Oil on canvas, 116 × 89 cm
Paris, Denise René Gallery

in no way diminish her work, on the contrary. In an area where art was, more often than not, bordering on mechanical monotony her joyful creations were a surprising contribution. Her imagination always aimed clearly at semantic systems. The basic principles of her language and her 'tales' remain a living spring to this day.

Auguste **Herbin** too was concerned with communication, with a system of words in paint, a 'geometrical' visually musical alphabet. Next to the 'songs' of Sofie Taeuber-Arp, his own seem hymnical and full of pathos (Ill. 39). They are the fruit of expression and speculation, and mix Herbin's moral and religious beliefs with a scientific craving for method and system. As one of the leaders of Abstraction-Création after 1945, and the strong man of the 'geometricians', he wrote important theoretical articles, in which he was able to allay the impact of the exaggerated enthusiasm of some of the Concretists for the rational sciences. 'The problems which have arisen in the course of the development of painting, become, as far as form and colour are concerned, somewhat scientific, but of a science which we should not confuse with mathematical physics. We are concerned with the precise delineation of the boundaries and the means of non-figurative, non-representational painting. This kind of painting is difficult to understand for the objective and materialistic physicist. But if such a scientist is sensitive to the beauty which non-representational painting is capable of showing, then he will discover the principles of beauty itself, understand the reasons for his aesthetic satisfaction and be able to justify them; and that leads into another science. . . What the artist has to know is colour and form, which are closely related to each other and with art, and that in the limits which are set by the individual personality and the limits of painting. The artist has to achieve his own creative way of doing things'.

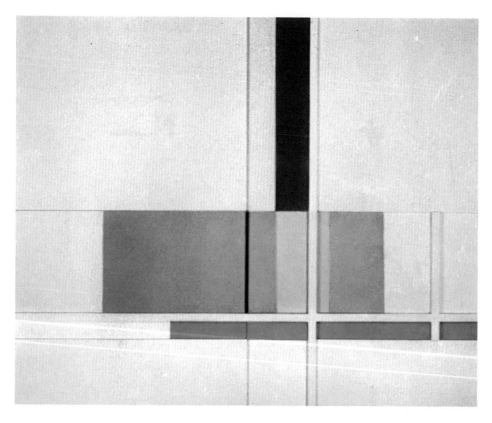

40 Jean Gorin
Composition no. 9, **1934**
Oil on canvas, 88 × 115 cm
Lüttich, Fernand C. Graindorge Collection

41 Georges Vantongerloo
Composition 15, derived from the
equation $Y = ax^2 + bx + 18$, **1930**
119 × 62 cm
New York, Silvia Pizitz Collection

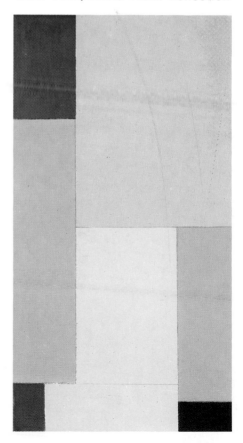

The struggles and tensions within the world of painting of the '40s and '50s were a manifold confirmation of the historical dialectic. There we see for example that several developments were gaining strength around the subjective, irrational opposite of Concretism, especially in the camp of the Surrealists, which were to become the moving force after 1944. Some elements of the Surrealist ideology, especially the method of psychic automatism, fused in a hundred different ways with non-representational principles and resulted in the nine to twelve movements of Lyrical Abstraction. It is a sad cultural paradox that the works of Kupka, the great predecessor of Kandinsky, should be neglected.

The prologue to Lyrical Abstraction before 1944 has been mentioned before. Important for the changeover to the new 'non-geometrical' way of expression were the paintings of Willi Baumeister, of Serge Poliakoff (Ill. 42), of Arshile Gorky (Ill. 44, 45) and of Juan Miró. It was only after 1935 that all of them were able to find the appropriate non-figurative style. For Baumeister, the pupil of Hoelzel, the magical pictorial signs succeeded Constructivist ones; Poliakoff came closer to the abstract by way of Cubist and Expressionist attempts. Gorky studied all the great minds from Cézanne to Picasso and the Surrealists. He meant to compensate for the lack of the American culture by a series of eclectic experiments.

Willi **Baumeister** (Ill. 43) was a painter and a thinker. During his first period he worked out the rules of a discipline of composition, in particular those of Constructivist harmony and rhythm. After these grammatical studies, he turned to the origins of signs and ideograms which arise out of a 'poetic-magical organ of speech within our imagination'. He researched into pre-rational, imaginative thinking (as did Klee), and the handwriting of unconscious calligraphy. He longed to get back to the origins, to the 'primeval' mud out of which all life had

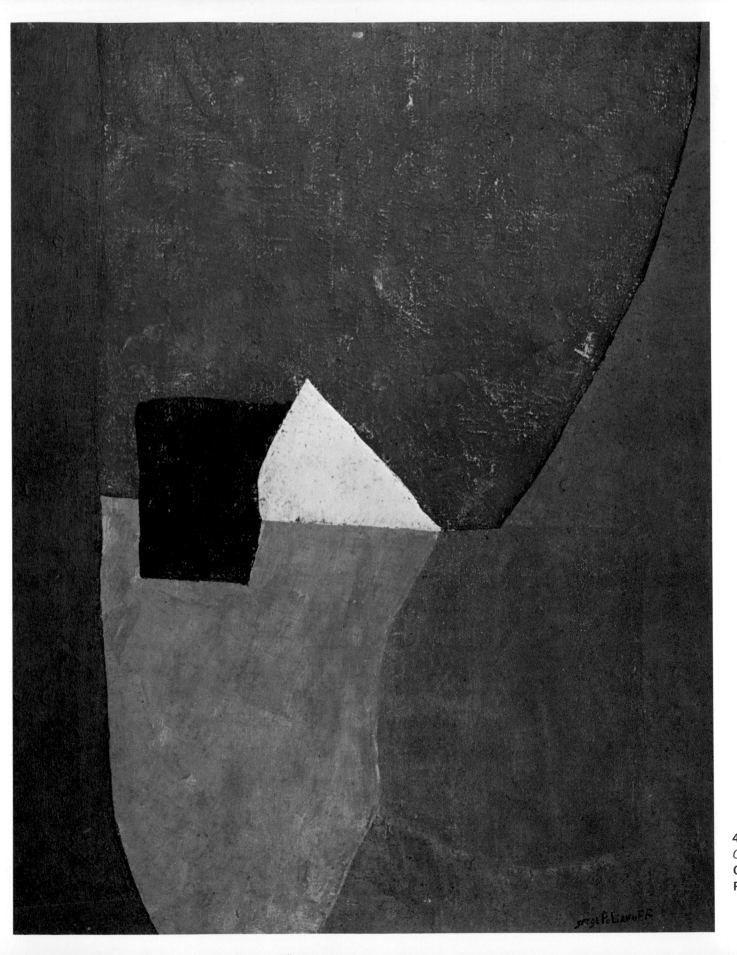

42 Serge Poliakoff
Composition
Oil on canvas
Private Collection 76

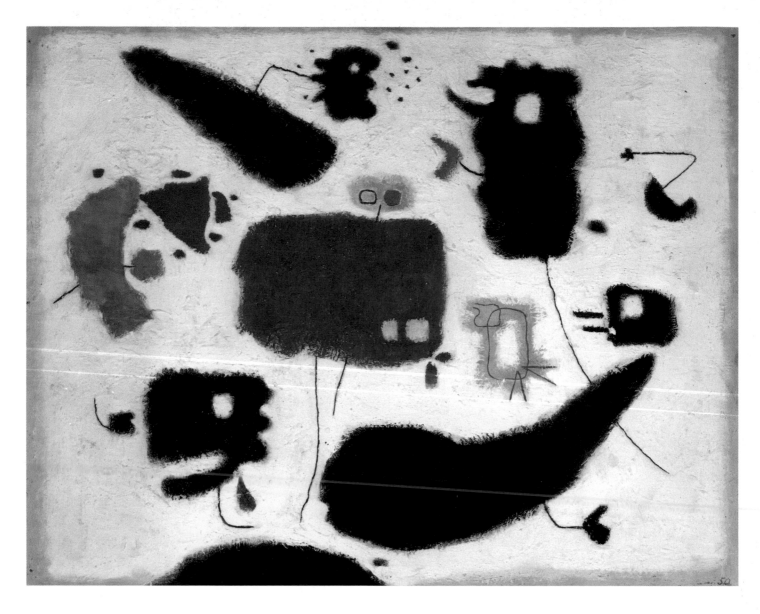

come. The results of his long years of research were published in the book *Of the unknown in art* (1947). What appears on the surface of the painting is the traces of inner movements which have stepped out of the unknown. 'The hitherto unknown are those strange, enigmatic formulations in a work of art which the spectator has to ponder in order to understand the essence of an artistic utterance. . . Art is not made up of rules but always consists of exceptions from the standpoint of usual experience.' Originality and visual beauty, therefore, can never be found in the conventional.

Poliakoff's way of working is not that of a magician but of a craftsman who is putting a beautiful piece together (Ill. 42).

He turns to a realm of the unknown with splendid symbols in which sensuous feelings of joy often change into the solemn mood of a ritual. His paintings are a praise of materials; some critics saw in them simple symbols of the earth, which exude a strange energy 'which never lets us forget the flowing fire under the heavy stone.' The unique art of Poliakoff, which is difficult to place, pointed to some problems of informal art and of American Colour-field painting.

43 Willy Baumeister
Black dragons, **1950**
Oil on hardboard, 65 × 81 cm
Bonn, Municipal Art Collection

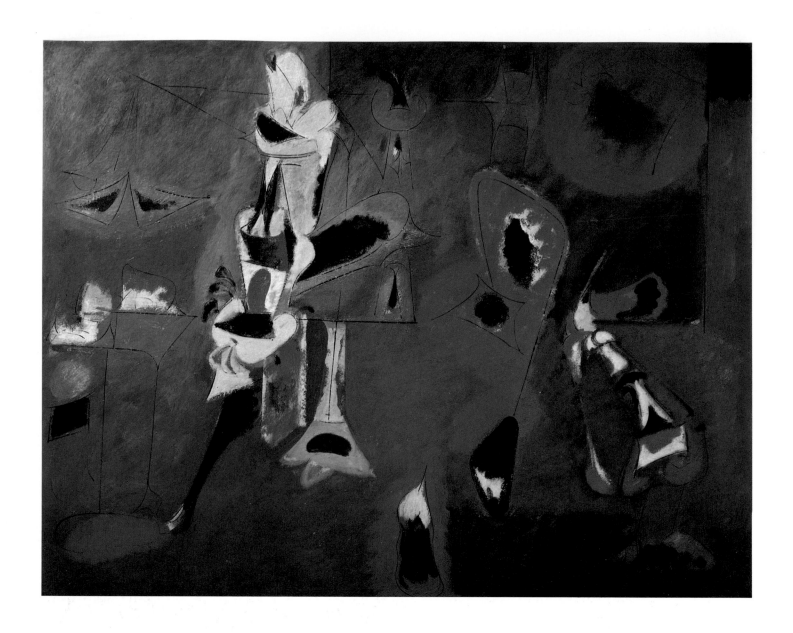

44 Arshile Gorky
Agony
Oil on canvas, 101·5 × 128.2 cm
New York, Museum of Modern Art,
A. Conger Goodyear Collection

Arshile **Gorky**, the friend of de Kooning, has been regarded as a great translator. He passed on important principles to the young American Abstractionists, for example the concept of the unconscious of C. G. Jung, and he himself profited from Surrealist ideas. His paintings (Ill. 44, 45) remind one sometimes of the metaphors of Miró. The hell of the unconscious, the subterranean world of repressed desires, were unfolded in the symbolic, passionate tales of Gorky's last paintings. Are they erotic landscape visions? 'They grew out of the wild and tender personality of Gorky, and speak of the sublime fight of flowers growing towards the sunlight. Nature is seen here for the first time as a cryptogram. . .', wrote André Breton who thought highly of Gorky as a Surrealist. How is one to interpret paintings like *The liver is the coxcomb* (Ill. 45). It is not easy, for

78

the title is out to hide the meaning.

A certain affinity with the extravagant Kandinsky helps a little, but the imagination of the spectator is free to do what it likes. Here invention has a free hand; this was Gorky's opinion too: 'Although the different signs all have a particular meaning for me, it is the right of the spectator to invent meanings for himself; I feel that they will be close to mine. We all dream; under this common denominator I was able to find a language of experience which everyone can understand'.

One can feel the mood of his painting *Agony* (1947): he had cancer, and in fact a year later he committed suicide.

45 Arshile Gorky
The liver is the coxcomb, **1944**
Oil on canvas, 185 × 249 cm
Buffalo, Albright-Knox Art Gallery,
Seymour H. Knox Donation

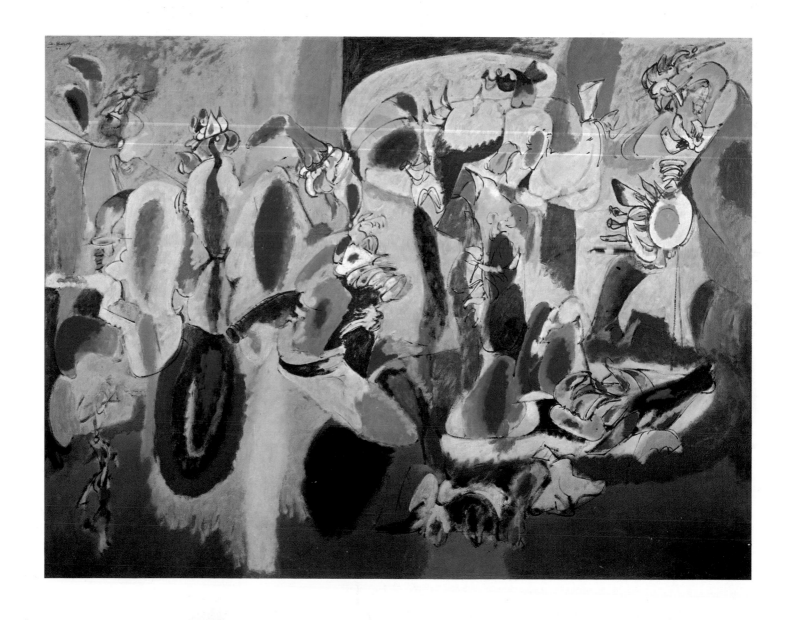

46 Alfred Manessier
Rural festival, 1974
Oil on canvas
Private Collection

The abstract beginnings of Alfred **Manessier**, who turned against Surrealism, fell also into the pre-war years. This pupil of old Bissière was one of the main representatives of the young painters of the French tradition who appeared in 1944 for the first time. The jubilant, joyful exclamation of his painting *Rural festival* (Ill. 46) may remind us of a cockfight against a blood-red background. The centripetal, beautifully coloured forms are much looser in comparison with his earlier, very ornamental compositions. It was these very paintings which made him famous, brought him the first prize at the Biennale in Venice and many commissions for stained glass windows. Manessier, who lived mainly in the country, has never disguised the inspiration he received from nature. He was concerned with a typical transposition, sometimes more on the structural-ornamental side, sometimes more tachistically loose. It has also been said that he was not a proper 'abstract painter' for there was no real basic principle to his works but only a method, a sort of stylisation which consisted of an open impressive use of 'dots' for the solution of 'inner problems'. 'Non-figurative art seems to be the chance through which the painter may express his reality and the real character of his consciousness' (B. Dorival).

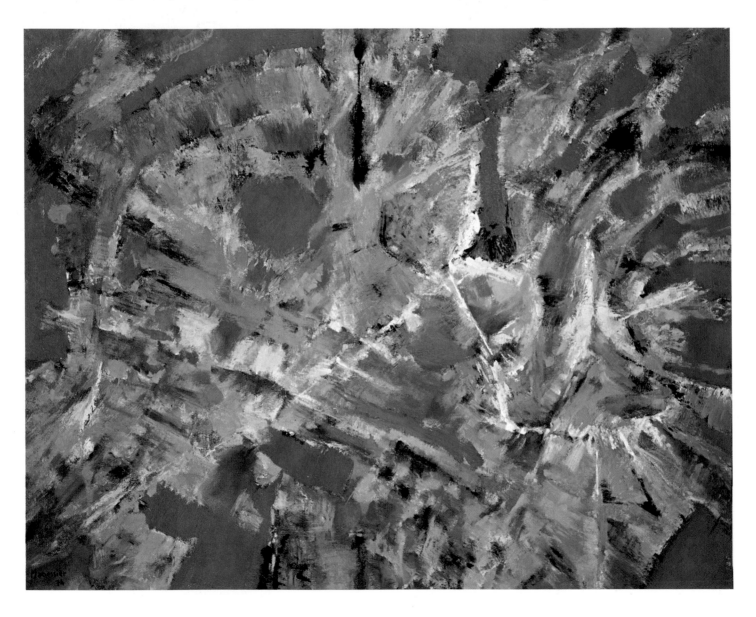

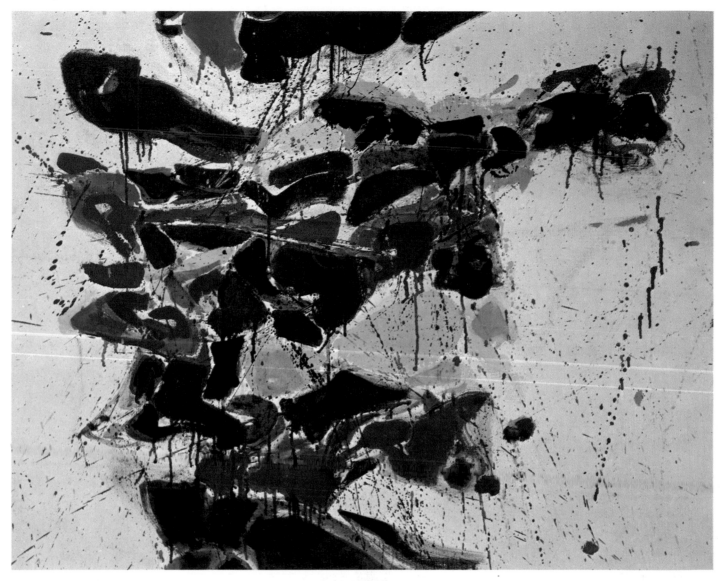

The paintings of the Californian Sam **Francis** (Ill. 47) breathe the wide American spaces and have the sensuality of French cult of colour. The free-floating galaxy of the organic forms reminds us of the mobiles of his compatriot Calder. What gives these islands of colour their supernatural quality of light? They do not seem to be painted, but to spring from the depths. They are pure pigments which impregnate the rough unprepared canvas; a beginning of the 'post-pictorial' Abstraction.

'The real dream-image abandons the tripartite soul and its vapour. That is the cloud moving across the blinking sea. You cannot interpret the dream on canvas, for this dream is the end of the hunt, on the celestial mountain where nothing remains of the Phoenix, captured in the midst of this wonderful blue'. This sentence expresses the poetical hope of everyone forced to live in the dirty labyrinth of the city. 'I believe that every act, as every painting, reveals its true character only after everything willed and intended has been shed', Sam Francis has said, 'for everything consciously intended forces us to see in a particular way, it has a surface under which the real essence is hidden. A work of art must put the spectator in a condition of doubt.'

47 Sam Francis
Composition, **1960**
Oil on canvas, 65 × 81 cm
Paris, Jacques Dubourgh Gallery

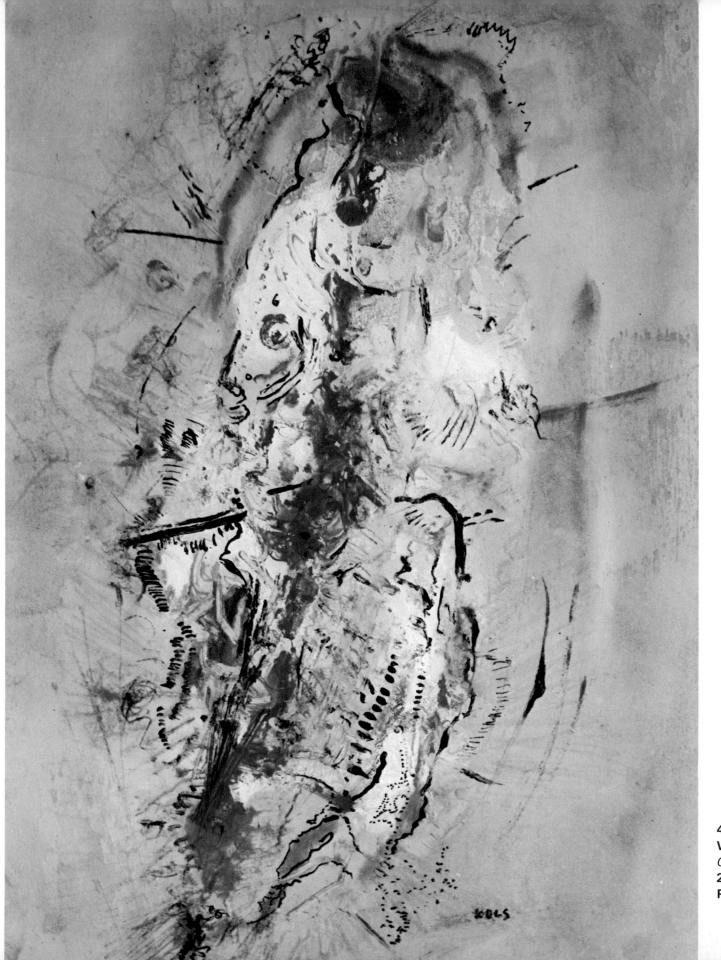

48 Wols (Alfred Otto
Wolfgang Schulze)
Gouache, **1949**
21 × 15 cm
Private Collection 82

Lyrical Abstraction prepared the ground for its appearance as the governing trend in art by several exhibitions of single painters. The great creative storm did not start till 1947. A group of younger painters, who had taken a fancy to absolute lyricism, gathered around a 'cursed' man, Wols. His exhibition at the Drouin Gallery in 1947 was a revelation.

'Forty paintings: forty masterpieces, each one more crushing, stirring, bloody than the next: an event, without doubt the most important since the work of van Gogh. The clear-sighted, penetrating cry, the most moving drama created by a man, all men. . .' thus wrote Georges Mathieu. 'This exhibition ends the last formal phase of development of western painting, which has been heralded for seventy years, since the Renaissance, for a thousand years . . . Wols painted these canvases with his dramas, with his blood. The proof of this will be demonstrated by his death, after his death . . . We are looking at forty instances from the crucifixion of a man who was the incarnation of purity, sensitivity and wisdom, who was not only an honour to western civilisa-

tion but to creation itself. . .'

These painfully prophetic visions were thrown onto the canvas by somebody who never felt himself to be a professional painter. This brilliant, all too gifted son of the chief of the Saxon State Chancellery fled to Paris in 1932; afterwards he lived for years in the south of France and Barcelona and made a name for himself as a photographer in Paris. During his internment in 1940 he began to draw and paint in watercolour. Plants from a different world, demons, fairies, pan-erotic figures, hundreds of visions bring the small shapes alive; later Wols hid with his dog in a shepherd's hut near Montélimar. He led the life of someone persecuted, who kept his imagination alive with regular sips from a rum bottle. He continued this self-destructive way of life after 1944 in Paris. The gallery owner Drouin, who gave him materials to work with, achieved success only with the second exhibition in 1947. This was the revelation which electrified the sensitivity of a generation. The formless paintings, with their soft faces and beings, spoke of decay and a

sense of malaise as felt by the existentialists whose thinking was very current then. J. P. Sartre was very moved by the works of Wols.

The frightful forms of nature, cadavers, a bloody wound as 'the eternal wound of the world' (Ill. 48), confronted the Parisian public like alarm signals, like symptoms of pain. His informal paintings do not become chaotic, they retain the emotional energy of his world. 'It seemed absurd to him to create forms in the artistic realm when the world itself was losing all sense of form'.

When Wols died at the age of thirty eight from food poisoning his, as well as Pollock's, works became the example for thousands of painters as well as a symbol of the new way of painting.

49 Wols (Alfred Otto Wolfgang Schulze)
Burning bushes, **1944**
Oil on canvas, 12 × 12 cm
Private Collection

WOLS

50 Georges Mathieu
Oliver decapitated,
1958
Oil on canvas
60 × 92 cm
Paris, Rive Droite Gallery

51 Jean-Paul
Riopelle,
*Painting, c.*1956
Oil on canvas
97 × 129·8 cm
Paris,
Berggruen Gallery 84

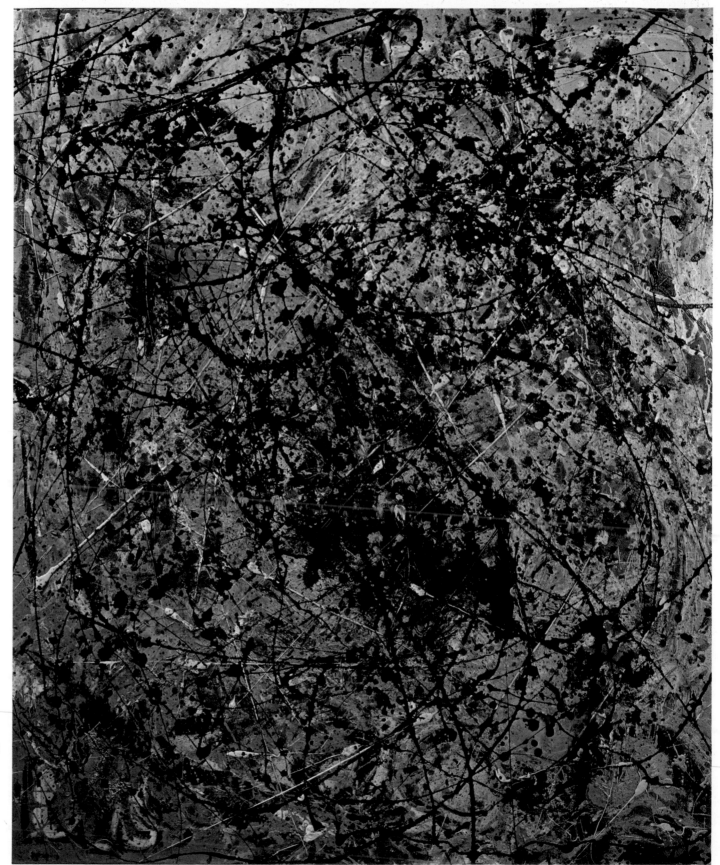

52 Jackson Pollock
*Reflections of a
celestial carriage,*
1947
Oil on canvas,
111 × 92 cm
Amsterdam,
Stedelijk Museum

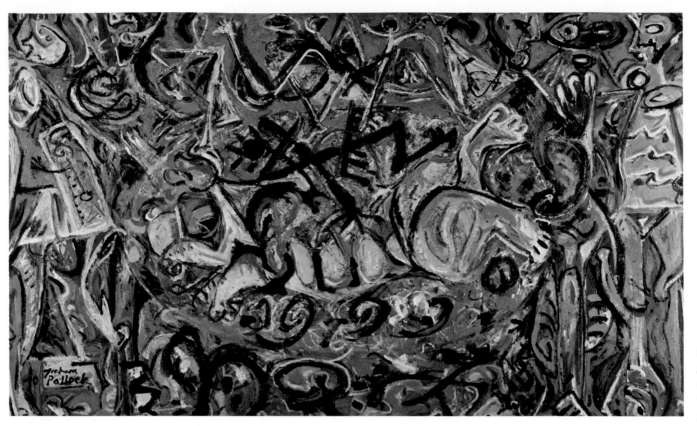

53 Jackson Pollock
Pasiphae, **1943**
Oil canvas,
142·6 × 243·8 cm
Private Collection

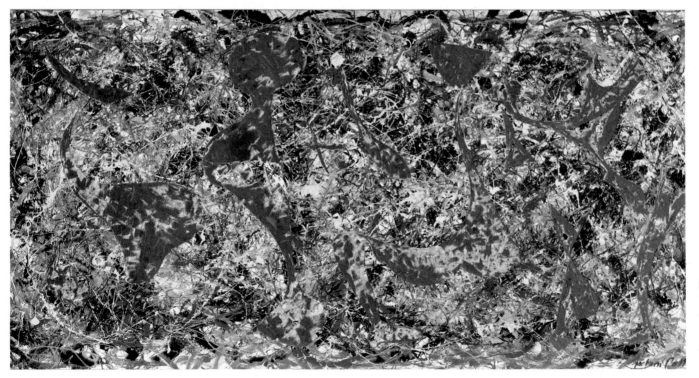

54 Jackson Pollock
Texture, **1949**
Oil on hardboard,
121·5 × 244 cm
Stuttgart,
National Gallery 86

'The life and work of Wols and Pollock derive their contemporary, documentary value from their calm, unequalled acceptance of facts which in the rough years before and during the war were inflicted by men on other men. That meant: persecution, want, homelessness, and again and again having to flee. Pollock was the rebel. Wols was the one who yielded and recorded what happened to him: not the facts of reality but the images which came out of the inner wounds inflicted by life. Everyone who wants to work in this movement has to be measured against the strength of his commitment' (W. Haftmann).

Mathieu wanted to call this movement 'Abstraction psychique'; it introduced itself to the general public for the first time in 1947 with the exhibition *L'imaginaire*. Some of the main criteria of this Lyrical Abstraction were the genuineness of experience and the authenticity of the signs on the canvas, which were also seen as the embodiment of large cosmic impulses. Georges Mathieu (Ill. 50), a very alive and intelligent man, was instrumental in organising the historical occasion of the movement, and became world-famous for his exhibitions This admirer of oriental calligraphy was convinced that painting 'manifests the pure essence of being, has to be created out of the materials of this world, to be done in the presence of all'. The act of painting was completed in a few minutes. In a world dominated by machines, this unique act renders them obsolete through the speed and precision of the creative act, through the revelation obtained by the co-ordinated dynamism of mind and hand.

One can relate the following thoughts of Mathieu also to the paintings of the Canadian J. P. **Riopelle** (Ill. 51), which were a hothouse of germinating half-signs: 'Art is the transcendence of signs. The only chance an informal painter has is to transcend the non-signs. The problem is clear: it is more than a questioning of the basic assumptions of our western culture ... In the informal state which precedes the beginning, when one is free to build anew, the signs of the structural elements are to be assembled, but

how? Only the phenomenology of the "act of painting itself" can help us here ... The phase from "the Abstract to the Possible" is more than just a phase. A new era of art and thought is beginning and this means the era of a new incarnation of the sign.'

The years 1942–43 were a time of fateful changes for Jackson **Pollock**. He was put under contract by Peggy Guggenheim on the recommendation of the Surrealist Matta and given the chance to find himself. His passionate approach and his feeling for deeper mythological interpretations of his own pictures led him to work on 'totemic paintings' (Ill. 53). Urged on by the tragic language of Picasso's *Guernica* he launched

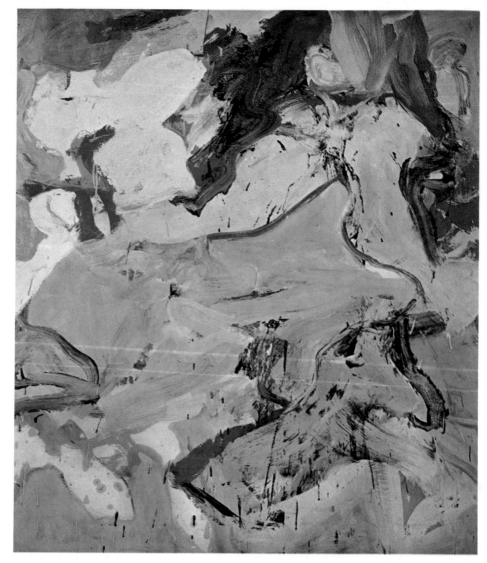

55 Willem de Kooning
Montauk V, **1969**
Private Collection

into new experiments. In his half-abstract paintings, hieroglyphs of his personal mythology, erotic symbols and powerful, aggressive lines came together. He was searching for a secret relationship with ancient mythology and the rituals of the American Indians. This experience, together with an intense evaluation of the work of the Surrealist immigrants, aided Pollock along a path which led to a new, rough-and-ready technique, an anti-art.

'There comes a moment for every

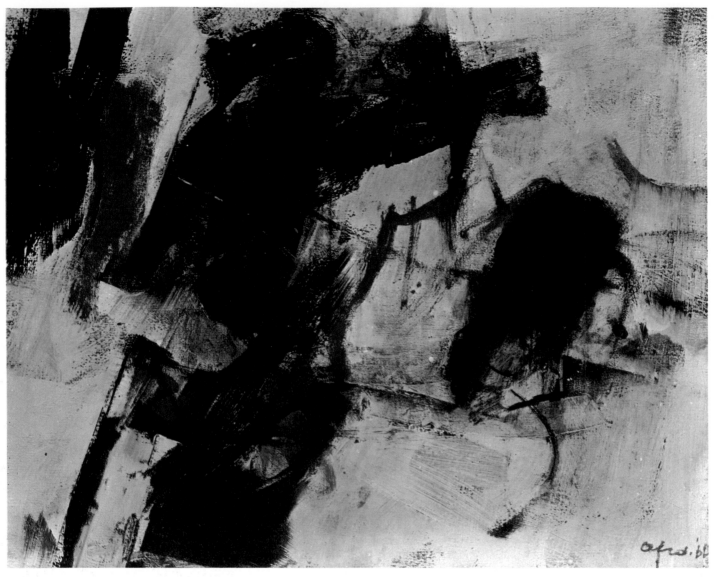

56 **Afro**
(Afro
Basaldela)
Villa Horizon,
1960
Oil on canvas,
85·5 × 100·3 cm
Private
Collection

American painter when the canvas appears to him as an arena for his actions' wrote the great critic H. Rosenberg. What happens on the canvas is not a 'painting' but an experience. Pollock himself explained it thus: 'My kind of work is not easel painting. I seldom put a canvas on a frame, I nail it to a hard wall or to the floor. I need the resistance of a hard surface. I feel more at ease on the floor, more at one with the painting, closer to it, for I can move around it from all four sides and literally be the painting. This is the technique of the Indian sand-painters of the American West. I deviate more and more from usual techniques of painting such as

easel and brush. I prefer to use sticks and knives, liquid paints and a heavy paste made of sand, broken glass and other unusual materials'.

During 1946–47 he created the 'overall paintings', similar to 'reflections of a celestial carriage' (Ill. 52), which are forever associated in our minds with the name Pollock. The early forms of 'écriture automatique' used by the Surrealists lost its playful capriciousness here; this kind of painting expressed the more wicked emotions of man as an answer to the evil state of the world. Haftmann has described this shapeless network of innumerable lines

without a centre as the 'choreographical trace of a dancing Dervish'.

Today we are used to calling this kind of work 'action painting'. Soon certain waves and cavities began to join and create the silhouettes of figures in the formless network of lines; sometimes these shapes would assume an anthropomorphical character (Ill. 54).

Was this then a return to figurative painting? We can say for sure that the mythological images of Pollock return this time in a celestial position, in the middle of a milky way. The main factor, rhythm, seems to combine the vitality and heartbeat of the

painter with the pulse of the stars.

Pollock's older friend, Willem **de Kooning**, led the 'active' way of painting into a different direction in his tuneful works (Ill. 55). He believed in the uncanny power of creation inherent in the act of painting. By painting over a background, and repeating this again and again, one discovers new implications, surprising silhouettes, the parts of a ghost as in an oppressive night-mare. Often erotic beings – half demon, half woman – appear, fixed to the canvas with a fearful restlessness. This Abstract Expressionist viewed the history of culture in the same way as he looked at his working methods. 'Everything is already there in art – like in a big stew. Everything is already in it, you just put your hand in and find something for yourself. It was already there – like a piece of meat'. His non-figurative attempts resulted paradoxically in quasi-figurations.

But there were to be no paradoxes in one matter: in the commitment of the artist. 'A painting is worthless if it is not the result of a great struggle which may be lost at any moment' (Rosenberg). This slogan guided the entire movement of Lyrical Abstraction.

The painting by **Afro** (Ill. 56) has the flourish of a baroque sketch. The vibrating macro-sign remains as a trace of this gesture of liberation. Afro released form from everything which hindered its dynamism and impulsiveness.

Emil **Schumacher's** *Lorbas* (Ill. 58) by contrast seems to be an object straight out

57 Ernst Wilhelm Nay
Retreating ochre, **1959**
Oil on canvas, 100 × 81 cm
Cologne, Schreiber Collection

58 Emil Schumacher
Lorbas, **1961**
Oil on canvas, 100 × 81 cm
Bonn, Municipal Art Collection

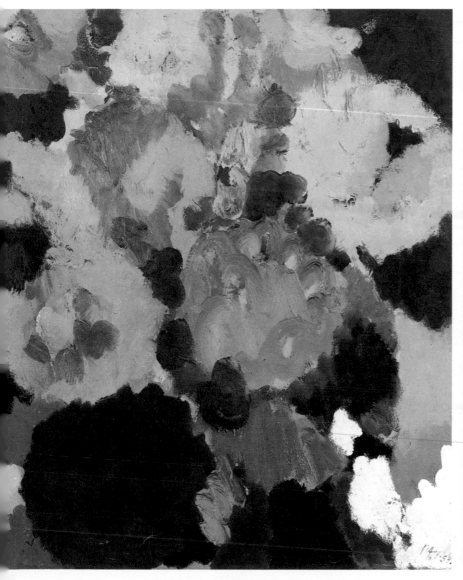

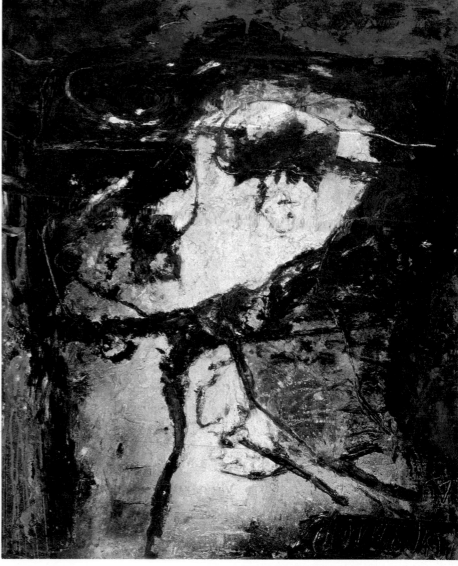

of a torture chamber where it was handled with a hot pair of pliers and then thrown out into an ice-cold yard to recover from unconsciousness. It is a painting full of pain. Schumacher once said: 'The likeable is dangerous. One has to destroy the painting again and again. Thus new layers are uncovered which one would never see otherwise. When I paint, I am in a state of feverish tension, an act of will which suspends me between reason and emotion . . . I move forward groping, without knowing where I am led. I only know the complete picture at any given stage of my work'.

Because of their fiery colourfulness, many paintings by E. W. **Nay** (Ill. 57) have been compared to the Expressionist language of E. L. Kirchner. They are not so much spontaneous 'expressions of experience', as carefully designed polycentric systems of the visual-musical kind. The problems of artistic composition attracted Nay most of all: 'If I put a dot of colour on a surface a surprising amount of tensions resulted at once. Contained within the dot, these tensions were without aim. If the dot was enlarged they grew in strength. Two discs, a third and a fourth — all of the same size — already created a most complicated relationship between forms. This also resulted in a mul-titude of colours as I gave each disc a different one. It could be viewed as a chromatic series'.

The disc joins the static and dynamic together. Such a basic form allows spontaneity, it binds the energies of the surface together and gives it rhythm.

W. Grohmann has drawn attention to the acoustic quality of Nay's paintings: 'There is an inner seeing just as there is an inner hearing. The first to feel this was Arnold Schönberg who wrote for the inner ear. Nay paints for the inner eye'.

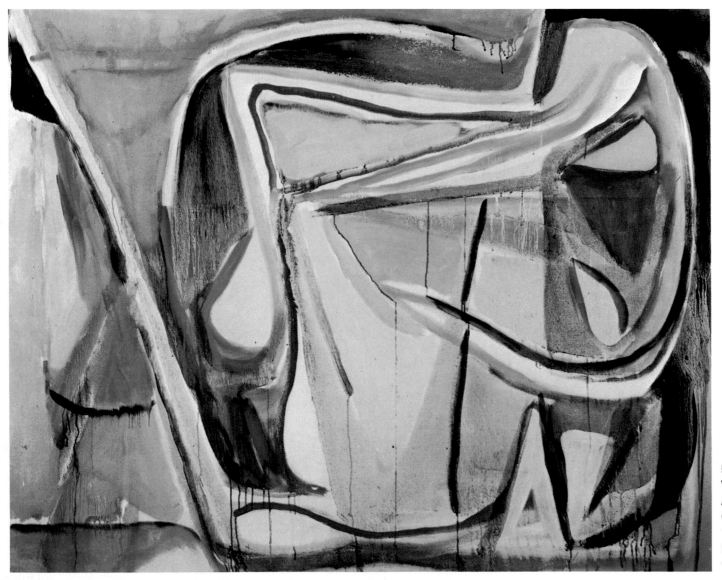

59 Bram van Velde
Painting, **1960**
Oil on canvas,
129·8 × 162 cm
Private
Collection

60 Tadeusz Kantor
Pas-Achas, **1958**
Oil on canvas,
135 × 145 cm
Warsaw,
Narodowe Museum

and express that which cries out of the depth of one's being, without any intervention or change on the part of rational thinking' (G. Mathieu). The moment of concentration and surrender decides all; Sonderborg used to note it down next to other data 'from 11.48 to 12.36 o'clock'. The diagonals of the main motif in the painting by Kantor, which suggest enormous speed, are strengthened again by quick, small bars. Here, the idea was to create new spaces, which in the case of Kantor led to such volcanic reaction. Next, there was also the question of 'space' for free creation, which was opened up in Poland since the autumn of 1956. With Kantor, a famous personality also concerned

Bram **van Velde**'s way of working (III. 69) is similar to that of de Kooning. The magical letter-forms serve as a starting point for denouement, for a poetic jaunt; whole new ornamental and colourful echoes reverberate against the initial shapes. These surprising echoes are lost every time in the completed lyrical labyrinth. Many have regarded van Velde as a Romantic, others an existentialist hurt by his environment. Samuel Beckett loved these images of decay. Van Velde seemed 'surrounded by a light torn from unknown depths and death, though rather more splendid than death. . .' (Jean Leymarie).

Speed of action unites the painterly explosions of the Dane K. R. H. **Sonderborg** (III. 61) and the Pole Tadeusz **Kantor** (III. 60). This speed, together with extreme concentration on the act of painting, is one of main rules of Lyrical Abstraction. 'Only the speed of action enables one to take hold of

61
K.R.H. Sonderborg
25th October, from
11.48 – 12.36 o'clock
Tempera paste
on canvas,
140 × 89.5 cm
Paris, Flinker Gallery

91

62 Hans Hartung
'T. 1974, E. 15', **1974**
Oil on canvas, 180 × 180 cm
Paris, Gallerie de France

with the experimental theatre *Cricot*, a new generation of artists became prominent (after the resourceful Constructivists of Strzeminski).

The direction of abstract painting based on calligraphy and signs is in a certain sense diametrically opposed to the concepts of Mondrian and some of the Concretists. They attempted to discover a geometrical equilibrium for all times; whereas Hartung, Tobey, Soulages and others had surprised matter in a transitional condition, in the course of amalgamation, and had made this behaviour 'transparent'. They followed up

certain ideas from the East and the style of the Surrealist André Masson.

Masson realised the central importance of 'written' signs and ideograms 'which awaken an unsuspected consciousness in man'. These signs translate the tensions inherent in man although much remains that is untranslatable. The signs are 'a way of life for the Chinese and Japanese, a way of yielding to the universal elements in life; for us they are a form of summary'. Masson, who worked in the USA during 1941–45, contributed with these ideas important stimuli for the beginnings of lyrical painting.

For Hans **Hartung** (Ill. 62) the act of painting is not the realisation of knowledge but an illumination of inner impulses, especially of the will. His signs are not indicative of a 'perhaps' or 'possible' but of 'certainty' and 'necessity', they are hard and sharp as though he had meant to write through the canvas onto reality.

This gives them ethical implications. The events in Germany and Europe after 1933 which prompted Hartung to emigrate and finally to join the resistance, forced him to paint images of revolt and negation.

The work and the life of the strange American Marc **Tobey** are surrounded by myth. It has been said that he looked to models in the Far East for his 'white writings' but these paintings were created before his journey to China. Parallels have been drawn between the jostling masses of the city and the structure of his work. But the network of his lines, these 'microcosms of signs' (Ill. 63) were probably meant as a liberation from the threat of the masses and the big city. Tobey, an initiate of the Bahai sect, described his feeling for the mystical and unknown: 'my work is an inner contemplation', every trace, every line represents a different moment in existence. His hand responded to the minutest vibrations of the deepest layers of the soul, a vibrating of the psycho-physical dynamism which is the basic source of all vitality — universal as well as human. The main problem was how to transfer, these all-embracing rhythms. The frequency points to depth and light. The 'meditative' networks unite space and time, bring the one into harmony with everything.

63 Marc Tobey
Microcosmos, **1959**
Oil on canvas, 25 × 31·5 cm
Artist Collection

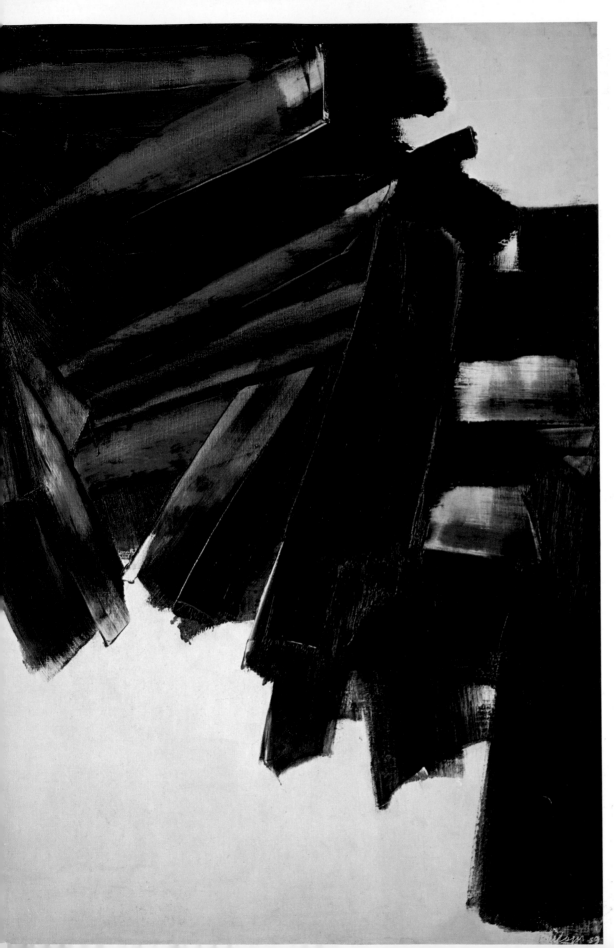

The macro-signs of P. Soulages and K. Kline are of a different kind. A strong mind given to the monumental separates the self-trained Pierre **Soulages** from Hartung. He regards his powerful style as the poetic method of pure painting (Ill. 64), and he confides: 'I do not know of the dilemma between figurative and non-figurative in my work. I neither start from an object nor from a landscape to be gradually transformed, nor, on the other hand, do I search for their appearance. I build on rhythm, the clashing of forms in space, the elimination of space through time. Space and time are no longer the containers for painted forms to be dipped in, they have become instruments of the aesthetics of painting. They are more than means of expression, they have become poetry themselves'.

'By using mellow colours between black and brown he forms expressive lines which capture the high flight of a tragic life' (Brion). This dark network of lines according to some critics symbolises our expectations of this world; the source of light is tragically cut off.

Is the interpretation of these signs always negative? Is the work of Hartung, Soulages, Vedova, Kline always an act of denial, of crossing out? Does it represent stains of guilt on a clear conscience? Some of the paintings of the New Yorker Franz **Kline** (Ill. 65), for example, resemble the structure of a bridge. Kline commented on this: '... if someone says "this looks like a bridge" it does not bother me. Much of it really does look like that ... I love bridges ... Of course if you read such associations into the work, and someone looks at the work he is bound to say: "he paints bridges" ... There are forms which are figurative for me, and if they develop into a figurative work then that is just the way it is. I do not think that anything should be purely without associations as far as the forms of figures are concerned ... I attempt to create a painting in such a way that the whole is imbued with a special kind of tension, not just particular forms of it.'

64 Pierre Soulages
Painting, **1959 (28.12.)**
Oil on canvas
Private Collection

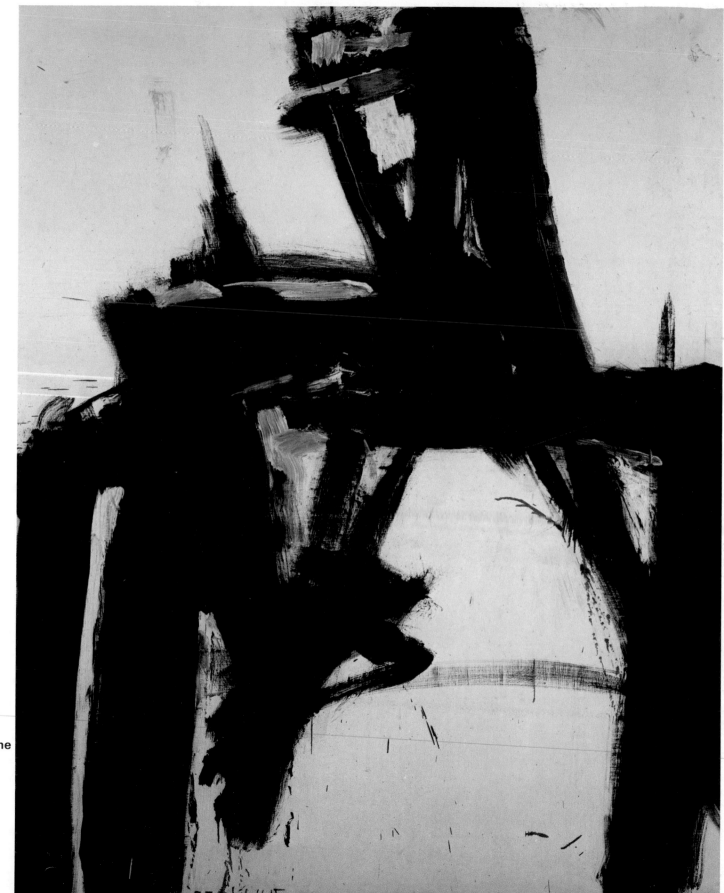

65 Franz Kline
Without title,
1957
Oil on canvas
Düsseldorf,
Art Collection
of Nordrhein-
95 **Westfalen**

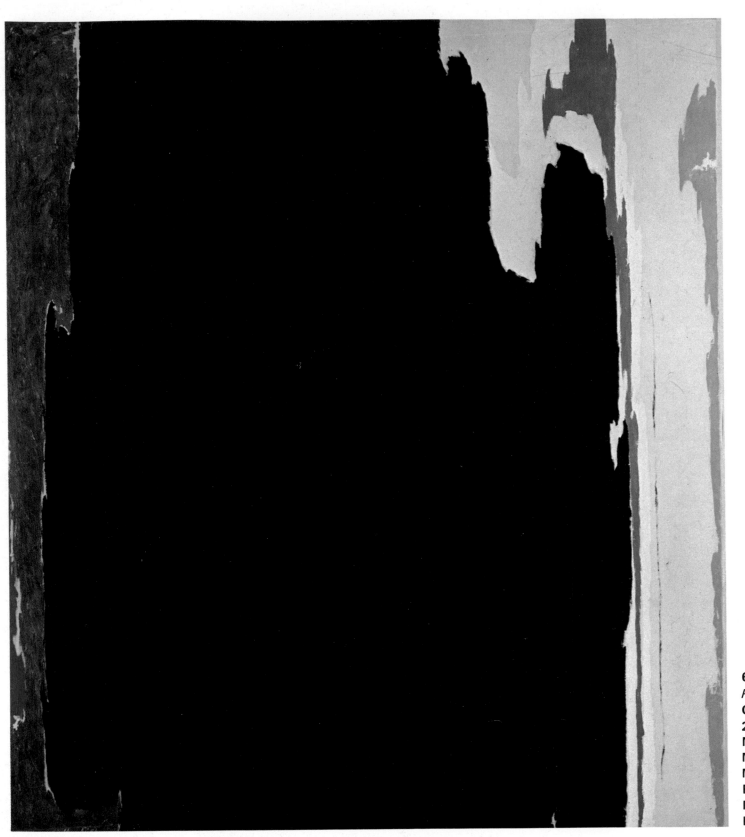

66 Clifford Still
Painting, 1951
Oil on canvas,
238·7 × 208·2 cm
New York,
Museum of
Modern Art,
Blanchette-
Rockefeller
Donation 96

Many have seen childhood impressions in the work of Clifford **Still** (Ill. 66). He himself however said that he only wanted to realise a pure way of painting, like Mondrian. He remarked: 'We don't have to draw attention to the fact that colour on a canvas causes people to have mostly conventional reactions. Behind these reactions is a mass of history and tradition. I despise the totalitarian hegemony of this tradition and reject its claims. Its sense of security is a brutal illusion, without courage . . . the fact that I grew up in the prairies has nothing to do with my work, with the things people seem to find in it. I paint only myself, not nature. I am not an "action painter". Every painting is an act, the result of action and its completion. I do not have a comic or a tragic period in any sense. I have always painted some dark paintings, some light ones. In all probability I shall continue to do so'. Still's vision is an American feeling for space and for behaviour, as it appeared also in the work of Pollock, Rothko, Newman, Noland and others. These different qualities are most clearly seen when compared with the 'European' concept of a Mondrian.

While for Mondrian the geometrical element was an inseparable quality, a given constituent of space, and therefore a generally and historically valid dimension, space and structure for Still are not something already 'there', something already structured. He simply tries to 'create room for his own existence' and join it up with the wider areas of life. The painting is not realised according to a fixed set of rules, all the different spots of colour are equal, without indications of fore or background.

The art of the American action painters too is not bound to a cultural system, it is simply a primary experience which excludes all preconditions. Each painting is an act in its own right.

67 Mark Rothko
Mauve-green-red, **1951**
Oil on canvas, 230 × 137 cm
Private Collection

97

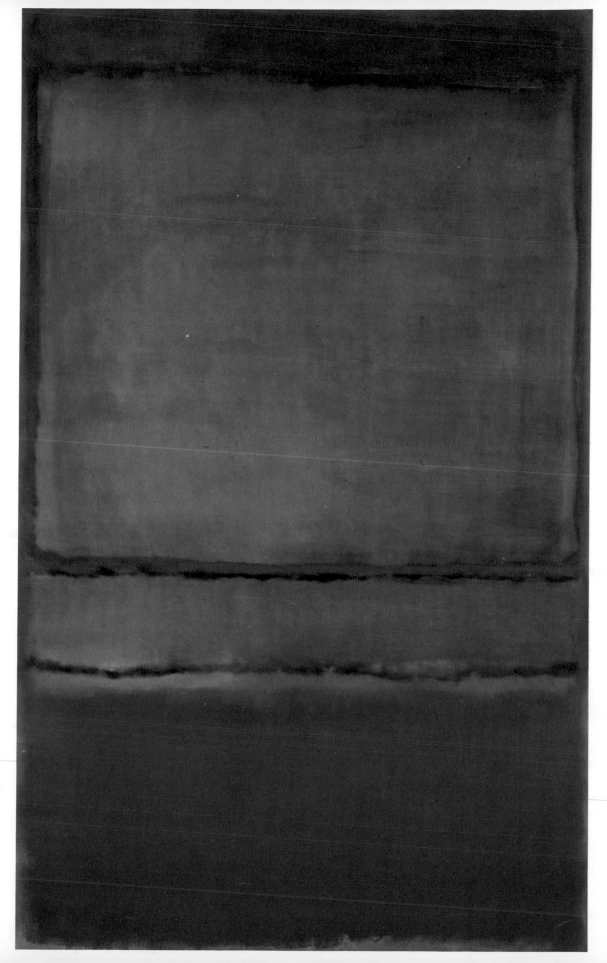

'I like to do large paintings' declared Mark **Rothko**, 'I understand that seen historically the painting of large works means the creation of something grandiose and pompous. The reason for my painting large canvases – and that I think goes for the other painters I know as well – is that I want to be intimate and human. To paint a small work means to put yourself outside the experience, to view it through a looking glass. If on the other hand one paints large canvases, one is part of them, one cannot control the whole anymore'.

Rothko also set certain problems for the art historians with his theoretical contributions. Often one is faced with subtle cultural criticisms and questions concerning the archetypal nature of things. One may realise for example that the late paintings (after 1949) are meant to be nothing but coloured walls (Ill. 67). Our whole life takes place within four walls. Yet no one before Rothko ever asked what a wall potentially means to the deeper levels of our subconscious. Is it a boundary or a protective screen? Does it not protect the inside of the room from the world outside? In any case walls are not only something solid, they are also identical with colour: in this way they provide the answer to space and light. This substantiates the art of Bram van Velde or the Zero Group even more.

Mark Rothko painted those large,

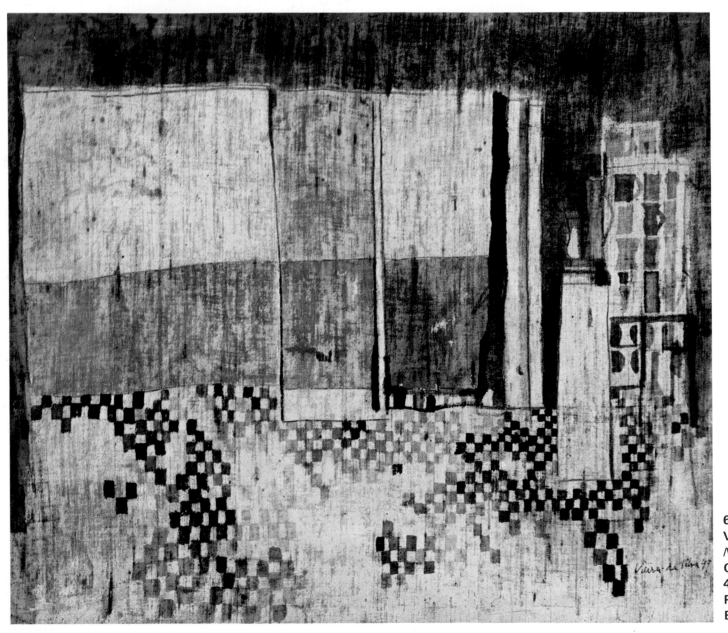

68 Maria Helena Vieira da Silva *Normandy*, **1949 Oil on canvas, 41 × 46 cm Paris, Jeanne Bucher Gallery 98**

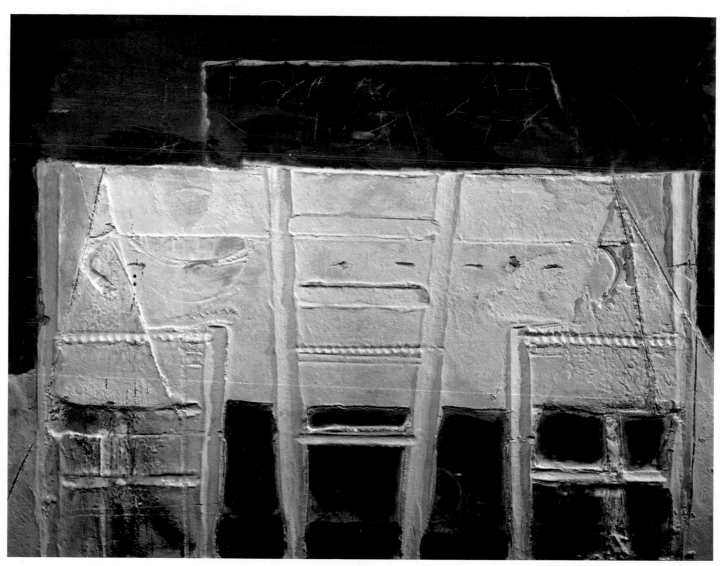

69 Antonio Tàpies
Three chairs, **1967**
Collage on canvas
Private Collection

suspended rectangles with the calm, broad gestures of a house painter; in this way he achieved an enlargement of space, a continuity. Rothko's paintings are a kind of arbitration between our empirical living space and that of the cosmos. According to Argan these meditational paintings mirror the magic of the splendid mosaics of the orthodox churches of Dwinsk where Rothko was born. In the realm of informal art, of magical abstraction and especially of genetical figuration, the unconditional rejection of the natural and the representational has never been followed consequentially. There are examples where the figurative ciphers can be reasonably identified.

The painting *Normandy* by Maria Helena **Vieira da Silva** (Ill. 68) shows us a delicate phase of reduction. The depth of the room, the substance of the furniture even the immediacy of colour diminish increasingly. What remains are the calm silhouettes of objects, a flat, tenderly graphic structure like a web of reminiscences. These are the first steps of Alice in Wonderland to which da Silva's painting has been likened. A little later the painter discovered the horrifying rows of terraced houses in the city, and the perspectives of factory halls with giddying vanishing points. 'Insecurity, that is me,' she has said, 'this insecurity can be seen in my work, this terrible labyrinth'. And Marcel

Brion commented '. . . Nowhere a surface on which a foot might rest, or slip on a shining pool of water, or break through an illusionary ground . . . space is in a state of ecstasy, the vertical lines are swaying . . . the condition of the soul is one of fear, of wanting to escape, which we know from our own nightmares'. How differently one can 'feel' space and interpret it!

In the case of Moholy-Nagy and other Constructivists, consciousness and space are almost unanimous. The elementarist Antonio **Tàpies** was conscious most of all of what is called matter. This also contains the key to the understanding of informal art, as

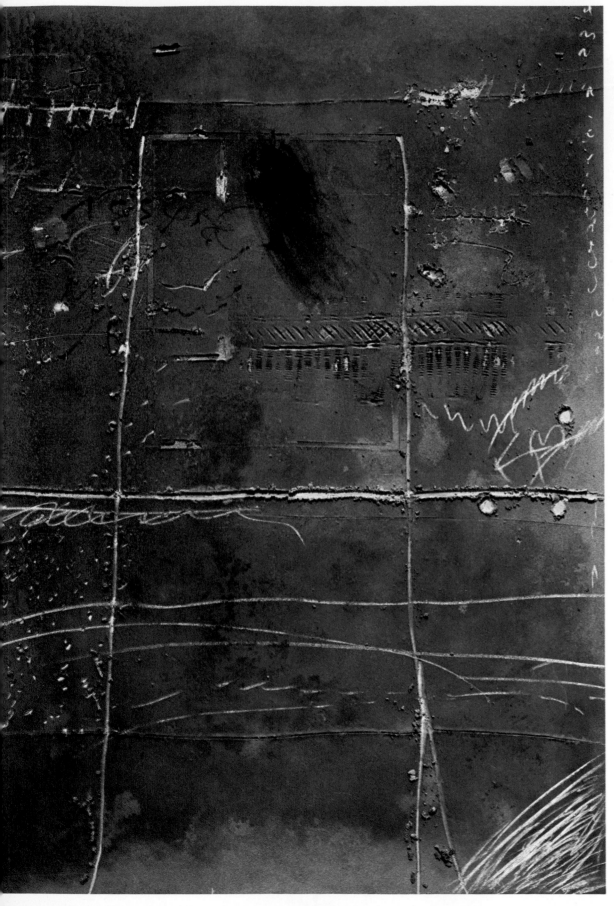

well as the key to the 'Spanish' idiosyncrasy of Tàpies. One has observed in the dark, brooding main motifs of his early work the tragic atmosphere of his country. The curtains are drawn, the doors are locked, and the wall becomes a reflection of existence 'like the walls of prisons become and pass on traces of the existence of those sentenced' (Ill. 70). This tragic view of life, the admonishment that death will come and the flesh will pass away, which has never left Spain since the Middle Ages, is visualised by Tàpies with a chaste strength and dignity. The strongly materialistic basis for his anti-paintings, cement surfaces with scratched traces, assumes spiritual qualities during contemplation. The traces of the three abandoned chairs around a covered table (Ill. 69) have the mood of a piece by Becket. These 'impressions' have a nailed-on quality; they are not symbols to ignite our imagination to flights of fancy. Physical reality, its constant 'now-ness', blocks the imagination, eats it up like quicksand and reduces it to a sign. Matter — sand, cement, asphalt, earth — is itself a symbol of the 'despairing absence of life' (Argan); it is also, according to Tàpies, capable of further interpretations. 'To force man to recall what he himself is in reality, to give him a theme to think about, to shock and awaken him out of the illusion caused by what is faked, this is what I attempt to do with my work', wrote Tàpies. He thought he would achieve this aim 'not by despising technology, but by fighting against the spiritless and material dependency into which technology has forced us, and trying to overcome it. I use the word technology in its widest sense, that is from the simple mechanism to start a machine to the instruments of power. With my work I attempt to help man to overcome his alienation; I do this by surrounding his daily life with objects, which confront him with the final and deepest problems of our existence in a ''touching'' way.'

70 Antonio Tàpies
Writing on the wall, **1971**
Mixed technique on canvas
Private Collection

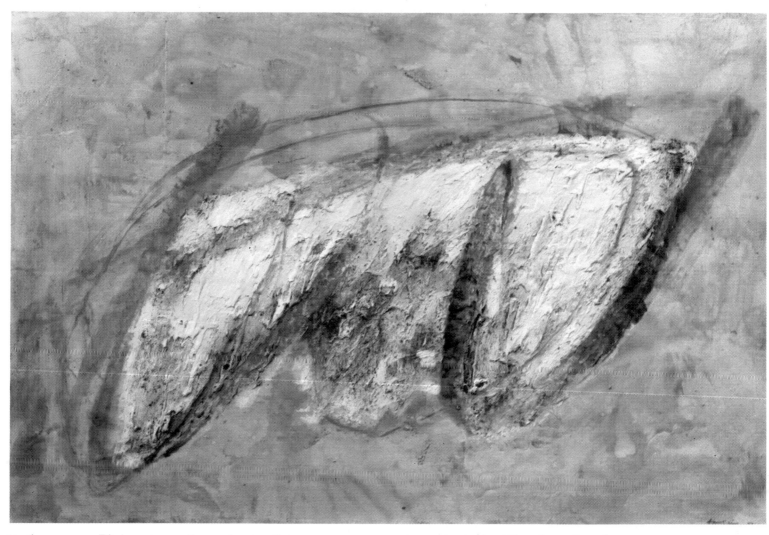

Next to the young Tàpies, two other masters became the leaders of the informal 'L'art autre': Jean Dubuffet and Jean Fautrier. In their work, too, rough or very exposed matter is the main medium of communication, but it appears as something alive and full of sensitivity, something which can assimilate impulses and integrate them. It is matter as memory in the sense of H. Bergson. **Fautrier** who is deeply related to the French sensualism of Monet and Bonnard, found his almost non-representational way of working as an illustrator in 1928. 'The eye has changed', reflected Fautrier, 'and no one can deny that our way of seeing today demands something different, something so different that one is puzzled to think that twenty years ago the

best artists were content and were looked upon as innovators when they painted black fishes or red trees in front of their motifs. Art is something which destroys itself as a matter of course, indeed it must do so in order to renew itself.'

Fautrier is a painter of crises, very much like what Camus was for literature. He felt that the painting was a fragment of reality (Ill. 71), in other words an allegory of our tragic, fragmented existence. He became famous for his cycles *Hostages* which he painted during the Nazi occupation, and in which he demonstrated the vulnerability of man through indeterminate, uncompleted forms, the movement of existence which is suspended between wish and pity, and consists of layers of desperate hope and fear.

71 Jean Fautrier
Naked woman, **1960**
Oil on canvas, 89 × 146 cm
Paris, de Montaigu Collection

The precarious situation of the hostage demonstrates the nonsense of our human condition as such: we suffer not only from non-freedom, but also from a denial of individuality and an offence to universal liberty. The slave becomes just a wounded piece of flesh.

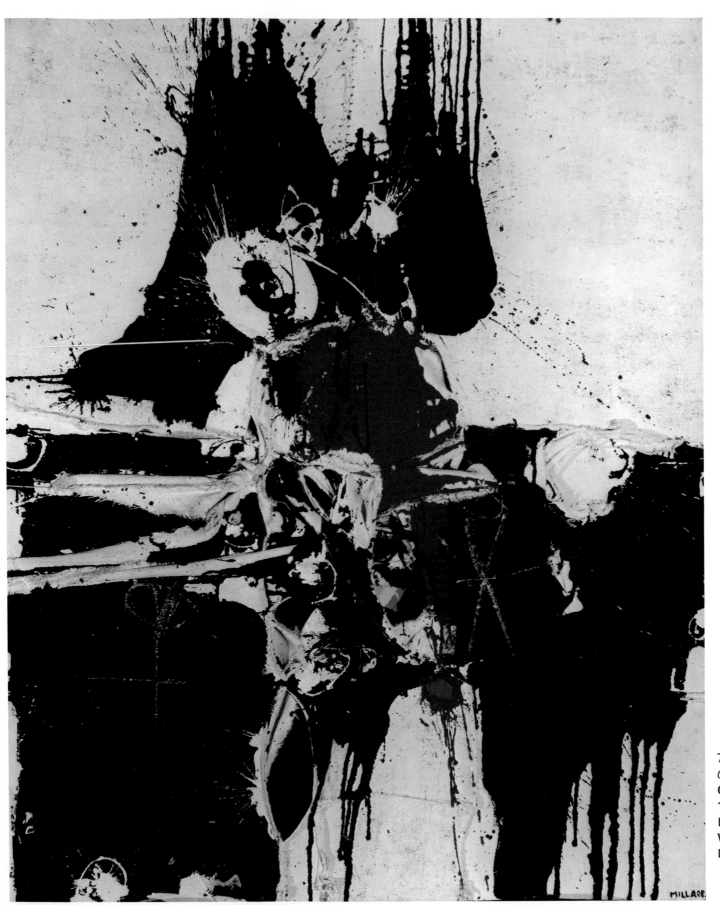

72　Manolo Millarés
Cuadro 66, **1966**
Oil on canvas,
160 × 130 cm
Ludwigshafen,
Wilhelm-Hack
Museum　　　**102**

73 Mikuláš Medek
Fragility, **1964**
Oil on canvas, 162 × 130 cm
Pilsen, Západoceská Gallery

A similar realisation informs the committed, magical form of art. Offended by the destitution of the times and the suffering of man in a prison called the State, the paintings of the Spaniard Manolo **Millarés** and the Czech Mikuláš **Medek** show the depth of despair and resistance. Millarés debases matter and crucifies his images forcing the drama of his art into a horrified cry of death.

In the case of Medek despair and humiliation found their answer in subtle, mostly enigmatic and secret messages. His paintings were created in a part of Europe where the only form of fine art allowed was of an illustrative kind, everything else was prohibited and condemned to destruction from the outset. As a result Medek was looking for another private form with which to accuse or to witness, an inner surface where repressed truths and feelings and their traces and scars could be written down (Ill. 73). Something here has fallen into terrible hands, has been attacked with claws. The surface of the painting is stigmatised with contradictions. Although the broad areas of the unknown throw shadows upon this document, the very existence of a prohibited non-figurative manner is a political act, has become a call to action, to identify with the outcast artist.

While Medek's psychic experiences look like the play of shadows on a screen, some of the paintings of Emilio **Vedova** are reminiscent of the corpses from yesterday's battle. By becoming monuments of destruction the paintings loose their pictorial geometry. Here is a reminder of the terrible year 1933 in Berlin (Ill. 74), a composition which has been infused with magic by the artist and therefore defeats the ever-present enemy and his system.

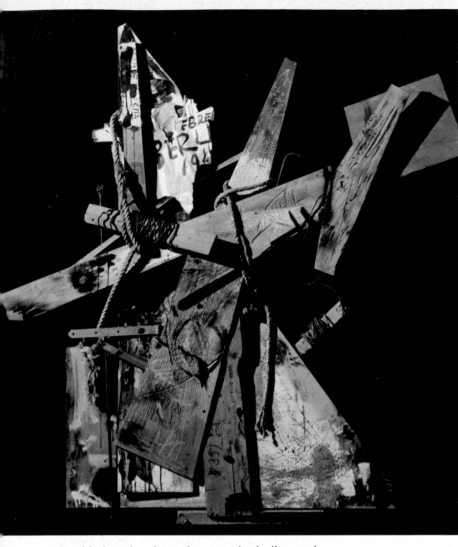

74 Emilio Vedova
Berlin 33, **1963**
Collage,
mixed technique
Venice,
Private Collection

specialised synthesis. Here is the enormous value of Fontana's ideal: he painted light and neon-curves, he led empty space through sculpture, he put spatial pieces of colour into his paintings. Fontana denied the boundaries between the different genres; after him comes a new era of thinking about, and working with, space.

The anti-art of Alberto **Burri** (Ill. 75) always works according to two levels. The old pieces of cloth, the rotten bread and pieces of bent metal remain what they are; at the same time they rise to the point of greatest value: they become colours, space; that is to say, they become contradictions to matter. This material does not hide the level of things past, the traces of an earlier life, of torture and humiliation. The second level is their presence itself: everything can be cruel too, but everything is before us, here and now. One has to identify with the materials

Vedova has brought us to the Italian anti-paintings and the new post-abstract movements which adopted the non-figurative as their basis. The names of their prophets were Fontana and Burri. The name of Lucio **Fontana** is synonymous with the symbolic destruction of painting as illusion (Ill. 76). The monochrome surface dispenses with any kind of implication. The cut, the hole are not an imitation but the real thing, of perfect proportions and in the right position. In the days of mass productions as well as thinking and acting, something like this was (according to Argan) a passionate turning towards unified action. Someone also wrote that the perforation 'allows nothing to flow on the surface'. Fontana himself was far removed from existential meditations. For him this hole meant the introduction of real non-illusionary means, most of all of real space, into an art progressing towards the

75 Alberto Burri
Sack no. 5, **1953**
Collage,
150 × 130 cm
Private Collection

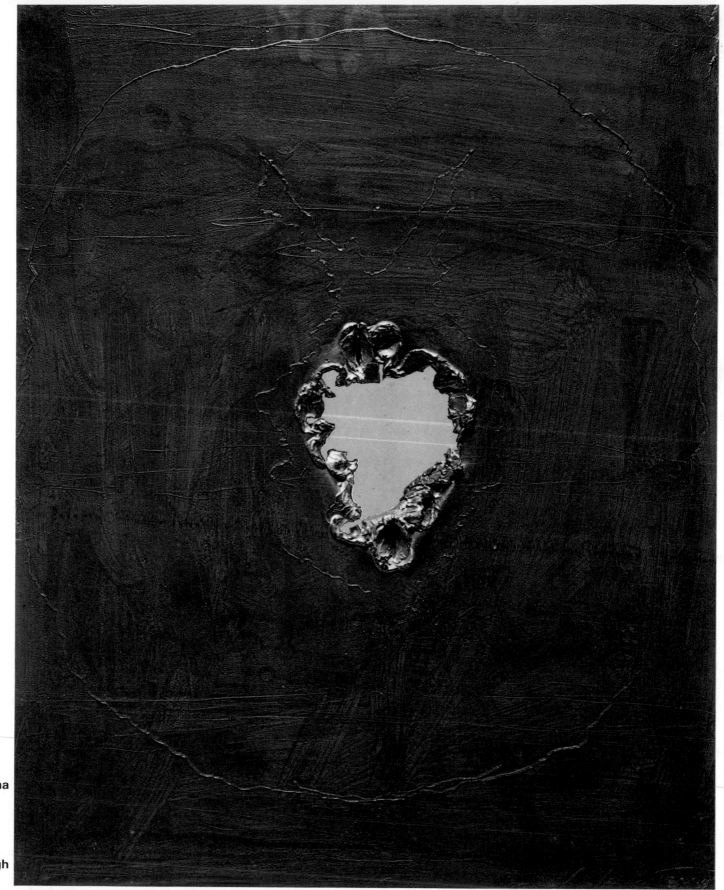

76 Lucio Fontana
Concetto spaziale,
1963–64
Gold on canvas,
80 × 64 cm
Rome, Marlborough
105 **Gallery of Art**

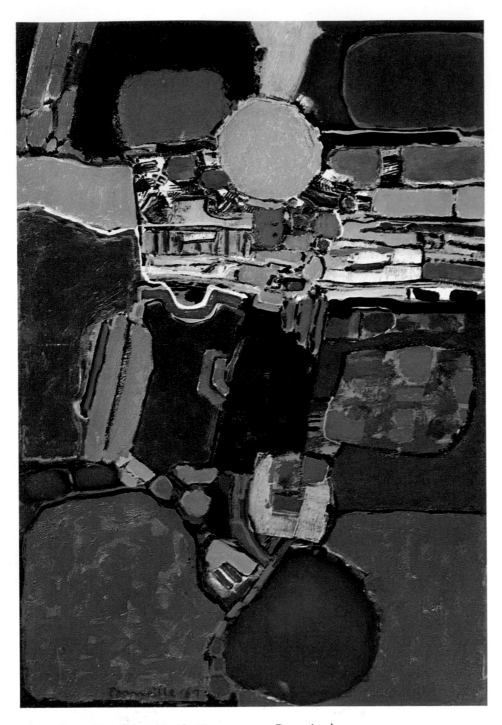

77 Corneille (Cornelis Guillaume van Beverloo)
Metaphorical ensemble, **1967**
Oil on canvas, 100 × 73 cm
Private Collection

and their suffering to achieve a higher form of consciousness. Burri's discoveries helped hundreds of painters by encouraging them to improve their work as well as reminding them of the moral connotations of committed works.

At the beginning of the 1950s, while innumerable movements were formed, an ideology of Abstract Art constituted itself. There were strict rules on what was permissible and what was not, far removed from a non-figurative realism. Was it a reaction to the earlier condemnation by 'figurative' art? At the centre of this ideology was the problem of 'truth'. While the figurative painters could do nothing else but sell poetical superficialities (lies, in other words), the abstract artist expressed a deeper, structural truth. The figurative artists could never express the truth because they operated with the old familiar stuff of tradition. The abstract painters on the other hand, discovered, often in a state of the highest emotional tension, the deeper and authentic level of reality. The figurative is a historical phase about to disappear, repeated the dogmatists. Now art is truly at the height of non-representational creation.

This evaluation had consequences of a moral kind as well, indeed it led to an 'abstract' puritanism. This accounts for the horror felt by the critics about the figurative 'escapades' of de Stael, Pollock and other informal artists. The 'Jerky' figurations of the Cobra group (1948–51, artists from Copenhagen, Brussels, Amsterdam) were followed with suspicion especially as they introduced yet other motifs, for example the animalistic, 'nordic' forms of expression.

One can see the change after the Second World War even more clearly if one keeps in mind that Corneille (Ill. 77) and Appel (Ill. 79) were compatriots of Mondrian and the Neoplasticists. The Cobra artists also opposed a certain kind of painting of 'good taste' as it was practised in France. Nevertheless they revered a great idol, Jean Dubuffet, the painter of 'pre-historic' emotions and demonology. Their thinking also tied in with the work of the informal 'L'art 106

autre' of the critic M. Tapiè: 'These two movements marked the gulf between figurative and abstraction and were concerned most of all with the power of expression, with impetuosity, with the lyrical' (Ragon).

Corneille, who disengaged form from everything relating to the past, followed his own artistic imagination. His work suggests many strange figurations with hints of a landscape here and there (Ill. 77).

Cobra paintings deal with the interactions of signals, signs and symbols, a kind of game which takes place in our imagination. A tension occurs between the representational references and the non-representational, emotional signals, 'The artintic signs', wrote the Cobra member Asger **Jorn** (Ill. 70) in 1958, 'corresponded to the objective or symptomatic signs: black clouds and thunder, which indicate a thunderstorm. A sign changes into a symbol if the object is absent ... Since man has the capacity to create with his imagination, he can develop the characteristic behaviour of the absent object'. He added: 'We may say that the aesthetic value of a human artefact is dependent on the extent to which it creates the impression of something real and present.'

This almost anti-abstract formula applied also to the magic of the new figurative movement, as it developed with the new non-representational painters such as Jorn, Corneille and de Stael.

All ways and means were welcome to Jorn in order to exorcise the apocalyptic demons. What is soberly described as a 'combined technique' was in reality a treatment based on de-collage. It was not unlike the process of skinning.

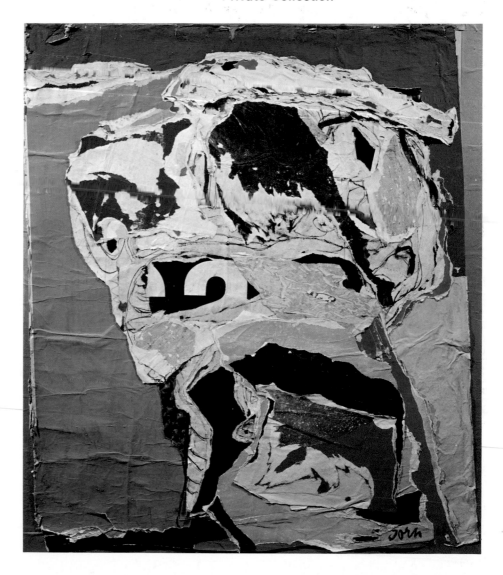

78 Asger Jorn
Striptease of skinned creatures, **1968**
Collage and oil
Private Collection

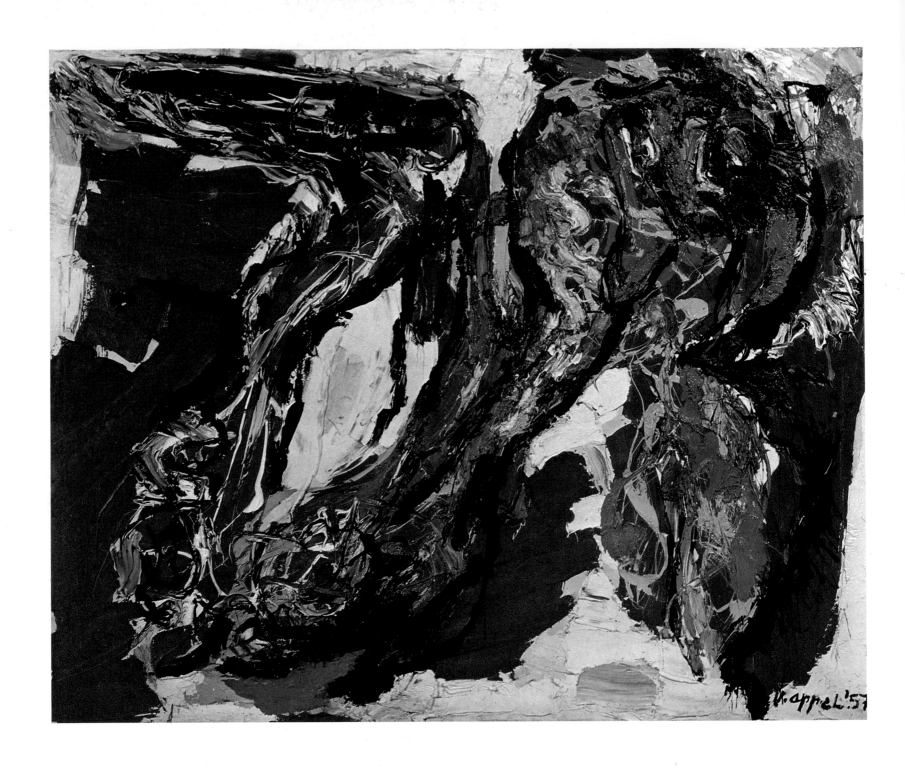

79 Karel Appel
Woman and flowers, **1957**
Oil on canvas, 130 × 162 cm
Amsterdam, Stedelijk Museum

Karel **Appel** (Ill. 79) drives these dramatic elements to a hellish convulsion of symbols and colours. It is a modern infernal Leda, an ecstatic marriage of forms and non-forms, an eroticism of massed colours.

The volcanic excesses of Appel contrast with the feeling for mass and harmony in the constructive sensualism of Nicolas **de Stael**. De Stael was a painter who went through an ascetic period of simplified forms and grey scales. He retained a taste for the dignity of geometrical forms. 'What determines the dimensions is the weight of forms, their position, their contrast. In order to develop in my art, I have to approach each work differently without the aid of a predetermined aesthetics. I lose touch with what I am doing from one moment to the next, find it again and lose it . . . It has to be this way, for I believe in chance . . . one never paints what one is looking at, or thinks one is looking at, one paints in a thousand vibrations the shock which one has received', wrote de Stael. His enormous landscapes and still-lifes fuse the poetry of things and man with the cosmos in a hallucinatory way. It is a ghostly, brilliantly shining world. De Stael was the true apostle of the new figurative work.

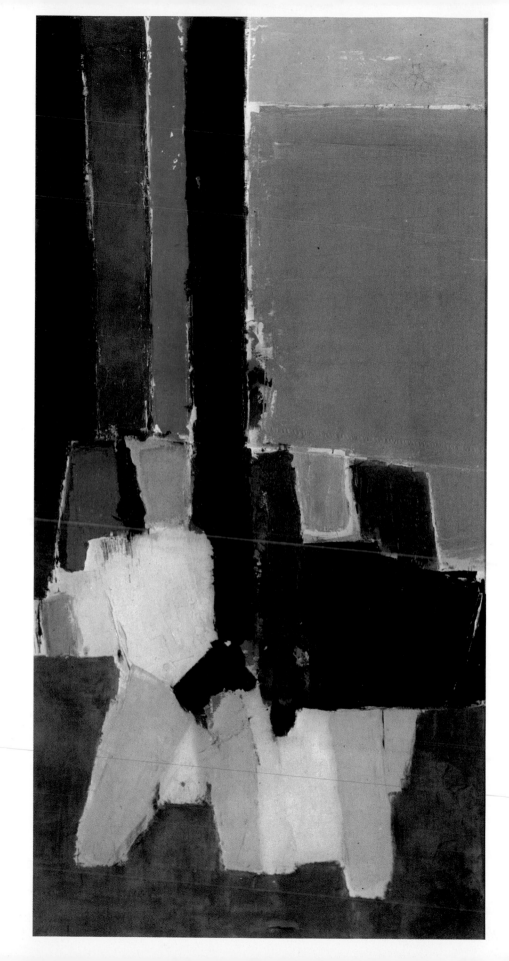

80 Nicolas de Stael
Le Lavandou, **1952**
Oil on canvas, 195 × 97 cm
109 **Paris, National Museum of Modern Art**

81 Nicolas de Stael
Football players in the park of the prince,
1952
Oil on canvas, 56·2 × 76·2 cm
Meriden (Connecticut)
Mr. and Mrs. Burton Tremaine Collection

The so called 'geometrical renaissance', which became very strong after 1955, not only generated new movements like Kinetism, Op art, Hard-edge and 'visual research', but also developed forms of the older Concretism, or 'geometrical signs'. The former are represented by the work of Jean Dewasne and Arturo Bonfanti; the latter Concretism can be seen in the works of Ben Nicholson(Ill. 83). This friend and admirer of Mondrian mixed the representational and constructional forms in a charming way, but always with a sense of classical harmony and a slight touch of sentimentality. He said: 'A square and a circle are nothing in themselves, they come alive through the use the artist puts them to when he wants to express a poetic idea.'

Arturo **Bonfanti** shows us in his painting *Apparent quiet* (Ill. 82) an instance of the formal self-innovation of a work of art. A 'hidden' identity and mirroring technique open a chain of creative and conceptional possibilities. While one is looking at the equilibrium of the work, it shifts slightly but constantly and this movement corresponds to what happens in our minds. The yellow colour gains the upper hand only gradually.

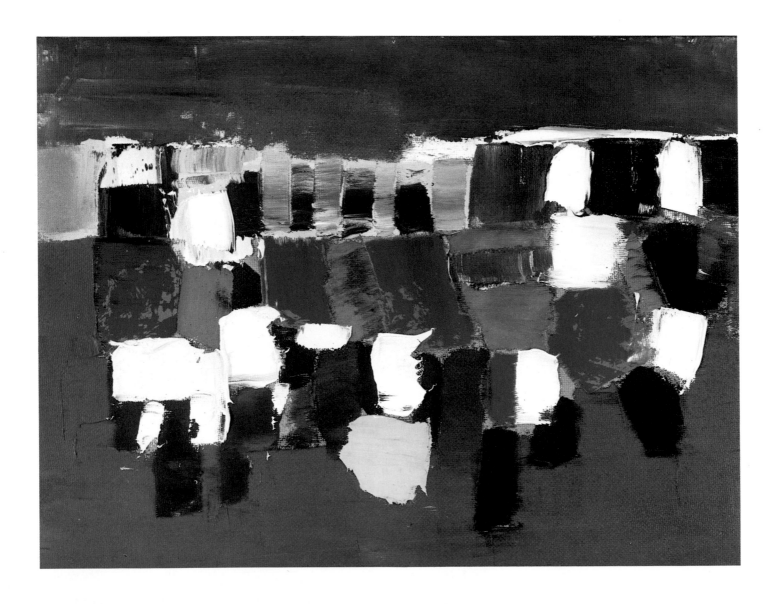

82 Arturo Bonfanti
Apparent quiet, **1960**
Oil on canvas, 46 × 55 cm
Private Collection

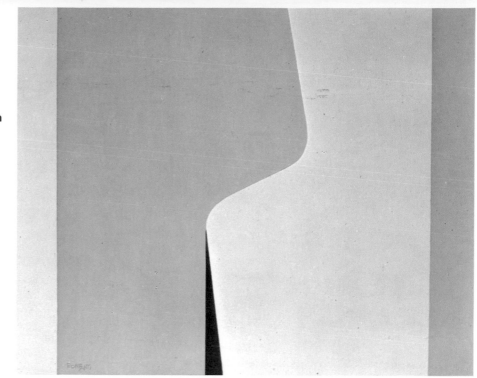

83 Ben Nicholson
Kerrowe, **1953**
Pen and oil on hardboard, 28·5 × 42 cm
Paris, Private Collection

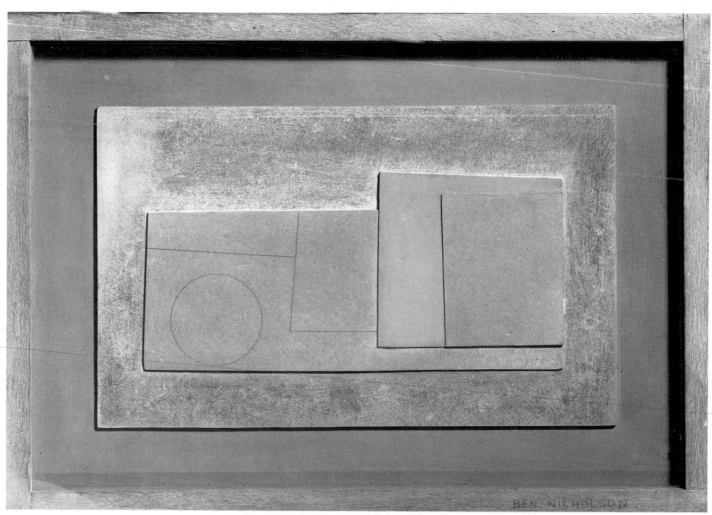

84 Jean Dewasne
Don Juan, **1953**
Oil on canvas,
96·8 × 129·8 cm
Paris, Denise René Gallery

Jean **Dewasne** (Ill. 84), together with Vasarely and Pillet, was the initiator of a new system of thought as well as a different stylistic expression. The strong rhythm and contrasting structures come close to African culture: 'His volatile temperament brings the geometrical forms close to the point of bursting' (Brion). Dewasne's theories were opposed to the one-sidedness of the cool specialists: 'The role of the artist lies in bringing the material to the maximum point of expressive power. But this alone would not suffice if he were not to use, at the same time, the structural logic which results naturally as the material unfolds itself . . . I have defined the new synthetic and

85 Richard Paul Lohse
Rhythmical progression, **1952–59**
Oil on canvas, 48 × 72 cm
Zurich, I. L. Collection

dialectical conception of Abstract Art, of an objective art as it is beginning to grow today; I have done this in opposition to the analytical and static conception of the early abstract works; the work of art is first and foremost a means to unite mankind. This is far removed from the type of work through which the artist pours out his secret complexes and inner sickness.'

Serial and systematic art takes us into the ante-chamber of a different sector, the exact sciences. Richard Paul **Lohse**, starting from Concretism, reached serial art already during the Second World War (Ill. 85). His colour exercises are carried out in a rhythmical, equally formed structure. Based on the pre-ordained order and on a limited number of elements, a mathematical series of variations develops with certain musical connotations. 'The pictorial elements are summed up in themes. Similar themes form a whole, which is equal to its parts. The anonymous form gains the dimension of infinity and the absolute. The method is the painting itself' declared Lohse.

The scientifically constructed paintings of Victor **Vasarely** (Ill. 86) give us a surprising proof of how the mathematical combination of two visual elements, i.e. of a colour unit and a colour scale, can lead to a very rich pictorial organism. The painting, which is composed by grading small cells, 'plastic units', can be read in many different ways. The proportions may be evaluated by means of the different tones either in a positive direction or a negative one. It is a model of the relationship colour-surface-perception which sets out clearly and consciously to teach us the art of seeing. Vasarely remarked: 'The masterpiece is not the concentration of every quality for a final goal, but the creation of a prototype, which serves as a starting point and contains all particular qualities which are perceptible in the numerical progression.'

The methodical research into variants does not necessarily have to combine with a mechanically repeatable almost anonymous concept. The mono-thematic serial paint-ings of Albers, Calderara, Reinhardt and Newman demonstrate the power of modern conceptual thinking fused with the secret of artistic poetry.

Since Monet's *Cathedrals*, fine art knows of a kind of experimental series, which had been the preserve of the natural sciences. But there is a difference. Of the many physical experiments carried out only one confirms the hypothesis, only one is true. In art however all experiments are true, which is to say they are all of value.

86 Victor Vasarely
Lant 2, **1966**
Tempera paste on chipped wood, 80 × 80 cm
Cologne, Ludwig Museum

Ad **Reinhardt**, an admirer of Malevich's metaphysical thinking, tended towards the absolute and esoteric 'art as art', and found his primary concept after 1950. At that time it was a hieratical red, blue, black, monochrome symmetry of squares, crosses and lines; after 1963 he painted black pieces of differing structures. 'I am about to create works as final as anyone is capable of' he wrote in 1966, the year of his death. Reinhardt's activity was laced with philosophical meditations; he also used two examples from the generation of conceptualists.

'The first rule and the absolute measure of fine art, the highest and most sublime of the arts, is purity. The more matter it contains, the more alive it is, the worse it becomes.

87 Josef Albers
Homage to the square: green scent, **1963**
Oil on hardboard, 120 × 120 cm
Cologne, Ludwig Museum

88 Barnett Newman
Midnight blue, **1970**
Oil and acrylic on canvas
133 × 239 cm
Estate of the artist

The many variants of *Homage to the square* (Ill. 87) by Josef **Albers** give all the relevant cases of possible relationships between colours. The neutral scheme of squares set into each other enables a high degree of concentration. The result is slight movement downwards or upwards, and perception comes close to a psychological colour test. The simple form becomes even richer on reflection; these meditative squares may, for example, be associated with 'green scent', with temporal or natural moods, as the title suggests. No one has exerted as much influence on American art, with the exception of the architect Mies van der Rohe, as Josef Albers.

canvases of Barnett **Newman** (Ill. 88). He himself thought that it was not so much his use of colour as his drawing technique which offered 'a new way of seeing'. 'Instead of working with fragments of space, I work with space as a totality.' Set against the European tradition, especially the 'empty formalism' of Mondrian, Newman attempted to achieve the maximum via a different route: not through harmonious relationships but through the expression of the sublime.

Newman, Reinhardt, Albers, Rothko have opened up new paths for American art. Their creative influence was taken up by the members of the so called 'post-artistic' abstraction and the painters of the Hard-edge.

90 Antonio Calderara
Orthogonal meeting of yellow with yellow, **1970**.
1970. Oil on canvas, 27 × 27 cm
Private Collection

89 Ad Reinhardt
Number 17, 1960
Oil and tempera on canvas
Private Collection

"More is less". The less an artist thinks in non-artistic concepts and the less he uses his old familiar skills, the more he is an artist. . . . The less a work is subjected to the whims of the public, the better. "Less is more".

These thoughts would not sound strange to the Italian Antonio **Calderara** (Ill. 90). This friend of Fontana found in the most simple forms of non-representational art a medium of communication with the beyond; this became a necessity for him after the death of his beloved daughter. But Calderara's dialogue with the 'other world' is full of harmony and filled with the tender light of hope. It is the eternal light of Mediterranean wisdom. One can see the eternal and infinite through his small paintings full of light, as well as one can

115 experience it in a flood of colour on the huge

For Morris **Louis** a painting is chromatic energy and motion (Ill. 91). Already in 1954, when the critic Clement Greenberg discovered him, his work distinguished itself from that of the action painters through 'veiled, transparent streams of colour which were kept close together. The transparency of the layers of colour was coupled with a spontaneous movement' (Claus). Organic, natural movement is kept to geometrical paths. Colour, not applied with a brush, is excluded as something absolute here.

91 Morris Louis
Columns at dusk, **1961**
Acrylic on canvas, 220 × 122 cm
Cologne, Ludwig Museum

92 Kenneth Noland
Via blues, **1967**
Acrylic on canvas, 288 × 670 cm
Pasadena, Robert A. Rowan Collection

93 Kenneth Noland
Provence, **1960**
Acrylic on canvas, 91 × 91 cm
Cologne, Ludwig Museum

His younger friend Kenneth **Noland** attempted to concentrate the potential of colour in another way. Next to 'target discs' (Ill. 93) and V forms, his work shows 'infinite' stripes (Ill. 92), The acrylic paint is sensitive and seems to breathe. 'In my opinion colour is the main thing in painting. Important is to find the right way to express colour, without destroying it, the way to make it retain its value independently of the form, whether hyperrealistic, Cubist or structural. Important is also to apply the paint so thinly that colour and surface fuse . . . everything is colour and surface. This *everything* has to fuse.'

Is there a relationship between Delaunay's *Circular forms* and Noland's discs? We are not concerned here with geometrical forms in the proper sense but with mental concepts which are related to ideas on space and light. It is a concept of cosmic wholeness. The white field is no longer a background, it is light. Or perhaps it is the symbol of an eye through which the Universe and the Ego can percolate.

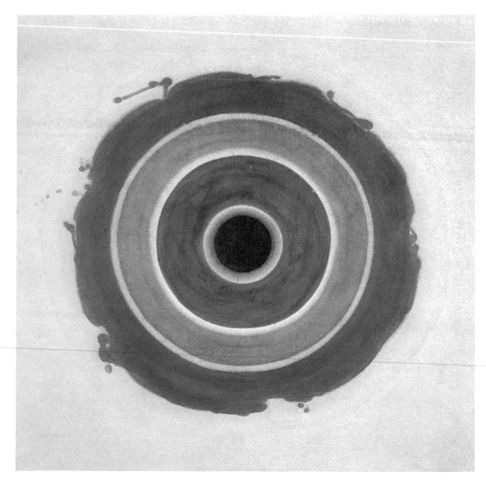

94 Nicholas Krushenick
Cocly, **1968**
Liquitex on canvas, 172 × 148 cm
Cologne, Müller Gallery

The provocative paintings of Nicholas **Krushenick** are built to a different principle of colour contrast (Ill. 94). Their sweeping, colourful, graphic effects are probably derived from the 'folklore of the city'. Are these paintings already part of Pop Art or do they still belong to the sphere of Hard-edge with its simple ornamental qualities?

The last examples show us only two of the hundreds of experiments which were generated by the original conceptions of Abstract Art and the experience of the non-representational.

118

Within the whole movement of 'Nouveau Realism' and the Zero Group, Yves **Klein** (Ill. 95) was the most versatile of anti-artists. He was searching for the language of rain and air and fire, of empty space, he wanted his work to exude an aura of quietness and peace. 'Then I learned to know nothingness, deep emptiness, the blue, deep deep blue. Once the adventure of the monochrome had started, my fine senses found their way — I was functioning'. The theory of the 'architecture of the air', had begun around 1958 with the title '*General development of contemporary art towards immaterialisation (not dematerialisation)* by Yves Klein and Werner Ruhnau.

Emptiness	Blue light
Stratosphere	Energy
Air	Heavy air and other gases
Optical fire	Heavier than air
Magnetism	Comont
Earth	Stones and clay, iron

The architecture of air is given here only as an example. In essence we are concerned here with the intellectual use of new materials meant to achieve a new, dynamic and immaterial architecture. . . .'

95 Yves Klein
Relief esponge bleu, **1958**
Mixed materials, 200 × 165 cm
Cologne, Ludwig Museum

Bram **Bogaert** had participated in the great battles of Lyrical Abstraction; around 1953 he belonged to the most respected protagonists of the dramatic-material trend. As he was leaving Paris in 1959 he discovered the shining light of the monochrome. His massive relief pieces generate the desire to wallow in a beautiful mass, they become symbols and fragments of architecture, or else they turn into a gleaming field in Brabant (Ill. 96)

Why do we stand in front of the walls of paint in childish fascination? Is it the result of the spontaneity of this simple work? Or is it the strong somehow familiar sensuality of matter? Or is it wonder at the sight of light turned into matter? One does not find the right answers. One thing is clear, Bram Bogaert has found a friendly primary element, something like fire, water or air, which we need to live. This material energy once captured through the creative act does not open up illusionary spaces but it dominates the real one, the one we live in. Are these fragments of a wall of colour 'anti painting'? Lucio Fontana felt them to be a contribution to the revolution of Spazialismo.

96 Bram Bogaert
Derroodruitgeel, **1976**
Plaster and paint, 195 × 135 cm
Private Collection